Edited by D. Jack Davis

BEHAVIORAL EMPHASIS IN ART EDUCATION

National Art Education Association
1916 Association Drive
Reston, Virginia 22091

[Second Printing, 1978]
05·1.5M·278

WITHDRAWN CONTENTS

LIST OF FIGURES

INTRODUCTION

D. Jack Davis

When teaching-learning situations are couched in an educational context, the resulting phenomenon is something which we have come to call curriculum. Barkan[1] says that the curriculum is a meeting ground on which educational instructions and students come together with the institution offering selected and contrived activities believed to have educational value and the student deriving experiences and achieving values from those selected activities which he encounters.

As the history of art education tells us, curriculum development in art has taken many turns. From the early attempts at developing a curriculum for the training of eye-hand coordination, to the more industrially oriented art curricula of the 1850's; to the culturally oriented art programs of the late 19th century; to the child centered art curricula of the early 20th century; through the emphasis on good taste in the 1930's; to the creative thinking emphasis in the 1950's and 1960's; to the present day concern with aesthetic education or interrelating the arts; art educators have been dealing with curriculum development.

While these efforts have varied greatly in terms of their precision and order, all have included in some form, either stated or unstated, some plans or directives for the learning activities, some means of implementing these directions or goals into a plan of action, and some efforts, either internal or external, to assess the results. More precisely, they have all given some degree of consideration to stating objectives, devising plans for implementing those objectives, and assessing the achievement of those objectives.

In more recent days with the emphasis on accountability, art educators have come to realize that they must sharpen their skills in stating and assessing the expected outcomes of learning. Realizing that the position and status of the arts in the total school program may depend upon the ability of art educators to offer concrete evidence of change in student behavior, arts educators have begun to systematically explore the basic principles of human behavior and learning and its implications for instruction in the arts. Based upon the empirical definition of learning as a change in behavior, such a position purports that all curriculum efforts are, or should be, behaviorally based if we are indeed concerned about changing students.

5

More specifically, the line of attack upon this problem has been the development and use of behavioral objectives in art education. While the formalization of the behavioral objectives movement can be traced to the early work of Ralph Tyler;[2] [3] [4] and the subsequent work of Bloom,[5] Krathwhol[6] and their colleagues and Mager,[7] two institutes held in 1968 and 1969 played a significant role in popularizing the idea among art educators and motivating action along these lines. These two unprecedented preconference institutes in research and curriculum development were sponsored jointly by the National Art Education Association and the Bureau of Research of the United States Office of Education. Prior to the 1968 regional conferences and the 1969 national conference of the National Art Education Association, individuals from all parts of our profession were brought together for intensive work in curriculum development. These institutes were specifically aimed at introducing art educators to human behavior as a basis for curriculum development in the arts — a position which has caused much discussion in our field.

The specific objectives for the 1968 institutes were:
The participants will be able to:

1. Identify both behavioral and conceptual objectives for art education.

2. Write behavioral and conceptual objectives for art education in a form which leads directly to unit construction and to instructional processes and materials.

3. Identify and produce the component parts of a unit to make a behavioral or conceptual objective operational for both instruction and evaluation.[8]

In order to achieve these objectives and obtain an initial familiarity with a behavioral model for curriculum development and research, conference participants were required to work toward the attainment of five specific objectives:

1. Identify and discriminate accurately between the conditions for learning which are required to produce:
 a. A change in the overt behavior of a person
 b. A change in a particular concept in a person
 c. Retention of an item of verbal information

2. Recognize and discriminate between these kinds of process-consequence phenomena:
 a. A human decision-controlled act
 b. An empirical event or process in nature
 c. A consequence produced by a human or an empirical act
 d. A composite act-consequence sequence

3. Recognize and discriminate accurately between:
 a. A *behavior* (the actual act or event)
 b. A *concept* (a mental record of something)
 c. An *item of verbal information*
 d. A topical or other reference to phenomena or knowledge (a title or name, topic, term of reference) whether it is written out in full or merely named or alluded to

4. Identify high-priority behaviors and concepts in human life for art education programs.

5. Write a behavioral statement in a form which matches each of these behaviors:
 a. A human decision-controlled act, both linguistic and non-linguistic
 b. An empirical event or process in nature
 c. A composite act-consequence sequence[9]

With the achievement of an initial familiarity with a behavioral model in the 1968 institutes, efforts were continued, and two institutes were planned and implemented during 1969. The first was held in Salt Lake City, Utah, for a small leadership group selected from the 1968 institute participants who were trained to serve as instructors for the second institute which was held for approximately 100 participants prior to the 10th Biennial Conference of the NAEA in New York City. To assure greater progress and to protect the investment made in the 1968 institutes, the 1969 participants were limited to those personnel who had the benefit of the 1968 training experience and who had the conceptual background for dealing with the content of the institute and to operationalize the behavioral model. Needless to say, certain higher level competencies had to be achieved. In addition to reviewing the objectives outlined for the 1968 institute, the objectives for the 1969 Institute were:

To develop the participant's ability to:

1. Prepare the content of a unit for a behavioral objective in a form which will transfer to regular life behavior.

2. Provide for measurement of the behavioral results of a unit.

3. Plan for research projects within a behavioral program.[10]

To achieve these objectives, three major content areas were explored:

1. Instructional tools for producing behavioral change.

2. Evaluating the results and improving the process.

3. Behavioral curriculum models (as they are related to research projects within a behavioral program).[11]

Within the past five years, we have witnessed the impact of these pre-conference institutes in the many individual, local, and state research projects which are attempting to put into practice the knowledge acquired from these experiences. While the long range efforts may not be realized for several years, one immediately observable outcome has been the activity which has been generated in relation to exploring and developing the possibilities of behaviorally based curricula in the visual arts. It is these activities which brought this volume into being.

Barkan has pointed out that there exists a direct relationship between the clarity of our identification of curriculum problems and the clarity of the resulting decisions concerning curricula. He states:

> To the extent that curriculum problems are vaguely defined, knowledges and beliefs upon which to base decisions are used indiscriminately. The consequences are vague judgments, ambiguous predictions, and a la mode decisions. Just as often, there are glorified and unverifiable hopes. But perhaps more importantly, the clearer the identification of problems, the better the grasp of relevant knowledge, of inadequacies and gaps in knowledge, and of limitations in decisions.[12]

It appears that at this point in time, we can identify four major problem areas related to developing behaviorally based curricula in the arts. They are: (1) the identification of relevant behaviors in art in which we desire to effect change; (2) the statement of precise learning objectives which relate to the behavioral changes to be effected; (3) the development of instructional sequences or modules which offer the means to fulfill the learning objectives; and (4) the development of appropriate means for assessing progress made toward achievement of the learning objectives. It is with these problems and related issues that the matrial in this book is concerned.

Through articulating the problems, art educators have been able to better grasp the relevant knowledge available and apply it to the problems at hand, as well as to identify the inadequacies and gaps in knowledge and initiate efforts to eliminate the inadequacies and then bridge the gaps. The progress which has been made is most encouraging.

The book is divided into four sections. Section I deals with the theoretical material which served as the bases for the 1968 and 1969 Institutes and which has had a decided influence upon the thinking of art educators in their efforts to explore the development and implementation of behaviorally oriented curricula. Section II includes descriptions of four K-12 efforts in behavioral curriculum development and implementation. Section III describes four higher education programs which have attempted to behaviorize curricula for art education undergraduates and graduates, elementary education majors, and general university students. The last section deals with staff organization and utilization in developing a curriculum which is behaviorally based.

REFERENCES

1 Barkan, Manuel. "Curriculum Problems in Art Education," in *A Seminar in Art Education for Research and Curriculum Development,* Cooperative Research Project V-002, Project Director, Edward L. Mattil. University Park, Pennsylvania: The Pennsylvania State University, 1966, pp. 240-258.

2 Tyler, Ralph W. "A Generalized Technique for Construction of Achievement Tests," *Educational Research Bulletin,* April, 1931, pp. 199-208.

3 Tyler, Ralph W. *Constructing Achievement Tests.* Columbus: Ohio State University Press, 1934.

4 Tyler, Ralph W. *Basic Principles of Curriculum and Instruction.* Chicago: University of Chicago Press, 1950.

5 Bloom, Benjamin S., *Taxonomy of Educational Objectives, Handbook I: Cognitive Domain.* New York: David McKay Company, Inc., 1956.

6 Krathwohl, David R., Benjamin S. Bloom, and Bertram B. Masia. *Taxonomy of Educational Objectives, Handbook II: Affective Domain.* New York: David McKay Company, Inc., 1964.

7 Mager, Robert F. *Preparing Instructional Objectives.* Palo Alto, California: Fearon Publishers, 1962.

8 Woodruff, Asahel D. *Preconference Education Research Program in Art Education,* Final Report for Project No. 9-0119, Bureau of Research, Office of Education, U.S. Department of Health, Education, and Welfare, July 1969, pp. 3-4.

9 *Ibid.,* p. 4.

10 *Ibid.,* p. 3.

11 *Ibid.,* p. 1.

12 Barkan, *op. cit.,* p. 241.

PART I

THEORETICAL INFLUENCE

The theoretical position which underlies the work of art educators in developing behaviorally based curricula and subsequently evaluating the changes which occur in human behavior has been largely influenced by the thinking and work of Asahel D. Woodruff and D. Cecil Clark as presented in the 1968 and 1969 NAEA preconference institutes. While both Woodruff and Clark have, in the intervening years, continually modified and refined the material which they presented in the institutes, their basic positions have remained the same. Because of the wide influence which these two scholars have exerted over curriculum development and evaluation in the visual arts, it seems appropriate to initiate a book on behaviorally based curricula in the visual arts with statements of their positions.

In Chapter I, Woodruff outlines a model for behavior-oriented curricula which moves beyond the limitations of operant conditioning and reinforcement and is broad enough in scope to include the most humanistic goals of education. Thus, its appeal to arts educators is obvious. Likewise, Clark, in Chapter II, outlines a plan for moving the evaluation of changes in art behaviors from a subconscious level to an intentional and precise operation which draws upon artistic training, background, and maturity.

CHAPTER I

A BEHAVIOR-ORIENTED CURRICULUM MODEL*

Asahel D. Woodruff
University of Utah

The Current Context

It is well to remember that what is commonly called the behavioral or performance-based movement in education is still very young. Like other vigorous movements in educational history it is carried by confident and aggressive people who speak as with authority and not a little finality. The neatest and most visible version of it takes the form of the operant conditioning or reinforcement model which is compact, explicit, demonstrable, and workable within its own limits.

Human behavior, however, is a very complex and broad phenomenon, and the goals of education cover a wide range of complexity. That range is not yet matched by the parameters of the operating behavioral models most widely in evidence. It is inevitable that we will be presented with bits and pieces of behavioral instructional machinery for a while, and that a system of adequate scope will have to be engineered over a period of time. If the bits and pieces are mistaken for the whole potential, the behavioral approach will probably be thrown out by school people after some initial effort, because it is already charged with falling considerably short of handling the most humanistic goals of education.

At this time attention should probably be as much on the development process as on any interim varieties of instructional devices. Current concepts will surely undergo steady modification, especially as we grapple with the humanistic goals of instruction. In spite of this, we are obligated to present each idea and proposed process with as much clarity and precision as possible, to avoid confusion. In this paper I will try to make unambiguous and definitive statements in spite of the seeming presumptuousness of such behavior, recognizing that those statements are still subject to modification through a long engineering process.

* This is a basic position paper prepared for several current projects now in the engineering stage.

A Behavioral Curriculum Development Flow Plan

Planning a behavioral curriculum is a complex task. It involves several kinds of informational input, and several analytical and synthesizing steps. The process described in this chapter is laid out in Figure 1-1. The discussion which follows holds rather faithfully to this development flow plan.

Human Behavior: The Central Datum

The behavioral movement clearly sets out to shape the behavior of students. Therefore everything else in the movement finds its relevance in its relation to human behavior in learners. This includes the goals of education, methods of teaching, subject matter, instructional materials and media, the education of teachers, and school organization and instructional support systems. To start on any of these components without using human behavior as the datum line is to invite almost sure failure, and yet this proposition is honored more in its disregard than in its observance.

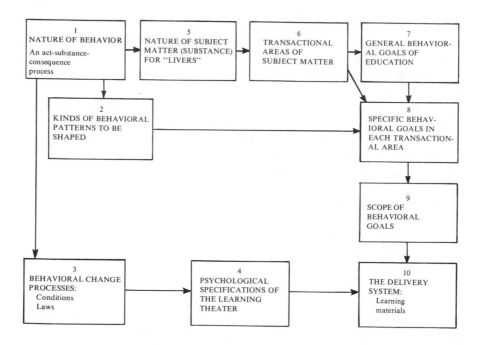

FIGURE 1-1. A BEHAVIORAL CURRICULUM DEVELOPMENT
FLOW PLAN

Furthermore, the characteristics of all of these component parts of an educational system would seem logically to derive their major operational characteristics from whatever their developers believe human behavior to be. This is the point at which the definition of behavior exerts its first and probably most critical influence on all else that follows. If a narrow concept of behavior is adopted, then a narrow instructional system will develop. If a broad-gauge system is to be developed then a broad concept of behavior must be its starting point.

It is possible, if one is primarily concerned with problems of measurement, to set up a limited concept of behavior by ruling out of it any covert and unobservable processes. This has been done in some of our most widely accepted literature. It is also possible, if one starts with his concern directed first to educational goals of all dimensions, to describe behavior in comparable breadth. This increases the measurement problems, and also the instructional design problems, but seems to be worth the cost.

Recognizing the rather formidable demands such a position imposes, behavior is nevertheless assumed in this paper to consist of any act a person can perform on something in his environment for the purpose of exploring that environment or of using it in some way to reach some goal. Within that definition I recognize four kinds of acts which, for the moment, complete the description of behavior. For convenience of identification I will speak of them in these terms.

Type I consists of *covert, nonverbal, cognitive/affective perceptual responses and decisions.* (See Figure 2) Type II consists of *overt, verbal expressions of the Type I responses and decisions.* Type III consists of *overt, nonverbal executions of the Type I responses and decisions.* Type IV consists of *sensate consuming acts* (of particular concern in the fine arts) such as absorbing, identifying with, empathizing with, and responding contemplatively to something.

I regard this as a behaviorist position for the following reason. A central notion of behaviorism is the close relationship between the response of a person to stimulus situations, and the perceived circumstances and consequences of the responses. This is a very sound notion. It does not in itself limit behavior to overt responses which can be observed and measured, nor to a single learning process such as conditioning. Such limits are imposed arbitrarily by exponents of those interpretations who impose them to limit the complexity of their tasks.

It is just as possible, working within the limits of sound research methodology, to ascribe to behavior some covert processes that are especially important to the more complex and creative range of human responses. All that is required is a little more ingenuity in dealing with the more difficult process of postulating those variables in the form of some useful construct, and in learning to assess their effects on overt and measurable responses. This is an old and profitable way of penetrating nature.

15

Three Behavioral Foundations for Curriculum Development

From the description of behavior just presented it is possible to name three derivative constructs to be developed, that are relevant and basic supports for a behavioral curriculum model.

The first is a valid model of behavior which reveals the laws of behavior and of learning, and which covers adequately the range of behaviors incorporated within the goals of education.

The second consists of a behavior-oriented version of environmental substance which is the subject matter content of the curriculum. What must particularly be identified here are what it consists of in behavioral terms, how it is involved in human behavior, and the form or forms in which it is behavior-compatible.

The third consists of the specifications of behavioral objectives stated in a form which is adequate for all the goals of education. We must be clear as to the scope of objectives across all aspects of a person's life, their scope across the range of complexity that marks human behavior, and their significance in the life of a person with reference to in-life reality, relevance to the individual learner, and manageability by the individual learner.

Behavior

This construct will be presented by means of a series of postulates.

1. Behavior is action, whether it be covert or overt. Each instance of such action is an operation upon something in the environment (an object, event, circumstance, or any other kind of referent) resulting in a consequence to the actor and to the referent acted upon. The consequence to the actor may be something as subtle as a conceptual change or it may be something as physical as severe damage. The consequence to the referent may exist primarily in the way it appears from that time on to the actor, or it may be an actual change in the referent itself. Figure 1-2 is a simple model of a behavioral act.

2. Each behavioral act is an orchestration of the four types of response named earlier. Figure 1-3 presents them in greater detail, and in a relationship which suggests the mediating role of Type I responses, and the expressive or executional role of Type II, III, and IV responses.

All the ranges of scope which are essential to a full educational program are operative within these four types of response, especially when their orchestrated relationships are kept in mind. An act composed of these components can occur (1) in any aspect of life (personal, interpersonal, institutional or social, physical, and aesthetic), (2) with a phenomenon or phenomena (i.e., a stimulus situation) of a very simple or a very complex nature, (3) at an infantile or elementary level or at a mature and advanced level, and (4) in a routine and mundane way or in an imaginative and creative way.

3. Each instance of behavior involves an interactive cycle. It consists of a man-environment interaction in which each is modifying the other. In the

16

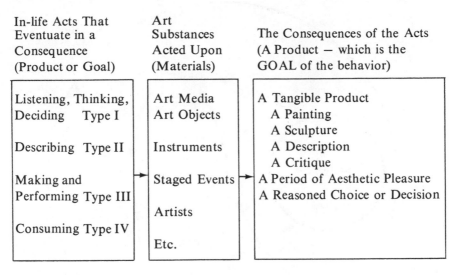

In-life Acts That Eventuate in a Consequence (Product or Goal)	Art Substances Acted Upon (Materials)	The Consequences of the Acts (A Product — which is the GOAL of the behavior)
Listening, Thinking, Deciding Type I Describing Type II Making and Performing Type III Consuming Type IV	Art Media Art Objects Instruments Staged Events Artists Etc.	A Tangible Product A Painting A Sculpture A Description A Critique A Period of Aesthetic Pleasure A Reasoned Choice or Decision

FIGURE 1-2. AN ART BEHAVIOR

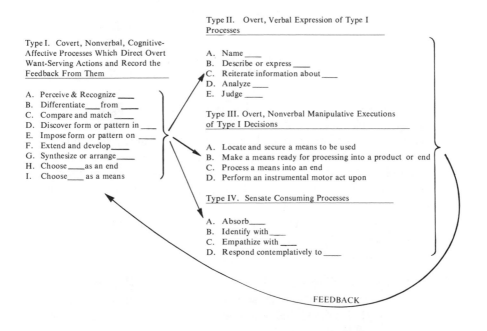

Type II. Overt, Verbal Expression of Type I Processes

Type I. Covert, Nonverbal, Cognitive-Affective Processes Which Direct Overt Want-Serving Actions and Record the Feedback From Them

A. Perceive & Recognize ____
B. Differentiate ____ from ____
C. Compare and match ____
D. Discover form or pattern in ____
E. Impose form or pattern on ____
F. Extend and develop ____
G. Synthesize or arrange ____
H. Choose ____ as an end
I. Choose ____ as a means

A. Name ____
B. Describe or express ____
C. Reiterate information about ____
D. Analyze ____
E. Judge ____

Type III. Overt, Nonverbal Manipulative Executions of Type I Decisions

A. Locate and secure a means to be used
B. Make a means ready for processing into a product or end
C. Process a means into an end
D. Perform an instrumental motor act upon

Type IV. Sensate Consuming Processes

A. Absorb ____
B. Identify with ____
C. Empathize with ____
D. Respond contemplatively to ____

FEEDBACK

FIGURE 1-3. TYPES OF HUMAN BEHAVIOR INVOLVED IN THE EDUCATIVE PROCESS

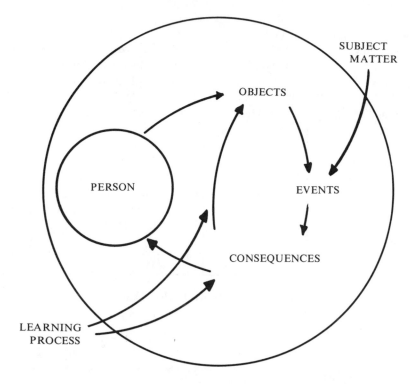

FIG. 1.4 THE SHAPING PROCESS
A MAN ENVIRONMENT INTERACTION

case of the person, there is also a cybernetic cycle operating through which
the subsequent behavioral processes are being modified by the feedback from
the man-environment interaction. For the breadth required by the goals of
education, the biological concept of *psychic adaptation* is more useful than
any psychological model of learning. Figure 1-4 presents the man-environ-
ment interaction in simplified form. Figure 1-5 presents the cycle going on
within the person.

 4. The behavioral change processes (learning) grow directly out of the
 interactions illustrated in Figures 1-4 and 1-5, and may be described
 as follows:

 A. Learning or behavior change occurs under these conditions:
 1) The person is doing something overt to satisfy a want.
 2) He is doing it in a real situation, to real things, on a for-keeps
 basis.
 3) The behavior is basically nonverbal and adjustive, although
 the person may verbalize about it.
 4) What he does involves a full cycle of behavior:

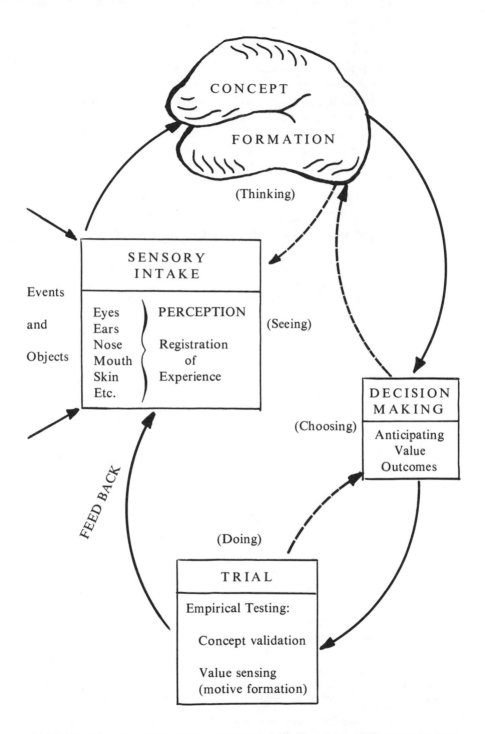

CONCEPT

FORMATION

(Thinking)

SENSORY
INTAKE

Events

and

Objects

Eyes	PERCEPTION
Ears	
Nose	Registration
Mouth	of
Skin	Experience
Etc.	

(Seeing)

FEED BACK

DECISION
MAKING

Anticipating
Value
Outcomes

(Choosing)

(Doing)

TRIAL

Empirical Testing:

Concept validation

Value sensing
(motive formation)

FIGURE 1-5. COGNITIVE CYCLE IN BEHAVIOR AND LEARNING

Perceiving
Thinking and conceptual organizing
Choosing a goal and a line of response with or
Executing the choice and precipitating without
 a consequence conscious
Being affected by the consequence, and awareness
 re-entering the cycle by perceiving
 some or all of those consequences

B. The "laws" of learning seem to be about as follows:

 1) Behavior is shaped by its immediate consequences.
 2) The shaping is specific to the particular bit of behavior going on.
 3) Only the consequences a person perceives will shape his behavior.
 4) The shaping takes effect by altering the concepts, habits, and skills which were mediating that instance of behavior.
 5) The shaping is basically involuntary and occurs whether the person is aware of it or not. Awareness may accompany the shaping, and can make it more deliberate.
 6) Behavioral patterns increase in their power to provide satisfaction as the shaping process brings them into conformity with the critical properties of the substances and situations we interact with.

C. The interaction is capable of producing change in the following kinds of behavioral patterns:

 1) *Concept formations and the use of concepts* in guiding behavior.* The underlying processes here seem to include perception, perceptual storage, recall of past perceptions, conceptual organization of perceptual memories, the selecting of conceptually constructed goals as targets for goal-pursuit activities (goal-choosing or decision-making), and the use of conceptually recorded procedures in the pursuit of those goals (concept-guided action). Imagination operates within the conceptual processes to supply whatever degree of creativity the person injects into his goal-concepts and his goal-pursuit processes.

* The term concept has no clearly settled definition. It is used variously to refer to a generalization formed by a learner, a generalization stated in a discipline, and a bit of subjective personal meaning at any level of specificity or generality. I use it to represent the last of the three. A person's concept of something may be wholly concrete, specific, incomplete, invalid, and vague, or it may be the opposite of all of these. In any case it is a bit of meaning he has acquired about his world through direct interaction with that world.

2) *Value formations and the effect of values in selecting pre-ferred goals for pursuit.* The underlying processes here seem to start with affective reaction (feeling) during experience in any situation, the subconscious ascribing of value on a personal and subjective level to the referents in situations according to the feelings they arouse during those experiences, the storage and the accumulation of those affective reactions, both positive and negative, into all forms of preference which are manifested in value patterns, interests, sentiments, emotions, and tastes. Concept formation and use, and value formation and its impact on subsequent choices of action, operate inseparably in all instances of behavior.

3) *Verbal memory and verbal response.* This includes the acquisition and use of vocabulary (whether meaningless or meaningful), the use of signs of all kinds, and the storage of data in the form of verbal information. The underlying processes are repetition of the verbal material, and recall and verbalization under appropriate conditions. Memorization appears to consist of some form of mnemonic storage which is obviously helped when the learner has conceptual patterns to which the symbolic material has a meaningful relationship *for him.* Recall may be limited to fleeting recognition of symbols presented to a person. It may extend to ability to recall any pattern of symbolic materials verbatim without prompting. This depends largely on the amount of repetition, and also on meaningful relationships for the symbolic materials.

4) *Motor skills.* Confusion surrounds the term *skill* today because educators have applied it to almost every form of action people perform, including the process of thinking. In order to construct an empirically defensible description of behavior it seems necessary to limit the word skill to *motor* acts whose significant characteristics are the degree of *grace, speed,* and *precision* with which they are performed. The underlying process in such acts is neuro-muscular coordination, which is produced by practice under coaching, with knowledge of results.

5) *Habits.* This term is used to refer to what literally amount to fixed *choices* of behavior — that is, options whose probability of occurrence have risen essentially to the level of practical certainty of occurrence in a given situation. Clear cut probabilities of this kind can be detected only in relatively simple situations, and the relatively simple little programs of action which occur in them. Examples include taking one's seat upon entering a classroom, versus wandering around the room,

21

picking up a book versus engaging in random activity, being noisy versus being quiet, and so on. Complex situations tend to involve much diversity, many options, and changing options. In such situations stabilized choices of response have little opportunity to form, or to operate, in any person who is sensitive to the complexity. In such complex situations, behavior seems to be controlled more by recognized variations in the circumstances and responsive choices made at the time than by conditioned and fixed patterns.

The competence with which one carries out one of these little "decisions" is not a critical property of a habit. What is critical here is *probability* of occurrence, or dependability. Competence is something else, which is better understood and nurtured under the conceptual or the motor skill paradigm. Habits are the principal examples of behaviors established through operant conditioning. The underlying process is affective, and it is shaped by reinforcement. This is a limited but very important instance of value formation, in which the formation is controlled by the reinforcer.

5. Although behavior has been described in generalizations up to this point, there is no such thing as a bit of general behavior. Each instance of behavior is a specific act. It is made up of an orchestration of specific concepts, skills, verbal responses, preferences, and values, and acting upon specific referents in the environment in ways which are related directly to the specific behavioral properties of those referents. Any change that may occur in behavior will therefore be a specific change in one or more of the component elements that are involved in that particular instance of behavior. This means that a behavioral objective becomes attainable only when it is stated as a specific instance of behavior. This precludes any possibility of trying to affect behavior in general ways, or of achieving behaviors that are stated as broad behavioral goals. An example is the ability to make wise decisions, or the ability to make accurate distinctions between living and non-living forms.

It has already been noted that behavior changes only while it is going on. Now we are delimiting the change process still further, by confining it to one specific instance of behavior at a time.

This will require provision in the curriculum development process for reducing the general behavioral goals to specific behaviors, and for finding a level of specificity which is motivationally meaningful to a learner. The combined demands of these two tasks have yet to be adequately met in practice. A possible solution is suggested later.

The translation of these characteristics of behavior and its change processes to a curriculum and an instructional system will be discussed later after we have drawn a picture of subject matter, and of objectives.

Subject Matter in Behavioral Form

Subject matter is one thing to a "scholar" and something quite different to a "liver". We are accustomed to seeing subject matter in verbal form, packaged in text books. In that form it consists of an abstract of the scholar's view of the world. A scholar's work is to collect, organize, and file data in topical and abstract form, and to look through his collection for generalizations which help him explain it. In this form it presents serious problems to a young learner, who is trying to learn how to *live* in his real world.

A liver is using his world to satisfy his wants. What we seem to overlook in our preoccupation with "scholarship" and with generalizations and abstractions, is that the behavior of a person within his world is always a specific transaction with concrete phenomena, in a real and specific situation. Generalizations and abstractions are *not* the primary mediators of daily behavior. That role is carried by concrete concepts of processes and procedures, which we match to specific situations, and follow just as precisely as our grasp of them enables us to do.

There is a curriculum for the scholar, and there has to be a different one for the "liver". The curriculum for the scholar can be composed of generalizations and abstractions about one limited segment of his world, but that is not a relevant curriculum for any person in those areas of his life that fall outside of a scholarly specialization. In this discussion the curriculum for the "liver" comes first.

In this approach, subject matter is that array of "somethings" in the environment upon which behavioral acts are performed. If behavior consists of acts upon those somethings, then subject matter consists of the things we act upon, in their real sensuous forms — real soil, real persons, real trees, real art, real city councils, real neighbors, and the learner's real self.

If one is trying to master his interactions with these things, then what he most needs to know about them (their critical properties) is what they *do* — i.e., their own inherent processes and behaviors, the consequences they produce in their interactions with other things, and the way they react to whatever he may do to or with them. This is so because his only interest in them is a behavioral interest. He sees them as objects or events that affect him or his world, or as means he can use to pursue his goals.

From such a behavioral point of view, it is helpful to identify the behavioral "rules" (the natural laws) upon which environmental phenomena act, so we can learn how to transact our business with them. One scheme that seems to serve this purpose is described here.* The environment can be divided into transactional areas based on these inherent natural laws.

*This scheme was developed by the writer and others as part of two projects. One is the SPURS Project in the Western States Small Schools Program, and the other is the Pilot Experimental Teacher Education Program at the University of Utah.

1. *Self transactions*. The central phenomenon here is the self. The transactions consist of looking at or developing one's self or any aspect of one's self, as for example, developing control of body movemens, setting personal goals, assessing personal aptitudes, setting personal standards, or improving personal appearance. The natural laws that govern the behavior of the self are largely psychological in nature, particularly in the area of human motivation, human feeling and valuing processes, ways of seeing one's own characteristics with some clarity and objectivity, and ways of subjecting one's own ideas and decisions to deliberate analysis and evaluation. The first order breakdown of behaviors in this area includes the following:
 Consciously monitoring one's daily behavior
 Setting and modifying one's standards
 Setting and modifying one's major goals
 Acting on reasoned decisions and plans
 Getting relevant information before making and carrying out decisions and plans
 Cultivating personal appearance
 Developing the physical self

2. *Interpersonal transactions*. The phenomena here are other persons and interactions with other persons. The transactions consist of interacting with another person or persons on a personal basis — teacher and student, friend and friend, child and parent, and so on. Other persons are governed by the same kinds of laws that govern the self, but from their own centers of concern and interest. If we understand the laws of personal behavior, we are helped in interacting with others, but beyond that we have the task of identifying *their* concerns and interests and of learning how those concerns affect their behaviors in various situations. The first order breakdown of behaviors in this area at present include:
 Recognizing what others say
 Communicating my thoughts and feelings to others
 Participating in social acts
 Examining and shaping personal standards of considerateness
 Identifying what I do to other persons
 Tracing the consequences of what I do to them
 Checking my actions against my standards of considerateness
 Noting how to modify my actions

3. *Communicative Transactions*. The phenomena here are things that receive, organize, and/or transmit verbal, nonverbal, and primary sensory information. They include natural receivers such as the sense organs, storage and organizing systems such as transmission channels and the central nervous system, and natural transmitters of non-

verbal and verbal expressions, primary object properties, and a variety of cultural indicators such as maps and signs. These phenomena are governed by the laws of verbal processes, of nonverbal expressions, and of the perception of sensory signals, and their relationships to the characteristics, thoughts, and feelings of both sender and receiver. The first order behaviors here are:

 Perceiving the properties of phenomena in the environment
 Storing and organizing the perceptions
 Transmitting nonverbal, and verbal expressions
 Perceiving and interpreting cultural indicators

4. *Institutional transactions.* The phenomena here are social structures, public opinion, beliefs, customs, language, laws, organizations, and so on, all of which we call social institutions. Institutions are governed basically by the interplay of the human ideas and feelings of those who make them up, and they have certain effects on the ideas and feelings of people. These social forces are the underlying "laws" we must comprehend. Our behavioral acts in this area consist of changing a law, establishing a business, joining a club, managing money, resolving a human issue, and countless other such tasks, all of which we can do better if we comprehend the laws of institutional phenomena. The first order behaviors in this area at present include the following:

 Interacting with organizations as a member
 Interacting with organizations as a nonmember
 Participating in organized events
 Earning money
 Saving
 Investing
 Spending

5. *Physical world transactions.* The phenomena are raw materials, animal life, plant life, machines, and other physical goods. These phenomena are governed basically by natural physical and biological laws. Our transactions are aimed at using and adjusting to physical forces, using technological resources, dealing with plant, animal, and insect life, and so on. To carry on these transactions successfully we must be familiar with the behaviors of the things that constitute our physical world. The first order breakdown of behaviors in this area include the following:

 Using and consuming environmental resources
 Changing and producing things
 Maintaining things
 Transporting people, messages, and goods and materials
 Researching and developing

6. *Quantitative Things.* The phenomena here are the quantitative properties of things, and things that identify, manipulate, and communicate quantitative information. These phenomena operate through the dimensional characteristics of things, and through the internal structure of numerical systems. They break down into weight, dimension, and particle density of physical phenomena, and into such numerical system properties as numbers, units of measurement, measuring instruments, numerals, formulas, equations, graphs, arithmetic processes, algebraic processes, geometric processes, comparative measures, stability measures, and trend indicators. The first order behaviors are:

 Identifying, both subjectively and objectively
 Communicating
 Calculating
 Interpreting

7. *Aesthetic transactions.* The phenomena here are the art forms and the aesthetic qualities of both art and non-art objects and events around us. Our behaviors consist of specifics within this first-order breakdown:

 Reacting to aesthetic qualities of both art and non-art objects and events by:
 Absorbing
 Identifying with
 Empathizing with
 Contemplating
 Reacting cognitively to art objects by:
 Describing
 Analyzing
 Judging
 Expressing aesthetic feelings by:
 Producing art objects
 Incorporating aesthetic qualities in non-art objects
 Performing artistically

These seven transactional areas appear to constitute the whole body of subject matter. They are identified here, not as bodies of information in verbal form, but as arrays of objects and events with which a learner is interacting in direct ways. The world is not conceived as something away from him about which he "talks" in school. Neither is it something about which he collects and stores data in verbal or symbolic form. It is conceived as an action theater in which he is personally engaged.

The break from a verbal instructional system to what is essentially a nonverbal behavioral system has to be faced openly. The approach described here is almost diametrically opposed to the notion of "meaningful verbal

learning." It is also opposed to the notion that verbal information somehow translates into daily behavioral acts. It rests on two assumptions. One is that behavior is mediated by the working familiarity we have acquired about our surroundings through direct interactions with them. The other is that such meaning cannot be transmitted from one person to another by any means, but must be developed by each person for himself. Only after these basic assumptions are clearly faced can we talk about a useful role for verbal processes in the instructional system.

A Place For The Verbal Processes

Having described subject matter in phenomenal form, with the claim that direct sensory interaction with phenomena is the most basic form of behavioral learning, we need now to accomodate the verbal processes within this orientation. It is perfectly obvious that there are two ways in which a person can interact with his environment. One is to manipulate it and watch it directly. The other is to think and talk about it.

The assumption is made in this chapter that one cannot think or talk about anything until he has some perceptual background with it, which has resulted in storage of enough perceptual grasp of a phenomenon to give him something to think about. There is substantial evidence for this in many studies of the educational handicaps faced by children raised in areas of perceptual deprivation. Hence it seems a prudent educational decision to use the processes of recall and verbal discussion only when children have something to recall and discuss. The verbal process is *not* a profitable way of trying to give children basic familiarity with new aspects of their world. It is nevertheless a very profitable way of reviewing and extending their ideas when they have some basic conceptual bases for that kind of discussion. Therefore the following guideline seems to be appropriate:

> *Materials and activities intended to activate learning about some phenomenon may operate through verbal channels when the student is capable of supplying the perceptual memories necessary to make the verbal materials effective. When this condition exists, the economy of learning is increased by verbal materials. In addition, verbal channels are necessary for acquiring data and for associating symbols (such as words, musical notation, or numbers) with past perceptions. These verbal channels are used for the purpose of checking or testing perceptions and resultant concept structures by means of verbal exchange with others. Since learners are continually being introduced to new aspects of the real world, however, direct sensory perception of that which is new to the learner will be a recurring feature of his education at all levels of learning.*

It may be helpful to note that it is only in a direct behavioral interaction with some part of the environment in its phenomenal form that conception,

value formation, vocabulary development, and motor skill development can occur simultaneously, and in fully relevant and transferable form, and with high motivation. But it should also be said that after such behavioral involvement, verbal review and discussion can also begin to be marked by the same motivation and relevance.

Behavioral Objectives

In the foregoing section we looked at the substances involved in behaviors. Now we will look at the behaviors themselves — that is, at acts *per se,* independent of whatever environmental substance they may impinge upon.

The search for an adequate set of behavioral objectives will be guided by this set of intents:

1. To include both consummative and productive behaviors.

2. To encompass the complex cognitive-affective behaviors of a mature life as well as the more atomistic and instrumental behaviors popularly identified with limited versions of behavioral objectives. This will include concepts and values, creative freedom and ability, motor skills, verbal communication patterns, and essential operant habit patterns.

3. To put the emphasis on the development of competency, not on the shaping of preference.

4. To work for competencies that flexibly serve personal goals and urges, not that foster or preserve any particular style of art expression or of life.

5. To focus on competence at a meaningful level in life — the level of holistic behaviors that include both an expression of feeling, and the exercise of judgment. This contrasts with mechanistic tool competencies that are meaningless in themselves.

6. To lay out a list of behaviors as possibilities, within which all interested people can express their priorities.

7. To establish a set of production steps that screen subject matter content through the desired behavioral goals, and allow the content which is relevant to those goals to get into the curriculum.

Throughout the life of a person literally millions of individual behaviors will occur. To reduce such an unlimited array of specific behaviors to some kind of manageable set of objectives requires us to do some categorizing. The purpose is to find behavior types that are pervasive, and in which all specific instances have common structures which can reduce the number of learning strategies or methods required. It may also be possible to sample instances from the identified types within the formal school program, and leave the extended development of exhaustive learnings to occur naturally outside of school. The first set of categories for this purpose will need to be psychological in nature since we are dealing with acts of the person and not with the substances acted upon. Here are some steps which are proving to be helpful.

1. All behaviors exhibit two aspects, making a decision of some kind, and executing the decision. In this context a decision is simply a bridging across from some stimulus and whatever internal meanings it may stir up, to an overt act of some kind. A simple S-R act fits this notion, just as does a complex piece of rational thought and action.

2. Decision-making seems to consist of getting oriented to something, and choosing one of the available ways of responding to it. Performing may involve expressing one's self, or manipulating something, or consuming something. Figure 1-6 represents these possibilities. Even at this elementary

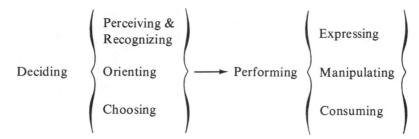

Fig. 1-6. SUB-BEHAVIORS IN DECIDING AND PERFORMING

level of analysis we have identified a few behaviors that occur over and over. Because of their prevalence in life, and their obvious importance, they are the kinds of behaviors in which we want to become competent. Therefore they are appropriate behavioral objectives, although very general ones as yet.

3. We can now extend this framework to another level of detail, by including all the behaviors in Figure 1-3. This set of behaviors has proven thus far to be sufficiently realistic and definitive to handle the things people do in all of the subject matter fields. Type I acts are essentially decision-making acts that lead up to commitment to some specific response. Types II, III, and IV acts are essentially performing acts.

4. The relationship between acts *per se* and the substances that make up the subject matter fields can now be illustrated in Figure 1-7, which puts them together. A person may perform almost any act in the left side of the figure upon almost any substance in the right side of the figure. When the right side is translated into the specific phenomena of a given field, the practicality of the arrangement, and its relevance to human life become even more evident.

5. Now that we have behaviors and subject matter put together we can develop a more complete set of objectives at a more specific level. In doing so, we should remember that the complexity of human life does not allow us to state our objectives entirely in the form of explicit overt acts because of the vast importance of the cognitive-affective behaviors that mediate overt acts.

THE RESPONSES	THE SUBSTANCES

TYPE I. A. Perceive & Recognize... OBJECTS



<table>
<tr><td>

TYPE I.

Covert,

Nonverbal,

Cognitive-

Affective

Processes

Which Di-

rect Overt

Actions

And Record

Feedback

TYPE II.

Overt,

Verbal

Expressions

of Type I

Processes

TYPE III.

Overt,

Nonverbal,

Manipulative

Executions

of Type I

Decisions

TYPE IV.

Sensate

Consuming

Processes

</td><td>

A. Perceive & Recognize...

B. Differentiate...from...

C. Compare & match...

D. Discover form or pattern in...

E. Impose form or pattern on...

F. Extend and develop...

G. Synthesize or arrange...

H. Choose...as an end

I. Choose...as a means

A. Name...

B. Describe or express...

C. Reiterate information

 about...

D. Analyze

E. Judge...

A. Locate and secure a means

 to be used

B. Make a means ready for

 processing into a product

 or end

C. Process a means into an end

D. Perform an instrumental

 motor act on...

A. Absorb...

B. Identify with...

C. Empathize with...

D. Respond contemplatively to...

</td><td>

OBJECTS

 Persons

 Self

 Others

 Social groups

 Things

 Individual objects

 Sensory qualities

 Esthetic qualities

 Moral qualities

 Objects in configurations,

 relationships, and

 circumstances

PROCESSES (INTERACTIONS

 BETWEEN OBJECTS)

 Single events

 One event in nature

 A recurring event

 A human decision-

 controlled act

 Forces in action (Conse-

 quence inducing processes)

 Energy

 Electrical, etc.

 Creation

 Reproduction

 Managed reconstruction

 Growth

 Fragmentation

 Radiation

 Separation (Fission)

 Deformation

 Elastic

 Permanent

ACT-CONSEQUENCE SEQUENCES

</td></tr>
</table>

FIGURE 1-7. RESPONSE TYPES AND SUBSTANCES
OF RESPONSES

Such acts have to be cultivated through education just as carefully and perhaps more so than the visible behaviors themselves.

A practical way to solve this problem is to shift from a narrowly defined notion of overt *behavioral objectives* to a more broadly defined notion of a *behavior-oriented* curriculum. In such a curriculum there will be a substantial set of very basic behaviors (as in Figure 1-3) and also a very extensive set of supporting behavioral familiarities which are required for the behaviors. The familiarities will be acquired experientially as the basic behaviors go on, and form a growing and maturing conceptual/affective base for behavioral acts. In other words, the person needs a lot of concepts of his world to enable him to act upon that world effectively. He needs planned educational help in developing those concepts.

The term behavior-oriented implies that the concepts are to be of the behavior-oriented or operational kind, and not of the verbal information kind. If this approach is taken a set of objectives can be developed of the kind in Figure 1-8.

FIGURE 1-8. GOALS FOR STUDENTS IN THE SCHOOLS

(Sections I and II are behavioral goals. Section III is composed of conceptual learning incorporated into the behavioral goals)

I. Self-Directing Behaviors

Identifying and choosing goals to satisfy wants or needs
Formulating specifications for goals to be reached
 Workable specifications
 Creative specifications
Making a job analysis for reaching a goal
Selecting and using productive processes
Adapting to reality in carrying out processes
Following orderly processes in the pursuit of a goal
Recognizing when learning will help in the pursuit of a goal
Using learning deliberately to improve knowledge and competence
Putting learning to immediate use in practical situations
Evaluating personal effectiveness in doing something

II. Identifying and Analyzing Behaviors that Support Self-Directing Behaviors

Identifying significant issues in the local, national, and international scene
Describing how those issues involve and may affect the self
Describing how those issues involve and may affect other persons

FIGURE 1-8 (continued)

Identifying values that may be preserved, enhanced, or diminished through social actions

Identifying actions people could or might take in various situations

Determining what might be required to carry out various actions

Determining the probable consequences of acting in various ways in social problems

Justifying a proposed line of social action

III. Behavioral Familiarities Required in Both of the Above Sets of Behaviors

Familiarities with the Self

One's own patterns of behavior

The consequences of one's behaviors

How one appears to others

Personal physical characteristics and ways of cultivating them

One's personal standards in the form of values, ambitions, concepts of right and wrong

One's vocational and other personal goals

The processes of making decisions and of executing decisions

The value of "knowing" in pursuing one's goals

Ways of knowing, and of interpreting information

Familiarities With Other Persons

How people communicate

How people function in social groups and with other individuals

How people feel, and how they treat each other

Familiarities With Communicative Phenomena

Natural receivers

Storage and organizing systems

Natural transmitters

Cultural indicators

Familiarities With Social Institutions

How institutions affect human purposes:

Organizations

Legal systems

Authority systems

Membership and nonmembership

Joining and withdrawing processes

Recreation in human life

Economic systems and behaviors

Earning

FIGURE 1-8 (continued)

Saving
Investing
Spending

Familiarities With The Behaviors of the Physical World
Using and Consuming environmental resources
Ways of dealing with the environmental surroundings in quantitative terms
Changing and producing things
Maintaining the physical world
Transporting things
Researching and developing things

Familiarities With Quantitative Phenomena
The quantitative properties of
Weight
Dimension
Density
The processes of
Identifying quantity
Communicating quantity
Calculating quantity
Interpreting quantity

Familiarities With the Aesthetic Properties of Life
The aesthetic qualities both art and non-art objects and events display
Consuming them
Understanding and describing them
Expressing aesthetic feelings in the forms of art, music, dance, literature, drama
Putting aesthetic qualities into the regular world around us
Performing aesthetically through playing, singing, dancing, acting, oral reading

Sections I and II are clear and actual behavioral objectives. All of them can be made visible in one or another way and in connection with many kinds of environmental substances. These behaviors are highly pervasive and are particularly important in the more humanistic aspects of life. Section III lists the kinds of concepts required by the behaviors. The task of putting these three kinds of objectives into a behavioral curriculum remains, and is described later.

The problem of scope in curriculum development can now be resolved,

indeed is already resolved by this approach. The scope across the aspects of a person's life is provided by the seven transactional areas. The vertical scope can be provided by the simple process of distributing all of these basic behaviors across the age or maturity levels, with appropriate simplicity or complexity to match the developmental level of the learner.

The task of making the content and the objectives significant in the life of the learner is accomplished by selecting the behaviors and the phenomena from his life domains in the first place, as illustrated by the seven transactional areas. There are already developed effective tactics for plotting relationships between student project activities (See Figure 9) and the increments of learning to be achieved within them. There are also tactics for comparing the coverage in this approach with the coverage in the traditional curriculum. They are too detailed to discuss here.

The Curriculum Development Process

Staying on the behavioral target. Behavioral goals have been stated for education for many years, at a broad level. By the time they were cut down to course and class size, however, they were no longer behavioral. The traditional way of deriving curriculum from broad behavioral goals is to identify subject matter fields believed to be essential to those broad behaviors, and then to set up courses and lessons to present verbal information about those fields.

With the advent of the current behavioral objectives movement, two other approaches have been prominent. One is to begin with the subject matter fields again, and' divide them into small increments of verbal information. For each item of information an academic verbal behavioral objective is then written, usually in the form of a test-taking behavior, with criteria of competence. Such objectives are boring and tedious, and are subject to the charge that they have little transfer value to life outside of the academic world.

The other approach is to divide the broad behaviors into a large number of small and specific competencies, such as the ability to tune an E string, or make a straight cut with a saw, or print the letters in the alphabet. These very specific objectives are achievable, but they also are boring and rather meaningless taken one at a time. Their achievement, even in large numbers, is believed by many to lack the power to produce higher and more complex behavioral competence.

The problem appears to be one of getting down to motivationally meaningful specific behaviors, and not reverting to the academic verbal information game.

A Proposed Approach. Within the confines of this paper it will be impossible to describe this approach in detail, but a series of steps can be identified. They are steps for assembling the parts we have already discussed into a working curriculum.

1. Each subject matter field is first recognized as a behavioral field

rather than a body of verbal information. How is such a behavioral field related to the four types of behavior identified earlier, and to the behavioral and conceptual objectives listed in Figure 1-8? The field of art, for example, can be called a field of behaviors with art objects and events, including the component parts of all those objects and events. The behaviors include painting, sculpting, throwing pots, constructing such objects as bracelets, puppets, or papier-mâché figures, or arranging a display, and all of the Type I perceptual and conceptual responses and decisions connected with them. All of those specific acts are composed of the various combinations of the four types of behavior, and of some combination of the behavioral and conceptual objectives which apply alike to all subject fields.

2. When a comprehensive list of such behaviors has been made, the next step is to identify specific instances of behavior within each of the general behaviors in the list. Each instance must now consist of a particular act and a particular substance to be acted upon. The instances may vary from global acts such as making a puppet, to atomistic acts such as painting an eye on a puppet.

3. The identified behaviors may then be grouped into "families" in which the atomistic acts are subsumed under the global acts within which they normally occur (or may occur). The global acts are the significant behaviors to become direct targets for student activity. They qualify for this role because they involve two elements: Motivational value to the learner, as potential want satisfiers, and learning potential, because they require the learner to learn something in the process of performing them.

Any atomistic act may appear in several global acts in a pervasive way. Those that have such a pervasive presence have a higher mileage value than those that do not, and would seem to be more worth learning. This is a useful clue in curriculum building.

The global acts are the application-behaviors that make the atomistic acts useful and significant rather than merely tedious chores, and keep them from becoming a random mass of inconsequential proficiencies. When they are learned as part of motivationally significant behaviors, they share in the motivation. When we try to get students to learn them apart from such direct involvement, they lack that motivation.

4. The global behaviors may now be spread over a range from elementary or beginning instances, to advanced instances. This is done, not by putting each act in one place in that range, but by putting each act at all points in that range. The act varies in its complexity as it moves up the range toward higher maturity and competence.

When these four steps have been completed, even in tentative and incomplete form, they provide us with the scope of the curriculum content. At this point, however, the content appears only as instances of daily behavior which have potential appeal to students, and potential learning value. We have yet to identify the actual phenomenal content of the behaviors.

5. For each holistic or global behavior, with its essential atomistic components, we can now identify the phenomena involved in the behavior. They consist basically of two kinds of things. One is objects acted upon, or used as instruments. Examples in art are all the varieties of media, all the possible subjects, and all the possible instruments to be used. The other is processes, either natural processes utilized, or manipulative processes performed.

These phenomena are the actual subject matter to be learned. The global acts are the vehicles within which they will be learned, and the vehicles provide the purpose and motivation, and the direct transfer to life. The phenomena provide the competence for those global acts.

6. One more problem remains to be resolved. It is basically a motivational problem, but has a significant transfer element also. It has to do with how much a learner should be asked to learn about a phenomenon in one learning episode.

The traditional position has been to present the learner with all the properties of a phenomenon, and ask him to learn them all equally well and with impartiality. To take an overly simple example, when he is introduced to a hammer he is expected to learn its nail-driving properties, its nail-pulling properties, its ice-crushing properties, and its several structural properties. We have argued that as long as he is going to learn about a hammer, he may as well learn about the whole hammer and get the job done. Then when he needs to know some of these things later, he will have them.

This very logical argument falls completely flat from a motivational and transfer point of view. Learning is not a logically governed process. It is a pragmatic process. A person learns what he has to learn in a given situation to satisfy his then-active motives. Anything beyond that tends to be "more than I wanted to know about it." Furthermore, it turns out to be more than he can "use," and therefore more than he can incorporate into his actual behavioral repertoire. This approach violates the assumption that behavioral learning requires the whole cycle of interaction, and that a specific bit of behavior is not changed until a newly acquired understanding or skill is activated or carried directly into use and given its empirical test.

If this rationale is entertained, then step 6 consists of identifying, for each phenomenon, those of its several properties which are directly involved in the behavior within which it is to be encountered. The rest of its properties are to be disregarded at that time. The involved properties are the "critical properties" for that behavior. The others will become involved in some other behavior and be given central focus then. If by chance no other behaviors ever involve them, it is doubtful that they are worth learning. To illustrate, it is quite possible to use a hammer as a paper weight on a desk. That is certainly one of its potential properties. It really isn't worth bothering with, however, and shouldn't clutter up the curriculum. If a person finds it out by himself some day, he may then have a new bit of information he can use at an appropriate time, but this kind of incidental learning should be going on constantly

outside of school, and be eliminated from the school curriculum deliberately. Figure 1-9 contrasts ways of presenting an item of subject matter to a learner.

With the completion of Step 6, the subject matter content of the curriculum is identified, but not yet packaged for learning. It is not available to individual learners on a self-learning basis until some kind of self-administering learning episode is provided for him. There are currently a number of versions of learning units being constructed, and it appears that considerable variety is feasible. The important thing is to have some specifications that meet the psychological requirements of a learner.

In this paper the learning of verbal information about a phenomenon is rejected as the principal approach. Instead the learner is to become behaviorally familiar with the functional and structural properties of the phenomenon. The following steps suggest specifications for that purpose.

A learning unit is constructed for one phenomenon as described in Step 6 above. We may well be talking about having as many units for any phenomenon as there are different sets of its critical properties for whatever specific behaviors it may be involved in. This problem has yet to be resolved through empirical effort. Assuming that a unit will deal with one functional property, however, this could be the procedure.

7. Each critical property would be stated precisely, and with meticulous accuracy. This statement will guide the unit developer in finding ways and means for exposing the property to the learner. Inaccurate identification of properties leads to misleading instructional media and other materials, and interferes with concise and useful learning.

8. It is then helpful to a learner to know where in the real world instances of that property are visible or otherwise sensorily accessible. The purpose of providing the student with this information is to enable him to keep oriented in his natural world, even though the objects or events are not physically present. This may help him recall what he has already seen and relate it to the immediate learning task.

9. Media can now be prepared to enable the learner to become familiar with that property. Two guidelines are helpful: There should be sense-perceivable media (nonverbal, phenomenal) for learners who have not had previous perceptual experience with that property. There should be lucid and accurate verbal media for learners who have had adequate perceptual contact with it and can now react with comprehension to written materials.

10. Test items can now be prepared. These are of any kind that can be accepted as evidence that a learner has a *working* comprehension of the property. Concept-testing items in written or other valid form are quite useful, and they should be accompanied by performance items which require the student to exhibit functional possession of understanding. The latter should generally not be paper and pencil test items.

11. A final and very helpful step for the learner is to prepare a simplified portrayal of the phenomenon with its critical properties, which is ad-

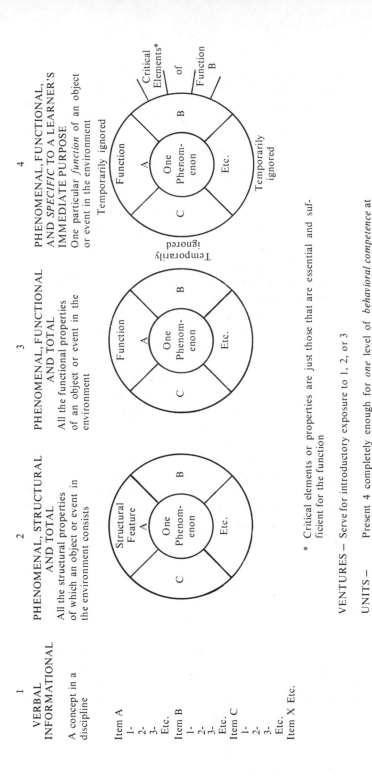

1

VERBAL
INFORMATIONAL

A concept in a
discipline

Item A
1-
2-
3-
Etc.
Item B
1-
2-
3-
Etc.
Item C
1-
2-
3-
Etc.
Item X Etc.

2

PHENOMENAL, STRUCTURAL
AND TOTAL

All the structural properties
of which an object or event in
the environment consists

3

PHENOMENAL, FUNCTIONAL
AND TOTAL

All the functional properties
of an object or event in the
environment

4

PHENOMENAL, FUNCTIONAL,
AND *SPECIFIC* TO A LEARNER'S
IMMEDIATE PURPOSE

One particular *function* of an object
or event in the environment

* Critical elements or properties are just those that are essential and suf-
ficient for the function

VENTURES — Serve for introductory exposure to 1, 2, or 3

UNITS — Present 4 completely enough for *one* level of *behavioral competence* at
some point along the continuum from elementary to advanced, or from
amateur to professional.

FIGURE 1-9. WAYS OF PRESENTING AN ITEM OF SUBJECT MATTER TO A LEARNER

equate to give a learner a first introductory, but accurate exposure to the phenomenon. It should be in sensuous form — i.e., the essential sensuous properties of appearance, sound, odor, taste, touch, and so on should be present.

12. All of the foregoing components can now be packaged into a unit to be made available to learners on call. The unit should be in a format which provides directions for its use, and permits the learner to pre-test himself on its contents before he goes through the suggested learning steps.

Planning Instructional Machinery

A behavioral program exists when both the content and the delivery system meet the requirements of the man-environment interaction model. The learning process is embedded in that interaction. The behavior-compatible subject matter described thus far is to be encountered by the learner while he is engaged in the in-life behaviors which involve that subject matter. Can we identify some characteristics of human want-serving behaviors which we can shape into instructional instruments? The answer is clearly that we can.

In the discussion of behavioral objectives, behavior was described as a continuing flow of decision-execution activities (Figure 1-6) within all instances of which we can identify also four component types of sub-processes (Figure 1-3) operating in orchestrated relationships. Another characteristic of those decision-execution activities turns out to be useful at this point. They tend to take one of two forms, both of which occur repeatedly. One is exploratory behavior in which a person pokes around in his environment to satisfy his curiosity. He makes and executes decisions, which revolve around the satisfying of his interest in his surroundings. This is purposive behavior.

The other is the direct pursuit of some goal the person wants to reach, such as earning money, getting to some particular place, cooking a meal, resolving an issue, and so on. This too is purposive behavior. Both of these forms of activity carry learning with them, simply because they expose the person to his world, and he has to acquire concepts and abilities to reach his goals. Exploratory behavior tends to result in introductory learning, because it usually occurs with phenomena which are relatively new to the person, and because the person's curiosity is likely to be satisfied before his learning penetrates very far. Want-serving or goal-pursuit activity can produce more extensive learning because the pursuit of goals demands that the person have the necessary concepts and other competencies to reach a goal.

In a goal-pursuit activity a person frequently has to develop some bit of competence by a direct approach to it, after which he can return to his project and use his newly acquired ability to get to his goal. Those little learning detours offer us a third vehicle in the form of a small-increment learning unit designed to serve the goal-pursuit activities of the person.

There is one further identification that is helpful. The goal-pursuit activities we have called "projects," vary as to whether the dominant concern is to

make a reasoned decision, or to produce a product of some kind. All of them involve both potential ends, but when one is wrestling with an issue, the immediate goal is to arrive at a decision, and that decision becomes the goal which shapes the behavior. We therefore see two kinds of projects that are capable of carrying learning with them. Decision-making projects and decision-execution projects, or issue-projects and product-projects. Learning units are needed to serve both kinds. The exploratory behaviors we have called "Ventures." Figure 1-10 illustrates the derivation of these four instructional instruments, and offers a concise description of each.

With these instruments, it is now possible to put the learner fully into a continuing flow of in-life behaviors consisting of ventures and projects, with focused and relevant learning units to help the student develop the concepts,

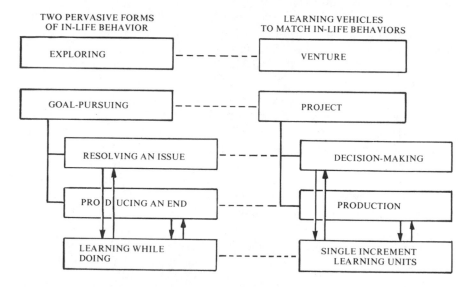

A *Venture* is a direct perceptual interaction with a phenomenon that is new to the learner. Ventures are undertaken just for the sake of getting acquainted with new phenomena. Such phenomena might include "urban sprawl," "politics," "a camera," "optimism," or any one of countless other objects, facts, and events in the environment. In addition to opening up new areas to learners, Ventures can also lead into the other three curricular vehicles.

Both *Decision-Making Projects* and *Decision-Execution Projects* are planned efforts by the learner to satisfy some need he recognizes by producing or obtaining something he wants, or by resolving an issue that concerns him. Projects are not learning acts in themselves except as they utilize both Ventures and Units. Through a cycling relationship between Projects, Units, and Ventures, learning becomes a way of succeeding in one's daily activities.

A *Unit* is a focused and purposive interaction with a phenomenon to become behaviorally familiar with its properties, so that the learner can proceed with a project in which the phenomenon is involved. Phenomena appropriate for unit development might include "writing a headline," "social effects of drug use," "getting elected to public office," and "sewing in a lapped zipper." Units can also, of course, be studied independently if the learner chooses to do so.

FIGURE 1-10. INSTRUCTIONAL VEHICLES DERIVED FROM DAILY BEHAVIORS

verbal abilities, information, and motor skills he needs in the pursuit of his wants. All of the interactive behaviors identified through the process for naming behavioral objectives are potential projects. All of the phenomena involved in them are potential units. Any aspect of the world around us is a potential venture.

Experimental curriculum development projects indicate clearly that this behavioral route for identifying phenomena yields approximately the same set of subject matter items as does the traditional process of breaking down a subject matter field, but with some important differences. The behavioral route turns them up as environmental phenomena which are involved in daily behaviors, while the traditional route turns them up as informational items within a topically arranged academic discipline. The behavioral route brings them to the student while he is engaged in a piece of want-serving behavior so they contribute to that behavior immediately. This installs them within him as part of his behavioral system. The traditional route brings them to him in a classroom that is detached from life, where he deals with them in abstract and verbalized form. The student is left to his own devices to get them related to his daily behavior if he can. The behavioral route lacks the tidy sequences that match our academic outlines and make it easy to know when a student has "covered" a subject, but it makes of learning a way of succeeding in living, and can make the student an independent and purposive learner for the rest of his life. Furthermore it screens subject matter content through the behavioral grid and allows only the content which is relevant to the behaviors to get into the curriculum.

Some Difficult Reorientations

There are a few very difficult reorientations involved in going all the way into such a behavioral system as is described here.

1. The grip which the "discipline" approach has on American educators is unbelievable. Even many who "talk" the behavioral game still try to feed the discipline structure to learners under the guise of academic behaviors.

2. The fear that students will not "cover" all the topics that have become sacred with tradition drives many would-be behaviorists back into the orderly world of the text-book system.

3. To relinquish the center of the stage to students, to give up being the great dispenser of knowledge, and to step into the background as a stage-setter with all of its different demands, is distasteful to many teachers who literally enjoy the traditional teaching role, and feel baffled by the background role.

In spite of these and other difficulties, programs with the characteristics described in this paper are gradually becoming operational, and their effects on students are most encouraging.

CHAPTER II

EVALUATION IN ART EDUCATION:
LESS SUBCONSCIOUS AND MORE INTENTIONAL

D. Cecil Clark
University of Washington

The practice of formal evaluation in art education has enjoyed a less than significant status over the past years. There are at least two factors contributing to this low status. First, very few art educators in the field have been seriously trained in evaluation; hence, few are actually committed to its practice. Such a lack of training must be a direct reflection upon the teacher training program from which the art educator emerges. This leads to a second and more basic reason. The process of evaluation, as traditionally taught, has had little relevance to the evaluation of art instruction. In a typical program, potential art educators are herded through a single course titled "Measurement and Evaluation in Teaching." Unfortunately, such a course too often focuses on the selection and development of tests which appropriately measure the more simple and straightforward cognitive outcomes in various subject matter areas like math, science, and English. More specifically, the soon-to-be art educator is obliged to learn about standardized aptitude and achievement tests as well as how to construct multiple choice and short-answer instruments for measuring easily-defined cognitive outcomes like "knowledge," "concept formation," or "application of principles." While such cognitive skills are crucial for the large majority of potential teachers, they have less relevance for art educators who are usually concerned with more subtle and affective art outcomes like "sensitivity to color and size contrasts," or "ability to express moods through art media." For these and similar objectives, traditional evaluation instruments like objective paper and pencil tests are less relevant, more technically, less valid for the art educator (not to mention long and tedious study of the mean, standard deviation, and item analysis).

For the art educator to emerge from such a frustrating experience with the conclusion that art education is just not conducive to serious evaluation is understandable but inaccurate and nonviable. However, suppose for a moment that one has arrived at just such a conclusion. In addition, suppose the art educator has further based his conclusion on the reasoning that evaluation

is dehumanizing because it focuses on the quantitative differences among people. That is, since all are given the same evaluation, they will tend to respond in similar ways when in fact art education is committed to encouraging people to act in different ways. Or, he might reason that the more important outcomes in art education are not amenable to behavioral measurement and thus we end up with easily-measured but trivial outcomes for art education. These and other reasons are offered.

If these reasons are examined carefully, they reflect our general inexperience with evaluation *in art education* more than basic criticisms of evaluation per se. Evaluators have not as yet developed the background and sophistication for working with the types of objectives that dominate art education.

But, for whatever reason, suppose art instruction were generally devoid of systematic, preplanned, and intentional evaluation. Two simple questions can be legitimately raised. If the art educator wants to improve his instruction, how does he do so without evaluation? And, how can he tell whether or not a student has "gained" anything from the art experiences without evaluation?

To be sure, an art teacher does modify his instruction as well as introduce innovative practices in hopes that learning will be improved. But without intentional evaluation he can never have any degree of certainty about the effects of his changes. That is, without intentional evaluation we are largely without *direction* for improving art instruction.

The art educator may react to the foregoing comments as he contemplates his own teaching behavior. "I *do* evaluate my art instruction, and this evaluation does provide direction for improvement." However, are we both talking about the same level of evaluation?

Suppose the process of evaluation is redefined so that it might have greater usefulness specifically to art education. Let us define evaluation in art as simply the *process of judging a student's behavior or his product in terms of some criteria.* Several parts of this definition require explanation and example. "Behavior" is defined as any activity engaged in by the art student, whether observable or nonobservable. Thus, "making a pinch pot" is an observable activity while "being sensitive to design" is an unobservable activity; but both of these activities are behaviors. Why is such an inclusive definition of behavior more helpful? There are two reasons. First, our attention will now be directed towards the evaluation of all behavior, whether it is going on inside the learner or outside the learner. Second, we are now required to start thinking about the relationships between observable and nonobservable behaviors and decide upon what overt cues we will accept as evidence that some covert behavior is occurring inside the learner. In essence, this more inclusive definition will hold us more responsible for measuring — at least in part — those important internal behaviors which, until now, have escaped our evaluation.

A "student's product"* refers to any thing-like production made by the student. Thus, pinch pots, collages, paintings, bracelets, etc., are all products made by the student.

The definition of evaluation also involves "judging a student's behavior or his product in terms of some criteria." Judgment here means deciding upon the presence or absence of something, or the degree to which it is present, or its quality. What are criteria? A criterion is a characteristic about which some judgment is made. This characteristic takes on different values. That is, it is present or absent, there is more or less of it, its quality is high or low, and so forth. Let us consider a simple example. Suppose a student has made a pinch pot and wants the instructor to evaluate it. The teacher might decide to use two criteria in his evaluation, namely, "bowl like" and "water-holding capacity." In evaluating then, he asks himself "Is this pinch pot sufficiently bowl like?"; and, "Is its water-holding capacity adequate or inadequate?" He is making a judgment about the student's pinch pot in terms of these two criteria . . . he is evaluating.

The criteria in art education seem to be of at least two general types. The first will be loosely called student behaviors. Here are some examples: Is the student *acting creatively* in his art work? Is he *being aware* of contrasts? Is he *expressing himself* through this medium? Is he *understanding* himself through this medium? Note that these are examples of criterial behaviors which are covert in nature. Following are some of a more overt type: Is he correctly *operating* the potter's wheel? Is he producing his intended colors as he *mixes* the paints? Is he *forming* the pinch pot so that it will hold water? Each of these criteria (behaviors) will have optimal or most appropriate values. More often than not, these values are held in the mind of the teacher. Evaluation, then, involves the comparison of *any given* student's behavior with the optimal values of these criterial behaviors. In some of the above examples, a teacher might simply be interested in whether or not the criterial behavior existed at all in the student (Is it present or absent?). More ambitiously, he might be interested in whether the criterial behavior existed in some degree (Is it present to a sufficient degree?). Finally, he might be interested in whether or not the criterial behavior was of an acceptable quality (Is it being performed ad-

*This definition of evaluation needs to be explained in terms of what art educators are now calling the "process" and "product" in art. Many art educators are now saying that the product itself is incidental to the more important process a student goes through as he manufactures the product. This definition presented here requires that both processes and products be ultimately identified as outcomes or objectives. The "process" would be identified as some desirable internal (covert) behavior which becomes an objective itself. Therefore, attempts should be made to measure, at least in part, these covert behaviors. The "product" is identified as either a thing-like production of the student *or* some overt behavior; both of these likewise become objectives. For example, the product outcome might be a series of completed paintings or some overt skill such as ability to correctly prepare and mix colors. The process outcome — a more important one having resulted from producing these paintings — might be the student having become aware that he can now express himself through the medium of paint. Thus, both the "process" and "product" in art need to be evaluated in terms of some criteria.

equately?). More simply put, the teacher (and/or the student) decides upon some important behavior. This becomes the criterion against which the student's actual behavior is judged. Does the student's actual behavior approximate this criterion behavior at all? Is it similar to at least some degree? Is it acceptably similar?

The second general type of criteria will be loosely called characteristics of a product. In our earlier example of the pinch pot, the criteria were "bowl like" and "water-holding capacity." Other examples are: Does the painting express a *melancholy mood?* Is this painting *naturalistic* in style? Are these qualities of a *Van Gogh?* Is this design *balanced?* Does this bracelet show *contrast* in colors? Is that a *controlled* line? Is that collage *rustic?* Has that cup been properly *fired?* Here, as with the other type of criteria, the characteristics of a given product are judged in terms of some optimal or appropriate characteristics the teacher has in mind. She may be interested in whether or not this criterial characteristic is present or absent in a particular product; whether it is present in sufficient degree; whether it is of a certain quality; whether or not it is appropriate, and so forth.

We must be careful not to imbue this definition of evaluation with more meaning or precision than is intended. There have been no limits or qualifications placed on the criteria. Thus, they can be established by the teacher through long years of experience, or by the student, or by both the teacher and the student, or by someone else. Also, any kind or number of criteria can be used. Furthermore, they can be clearly identified, measurable, and intentional, or they can be hidden, nonmeasurable, and subconscious. The sole qualification is that there be *some* criteria used in making the judgment.* Additionally, there are no limitations placed upon the nature of the judgment. It can take place in one situation or over a variety of different situations. It can be conducted loosely or very precisely. And, it can occur at a subconscious level or at an intentional level. Here, again, the only requirement is that *some* judgment be made about the student's product and/or his behavior in terms of the criteria. Following are two extreme examples.

Suppose a teacher systematically demonstrates the proper method for operating a potter's wheel and shaping clay through its use. Here the set of criteria have evolved from many years of people working with clay on a potter's wheel and are to some extent "standardized" (that is, they tend to produce the most desirable results for the person working the wheel). Likewise, these criteria are rather clear and easily identified. After a period of time in which the student works with the wheel under the teacher's supervision, the latter decides to evaluate the student's ability to use the wheel in making his

*Obviously, in practice, there will be many times when one can only assume that some criteria did or did not exist. Technically, one can argue that whenever a teacher makes a judgment, criteria have been utilized. An attempt to demonstrate the nonexistence of criteria is an impossible task. Certainly the more viable approach is to assume that whenever a teacher makes a judgment she uses some criteria, and every attempt should be made to identify them.

own desired products from clay. In this case, the teacher conducts an intentional judgment of the student's behavior at the wheel in terms of "proper" behavior. In an attempt to make her judgment as "objective" as possible, she lists on a sheet of paper the criterial behaviors to look for in the student. Opposite each, she draws a simple scale to rate the degree to which that behavior is adequately demonstrated.

Suppose a second example. Here the teacher has the student involved in the production of a variety of art works using paints as the medium. She wants the student to come away from this experience with "an awareness that he can express himself through the medium of art." The paintings themselves are considered to be incidental to this outcome but are often used to help evaluate the student's awareness. Over the years, this teacher has acquired a set of internal criteria for "an awareness of self expression." These criteria are embedded within her own repertory and are difficult for her or anyone else to identify. Nor, she would argue, can they be examined separately, but only as a group and over a period of time. Likewise, there is no conscious judgment made; it occurs automatically. She will be able to "tell" when the student has reached this awareness. If we were to sit down with this teacher and persuade her to help us identify at least some of the observable student cues she subconsciously picks up from which she makes her inferences, they might turn out to be such things as: the variety of different colors used in various paintings, the portrayal of objects and events that are important to the student, facial and verbal expressions of the student throughout the process, and a host of others. These criteria may remain hidden; the observable cues which represent these criteria may be unidentified; and the judgment may be subconscious, unsystematic, and imprecisely carried out, but nonetheless evaluation has occurred.

Importantly, both of the above examples represent evaluation according to the definition presented. All the necessary characteristics were present in each case (although *we* have to do some inferring as well). Both involve a judgment about the student's behavior in terms of some criteria.

By this time the reader might possibly have drawn at least two conclusions. First, the definition of evaluation given here is so imprecise and inclusive it is unlikely to be of much help in evaluating art instruction. That is, virtually any intentional or subconscious judgment made by the teacher can be construed as evaluation. This leads to the second possible conclusion, namely that art educators have been evaluating as long as they have been teaching, and will no doubt continue to do so in the future.

Whether this simplified definition of evaluation will turn out to be helpful remains to be seen. The second conclusion brings one to the satisfying realization that art educators have been evaluating all along. Too many people both inside and out of art education have denied the practice of evaluation among art educators. Such a denial is inaccurate (at least in terms of the definition presented here) and unnecessary. Indeed, artists and art educators who

might be inclined to scoff at the relevance of evaluation or its existence in their field are themselves constantly making judgments about student's products and behaviors based upon some criteria ... they are constantly evaluating. Thus, the important question is not why should we have evaluation in art education, but rather how can evaluation in art education be improved? The discussion up until now has established the background for answering this question; to which we now turn.

Perhaps the single most basic way to improve evaluation in any field is to make it more precise. That is, we need to work on our evaluation procedures until they do better whatever job we wanted them to do in the first place. An analogy may serve to develop this point. Suppose a doctor evaluates a client's general health solely by an overall look at his physical appearance, skin coloring, facial expression, and body build. But suppose after several misdiagnoses this same doctor feels the need to increase the precision of his evaluation. He would now undoubtedly examine the person physically, take blood and urine samples, obtain x-rays of various parts of the body, secure the person's past medical history, and so on. By increasing precision of evaluation the quality of diagnosis should be improved. We might note in passing that increasing precision has in no way minimized the importance of his subjective impressions in making the diagnosis. Greater precision allows the doctor to validate and heighten these subjective impressions.

How, then, might we increase the precision of evaluation that is constantly occurring in art education? By working on two different aspects. First and most important, we can identify more of our criteria and then make them more measurable. The author's experience suggests that even a modest amount of effort spent in making implicit criteria more explicit produces very satisfying results. This task will be facilitated if several positions are kept in mind. First, art educators need not feel they are burdened with the impossible task of attempting to identify *all possible* criteria for a given evaluation. Such an orientation is at present overly ambitious and mostly unrealistic and has, in the past, caused much consternation among teachers. We can start more modestly and still be significantly productive. We realize there are and will continue to be many criteria in art education which will never yield to clear let alone measurable definition; typically, these are highly individualized and encompassing in nature. For example, defining specific criteria for "aesthetic awareness" in an art form would require considerable time and energy. Second, we are now willing to live with merely a representative *sample* of all the criteria that could be identified. From this cautiously selected sample we draw inferences about how the student's behavior or product would be judged if the entire population of all possible criteria had been used. A few clearly-defined and well-chosen criteria are better than a large number of ill-defined criteria and certainly better than no criteria at all.

The identification of criteria is the first step; making them measurable is the second. However, even if we succeed in bringing them to the conscious

level without making them measurable, precision is increased. A teacher who can articulate more carefully what she thinks her criteria are has become more precise. For example, if she can say "At least two criteria I have for an awareness of painting as a medium of self expression are the displaying of likes and dislikes in the art work and the expression of moods."

The second aspect which will increase precision is work on the judgment process itself. While no attempt should be made to minimize the inclusion of subjective impressions in making the judgment, every effort should be made to base these impressions on as much "objectively"-gathered data as possible. The intentional observations of a student's behavior and/or products need to be characterized by at least some validity and reliability. At this particular point in the evaluation process (data gathering phase), a teacher must minimize a natural tendency to color his observations by his general impression of the student, the student's past work, how he personally feels about the type of art work engaged in by the student, and so on. The increased use of at least some type of measuring (data gathering) instrument will tend to produce more valid and reliable observations obtained by the teacher. Through their use, the teacher is obliged to become more objective in that he will have to identify and write down the criteria he intends to use in making the judgments. The use of instruments will also tend to minimize haphazard, piecemeal, incidental, and subconscious judgments. Let us return to an earlier example. If the teacher decides to use a checklist to determine whether or not the student is demonstrating "proper" behavior in working the potter's wheel, he will be required to write down those criterial behaviors and consciously look for them. The recording of these observations on a structured response sheet tends to minimize subjectivity in observation as well as omission of important criterial behaviors. Thus, the later judgment which is based upon these carefully gathered observations will be more accurate, more easily justified and, at the same time, generously imbued with subjective impressions. Subjective impressions, then, enter the judgment not the data gathering phase. In terms of the student, the use of a checklist happily provides him with the criterial behaviors upon which he will be judged.

This paper encourages the art educator to become less subconscious and more intentional in his evaluation of art instruction . . . become more precise. In doing so, he is in no way liberated from his artistic responsibility in evaluation. His artistic training, background and maturity all impact themselves on this process. They are at work in the selection of criteria to be used; the relative importance of each; the extent to which each criterion is used; the selection of student behaviors which represent evidence for internal states and feelings; the identification of various criteria for different types of products produced; and the decisions made based upon the results of the evaluation. There are undoubtedly more.

These suggested changes in art evaluation are modest in nature. They do not represent an overhaul of the process as it has been conducted in the past;

they do represent some clear changes in direction and additional effort on the part of the art educator. As it now stands, evaluation in art may be too personal, too unrefined, and too lacking in rigor to responsibly answer the staggering demands that will be placed upon it in the next few years. These demands will come in the form of expensive curriculum reforms in art instruction; banner-waving innovations that capture the excitement of art educators; deeply embedded programs yearning for reform. Perhaps art education, because of its inherently personal and sensitive nature, will never feel comfortable or satisfied with rigorous and detailed evaluation. Perhaps those of us in measurement and evaluation are overly naive in thinking not only that many subtle and delicate human endeavors can be evaluated, but that they ought to be. Would a compromise improve both evaluation and art education?

PART II

K-12 EXEMPLARS

Part II of this book presents concrete examples of behaviorally oriented curricula in the visual arts which have been conceived and developed during the past five years and which are reflective of the activity going on in public schools today. While highly varied in direction and method, they clearly demonstrate alternative approaches to dealing with the problem at hand. Not all of the programs and projects can be traced directly to the 1968-1969 NAEA preconference institutes, but the nature and extent of their influence is readily apparent as one examines the chapters in Part II.

In Chapter III, Brouch presents an exerpt from a matrix system for writing behavioral objectives and describes its use in designing an instructional program for an elementary school. Rouse describes in Chapter IV the conception and development of a structured art curriculum for elementary students. Of particular interest in this chapter is the thorough description of the complexities of bringing a complete curriculum to the completed, published form. In Chapter V Patton describes some of the basic materials developed in the Racine, Wisconsin, elementary schools to help classroom teachers plan art experiences based on specific goals. These specific goals are related to Learning to Make Art, Learning to See and Feel, and Learning to Understand Art. In the final chapter Loeh presents a philosophical basis for a behaviorally oriented awareness program for school district U-46, Elgin, Illinois, and describes how it is utilized to develop a curriculum in art for use by the elementary classroom teacher.

CHAPTER III

AN EXCERPT FROM:
A MATRIX SYSTEM FOR WRITING
BEHAVIORAL OBJECTIVES

Virginia M. Brouch
The Florida State University

Participants in the 1968 and 1969 Research Training Institutes cosponsored by the National Art Education Association and the United States Office of Education were asked to designate carrier projects for art learning experiences. More simply put, this means: describe in one statement what it is the art student will do during his art lesson. An example would be:

> *The student will produce a mixed-color tempera painting of a cityscape using brushes on 12" x 18" white drawing paper and emphasizing line and texture.*

It seemed logical that if individual art teachers throughout the nation wrote enough carrier projects and the behavioral objectives for them, eventually all of what is taught in art could be covered. Persons involved in research could then test, sort, and amalgamate programs to arrive at optimum learning/teaching effectiveness.

Although this process is not a complicated one, it seemed that much duplication of effort would take place. For example, the person writing objectives for producing a simple, ceramic pinch pot might state several steps identical to those of another person who would be writing objectives for a three-inch coil pot. If there could be a common base, a means of sharing devised, then cooperation during the initial stages of writing such programs would cause a reduction of repetition at the same time as it would accomplish the task much more efficiently.

A method, therefore, was sought to aid comprehensive thinking in order to maximize learning benefits, while minimizing both repetition and physical exertion on the part of the already very busy teacher of art. To facilitate program conversion, the matrix, constants, and learning sets presented in this paper were designed in the attempt to link carrier projects to what happens, often automatically, in the art teacher's head during instruction.

Three general items are basic to understanding the matrix system: (1) it was designed to represent the discipline of art through the vocabulary of materials and subsequent skills; (2) it grows out of the author's firm conviction that a student does not create out of a vacuum, but is motivated through experience and information to learn and grow[2]; and, (3) that the end products of our art instruction must remain unique and individual in expression while simultaneously reflective of established knowledge and progressively acquired perceptual, critical, and motor skills.

Figure 3-1 was designed to illustrate the relationship of the matrix to the ongoing development of curricula wherein Phase I reflects the goals of the community, district, school, and/or class situation, based upon the needs of society and the discipline of art. Phase II represents those materials areas with which we, as teachers of art, work: i.e. ceramics, paint, etc. Phase III is the matrix itself with its accompanying list of constant stems. Phase IV is the actual program per lesson, class, unit, semester, year. Sets are constructed from the material provided in Phases I, II, and III, and arranged by levels of difficulty called "strata". Phase V represents an area best described as cross-referencing of growth and provides for the flow of learning to become increasingly individualized through choice and decision-making based upon individual needs, growth, and mastery. Lastly, Phase VI involves testing, research, and evaluation which, in turn, closes the system by returning to each of the other phases in the hope of causing improvement to our basic goals, the choice of media, the instructional packages we have developed, or the tests themselves.

Phase I: General Goals

As a result of our art instruction in formal educational situations, we might expect that:

1. The adult will be able to discuss the visual/plastic arts in terms of information and acquired skills, as well as with regard for the relevancy of art to the ongoing development of himself interacting within his cultural milieu.
2. The adult will be able to communicate/share his learnings with others through discussion, publication, production-exhibition and his enriched living environment.
3. The adult will participate in the production of visually qualitative environments which demonstrate concern for both history and his contemporary society, with respect for the future, continued existence of mankind.

The above are but three statements from the eighteen plus eight sub-statements thus far evolved by the author in an attempt to establish a base unique to art learning from which we can draw programs employing experiences aimed at the accomplishment of these goals. With slight alteration, the

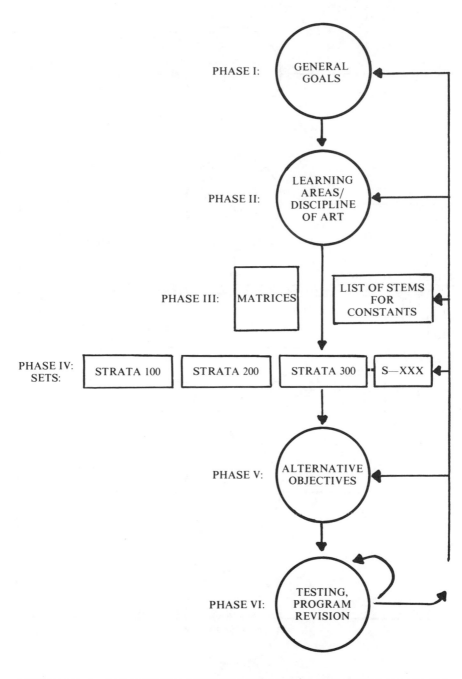

FIGURE 3-1. OVERVIEW OF THE RELATION OF THE MATRIX TO
CURRICULUM

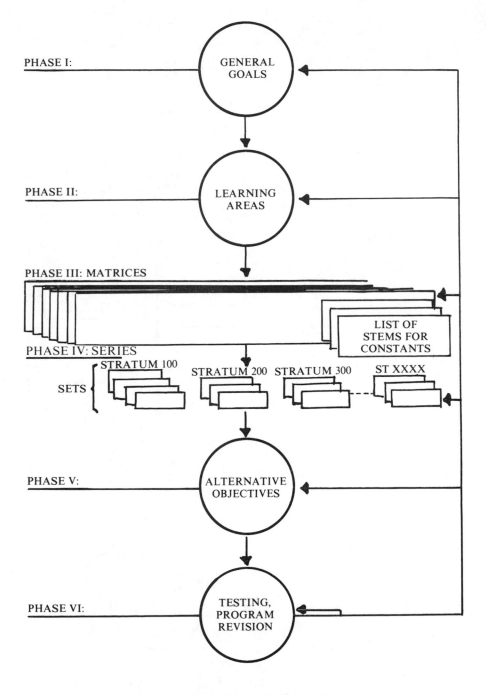

FIGURE 3-1 (continued)

above general goals can be modified to fit individual communities, districts, schools, and class experiences.

In stating our general goals, it is difficult to avoid making statements from the affective domain. At present, such goals as: "The student will become more appreciative of works of art", while real to us as art educators, present difficulties in testing and research. It would seem better to make the statement than to ignore areas of art learnings which we consider central to our programs.[3] Yet, too, for purposes of accountability, our goals should be as concrete and objective as possible.

Phase II: Materials

While admittedly not the only vehicle, the media we use are central to what we are about as teachers of art. In the matrix approach to writing behavioral objectives, materials were chosen as the art teacher's vocabulary of communication with students about art history, design and composition, perceptual and critical awareness, and the evaluation of works of art.

In a sixteen lesson in-depth experimental study of tempera learnings at the third and fourth grade levels, initial experiences were found to involve more information regarding materials and care of self, environment, and tools. Later experiences emphasized art design principles and elements. Closing experiences emphasized evaluation and the building of skills in the critical-appreciative area.[4]

The major areas of instruction, then, become the base from which the programs are developed. As an example, one elementary district's overall plan included the following areas of concern:

Painting	Crafts
Drawing	Ceramics
Printmaking	Sculpture

Within this district, there are eight art teachers and twelve schools. Art is taught once a week for forty-five minutes to the 4th, 5th, and 6th grades. It is taught twice a week to the combined 7th-8th grade students who choose it as an elective area of study.

While there is reinforcement and interdependency from area to area, each is also unique and constitutes a program emphasis. Painting, for example, is scheduled for five weeks of the academic year.

Figure 3-2 illustrates the painting matrix designed for this school district. It contains all of the elements of the program for the four levels being taught (indicated by asterisks above and to the right of the hexagon shapes), as well as those elements that have been determined as constants for all areas. Color received two asterisks as, in consideration of the other areas to be taught, it was thought that painting would best serve as the medium for teaching color theory and the basics of design and composition incorporating col-

Prepared For By:	Self: Shirt, Goggles, etc*	Work Area Surface*	Tools: Care and Maintnce*	Storage Information*	Cleanup Instructions*	I
Obtained By:	Teacher Distribution*	Student Monitor(s)*	Materials Center	Storage Center	Purchase	
Motivated For and Enriched By:	Classroom Demonstration*	Books and Periodicals*	Prints/Reproductions*	Films, Filmstrips, ETV*	Slides*	S iz T
Readied For Use By:	Surface Selection*	Selection Of Tempera*	Selection Of Watercolor Palettes*	Selection of tubed Acrylics*	Selection of enamel spray paint*	
Design Emphasis	Line*	Shape/Mass*	Texture*	Value*	Color**	H
Manipulated By:	Sponges*	Brushes: Variety*				
Finished By:	Drying*	Matting/ Mounting*	Assembly as a Mural*			
Utilized For:	Expression Experimentation*	Improve Perceptual-Motor Skills*	Improve Critical Skills*	Exhibit: Class/School/ Show/ Contest*	Home: Viewing/ Sharing*	
Evaluated By:	Self*	Teacher Verbal*	Peers: Discussion*	Judge(s) Rating Scale*	Paper-Pencil Test: Essay, Multiple, etc.*	E A

FIGURE 3-2. MATRI

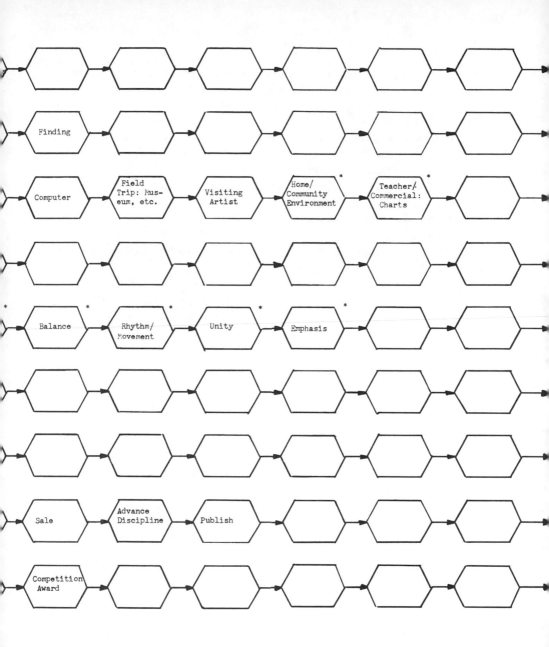

Finding

Computer | Field Trip: Museum, etc. | Visiting Artist | Home/ Community Environment* | Teacher/ Commercial: Charts*

Balance | Rhythm/ Movement* | Unity* | Emphasis*

Sale | Advance Discipline | Publish

Competition Award

R PAINTING SERIES

or. (In the sculpture matrix, mass and texture are emphasized by double asterisk; in drawing, line and rhythm.)

Phase III: The Matrix

Within the matrix, all of the areas have been established as constants regardless of the medium of expression *with exception to* the hexagons containing those items related specifically to the painting instruction within this district: "Selection of Tempera, Selection of W/C, Selection of Acrylic, Selection of Spray Paint: Enamel, Sponges, Brushes: Variety, Drying, Matting/Mounting and Assembling as a Mural".

Behavioral objective stems with missing blanks to fill in for media differences have been developed for all of the hexagons which remain constant. An example of this would be:

The student will prepare himself
by covering with/putting on ...

work shirt
smock
apron
welding mask
safety goggles
asbestos gloves

Use of the stems facilitates the development of learning sets. Use of the matrices facilitates comprehensive coverage of program development.

Only one of the constant stems is still causing this author difficulty. It involves the student "having access to motivation, perceptual training and verbal instruction ...". "... having access to ..." is imprecise, but, in this instance, the best terminology. We are not really certain that the student has received our instruction until he demonstrates it through his verbal or visual output.

Phase IV: Series, Carrier Projects, Strata and Sets

Within the elementary district mentioned above, there are five painting lessons conducted with intact groups in grades 4-6 and ten lessons conducted with the combined elective 7-8th grades. Four strata of difficulty were developed which stated the learning so that the 4th grade students received instruction regarding basic color theory, mounting information, and motivation suitable to their age level. For want of a better term, one strata has been designated as vertical learning: i.e., going through one grade's requirements toward the general goals for that grade without skipping lessons. Horizontal learning is what the students do as they move among strata. Thus, stratum

200 is more difficult than stratum 100 and covers new learnings based upon information and performance from stratum 100.

In Figure 3-3 two strata are illustrated for explanation and clarification. In Stratum 400, students move through five lessons, each with its own set of objectives and stated carrier projects. In Stratum 600, students elect from three different motivational and dimensional possibilities at the end of the second lesson. The first two lessons established class operational procedure and basic art information; the last three served to present options for expression. The learnings from any one of the three divergent packages are still vertical. The end products differ in that means to ends are not restricted and individual modes of expression are still open-ended and therefore diversified.

Within strata, then, learning is regulated by the teacher-chosen scope and sequence of learning. Thus, Grade 4 might learn the pinch-pull method of working with earth clay, grade 5 might learn the coil method, grade 6 the slab method and grades 7-8 might experience throwing on the wheel. From stratum to stratum, the difficulty increases.

Within strata, many variations are possible regarding motivation, procedure, and carrier projects. The basic learning is the item we are controlling in the effort of eventually achieving individualized instruction.

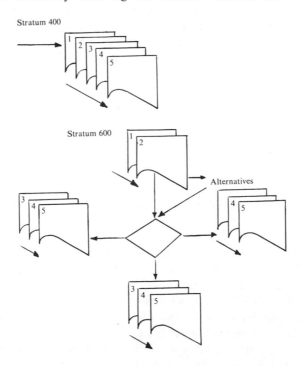

FIGURE 3-3. VARIATIONS WITHIN VERTICAL LEARNING STRATA

Phase V: Alternative Objectives

Alternative objectives basically provide two things: (1) the flexibility to skip sets within strata and to select from a variety of carrier projects which offer similar learnings; and (2) the flexibility to move from one stratum to another based upon tested competency in a given area. It is not impossible to foresee the difficulties at a high school when students come not only from elementary schools wherein art learning has been substantial, but also from schools without art programs at all. Traditionally, we have lumped all students into general art.

In behaviorally designed curricula, we can test students for prior learning and hopefully provide guidance and placement so that they may continue growth rather than repeat learnings already acquired. At present, this is difficult to administer due to the complexity involved, but it ought to be considered as an important part of our future thinking. Developing alternative objectives is a start in this direction.

Phase VI: Testing/Revision/Evaluation

In behaviorally objectivized programs, tests are drawn directly from the concepts and competencies desired as student learning. In art, most of the testing has been done through verbal exchange with regard to the work either in process or as final product. From paper-pencil tests, however, information can be obtained about not only student learning, but also about program effectiveness. Such tests are drawn logically and systematically from the behavioral statements. Still another record of performance can be obtained through the use of check lists and/or rating scales. The three types of feedback serve to aid the teacher as guides for evaluation and revision of the program, the student, the teaching strategies employed and the curriculum.

A Projected Program

The following series of experiences was chosen to illustrate the constancy and change to the otherwise basic behavioral objective statement. In Sets 2, 3, and 4, the changes have been *italicized*. In Set 5, where most of the objectives differ from prior sets, the italics have been eliminated.

In the actual classroom, alternative objectives might be considered at the completion of each set and the student permitted to change medium/stratum if so decided by him in consultation with his teacher. In the stark reality of existing school situations, the alternatives have been controlled by the teacher rather than the teacher-student choice due to situations warranting such behavior; i.e., class size, time allotments, etc.

The painting series herein contained was written for future programs wherein learning is increasingly individualized. The learning experiences were designated as sets rather than class periods to facilitate a student's progress through more than one set during a given class time or work session.

For the purposes of illustration, it has been assumed that a given student has either elected or been directed to progress within the same stratum without either regression or the skipping of sets.

The teacher, writing for this stratum, might first consider the general goal:

> The student will become more visually discriminating in regard to community planning.

Insofar as the sets to follow illustrate a direct line to this, it should be kept in mind that *many* sets could be developed at this level with many variations of motivation, procedure, and teacher strategy.

The carrier project statement:

> The student will produce a series of tempera paintings on a variety of surfaces, emphasizing the linear quality, texture, and plane of building shapes.

Set 1.

1. The student will prepare himself by covering his school clothes with a work shirt.

2. The student will prepare his work area by covering his table with newspapers from the newspaper storage area.

3. The student will select painting equipment from the materials center arranged by the teacher:

 3.1. The student will be able to identify camelhair brushes and list the steps necessary for their proper use and maintenance.

 3.2. The student will select a 12" x 18" white drawing paper surface from the materials center.

 3.3. The student will demonstrate the ability to pour liquid tempera from bottled, pre-mix into paint dishes.

4. The student will have access to motivation, perceptual training and verbal instruction regarding tempera painting and cityscapes from the teacher using charts and chalkboard.

5. The student will demonstrate his ability to produce building shapes upon the 12" x 18" white drawing paper using tempera paint and camelhair brushes.

6. The student will place his completed painting on the drying rack in the front of the room.

7. The student will demonstrate his ability to clean tools, work area, and self.

8. The student will consider the first painting as experimental work for expression and improved motor skills.

9. The student will elect his next lesson from the available alternative objectives.

Set 2.

1. The student will prepare himself by covering his school clothes with a work shirt.

2. The student will prepare his work area by covering his table with newspapers from the newspaper storage area.

3. The student will select painting equipment from the materials center arranged by *a teacher's aide.*

 3.1. The student will be able to identify camelhair brushes and list the steps necessary for their proper use and maintenance.

 3.2. The student will select a 12" x 18" *construction paper* surface from the center.

 3.3. The student will demonstrate the ability to pour liquid tempera from bottled, pre-mix into paint dishes.

4. The student will have access to motivation, perceptual training and verbal instruction *through the teacher presentation of a filmstrip of the New York City skyline emphasizing the linear quality of building shapes.*

5. The student will demonstrate his ability to produce building shapes emphasizing *line* on *construction paper* using tempera paint and camelhair brushes.

6. The student will place his completed painting on the drying rack in the front of the room.

7. The student will demonstrate his ability to clean tools, work area and self.

8. The student will consider the painting as experimental work for expression and improved *perceptual*-motor skills.

9. The student will elect his next lesson from the available alternative objectives.

Set 3.

1. The student will prepare himself by covering his school clothes with a work shirt.

2. The student will prepare his work area by covering his table with newspapers from the newspaper storage area.

3. The student will select painting equipment from the materials center arranged by *a small group of students assigned to this task* by the teacher.

 3.1. The student will be able to identify camelhair brushes and list the steps necessary for their proper use and maintenance.

 3.2. The student will select a *panel of corrugated cardboard* from the storage area.

4. The student will have access to motivation, perceptual training and verbal instruction through a *class discussion during the teacher presenta-*

tion of reproductions of works of art involving rustic, country buildings which illustrate *texture* in art.

5. The student will demonstrate his ability to produce building shapes emphasizing *texture* on *modified pieces of cardboard* using tempera paint and camelhair brushes.

6. The student will place his completed painting on the drying rack in the front of the room.

7. The student will demonstrate his ability to clean tools, work area and self.

8. The student will consider the painting as experimental work for expression and improved perceptual-motor skills.

9. The student will elect his next lesson from the available alternative objectives.

Set 4.

1. The student will prepare himself by covering his school clothes with a work shirt.

2. The student will prepare his work area by covering his table with newspapers from the newspaper storage area.

3. The student will select painting equipment from the *closet storage area.*

 3.1. The student will be able to identify camelhair brushes and list the steps necessary for their proper use and maintenance.

 3.2. The student will select a sheet of 12" x 18" *black or white construction paper* from the *window shelving area storage.*

 3.3. The student will demonstrate the ability to pour liquid tempera from bottled, pre-mix into paint dishes.

4. The student will have access to motivation, perceptual training and verbal instruction by means of *a synchronized, slide-tape package of black and white slides related to city planning historically* (Egypt, Greece, Rome, Paris, London, D.C.) and emphasizing *light and dark* visual area.

5. The student will produce building shapes emphasizing *light and dark using black or white construction paper,* tempera paint and camelhair brushes.

6. The student will place his completed painting on the drying rack in the front of the room.

7. The student will demonstrate his ability to clean tools, work area and self.

8. The student will consider the painting as experimental work for expression and improved perceptual-motor skills.

9. The student will elect his next lesson from the available alternative objectives.

Set 5.
1. The student will present the four previous tempera paintings to the teacher for evaluative discussion/critique.
2. The student will select the painting he thinks is most expressive of his information and interest in buildings.
3. The student will have access to motivation, perceptual training and verbal instruction from the teacher using charts and regarding the finishing of his work.
4. The student will demonstrate his ability to finish his work by mounting his selected painting on an appropriate surface.
5. The student will place his finished work in the teacher directed display area.
6. The student will demonstrate his ability to return materials to proper storage.
7. The student will elect his next lesson from the available alternative objectives.

Conclusions

The matrix concept herein presented is but one vehicle available among what might be a wide variety of possibilities for designing programs utilizing behavioral objectives. First we must decide to write them.

Five major benefits can be seen by so structuring our art programs:

Teacher Benefits.

Use of the matrix provides teachers with an overview of the materials to be covered; thereby recalling for those persons for whom such thinking has become automatic, the vast amount of detail involved in what is actually happening in their classrooms. By constructing matrices for the areas of learning in which we are involved, behaviorally objectivized programs can be more efficiently designed: i.e., much repetition in thinking and writing can be eliminated. Further, such effort provides tangible evidence for program existence and expansion in a manner comprehensible to administration.

Program Benefits.

When, as in the elementary program discussed in this paper, matrices are completed, contrast and comparison of these can lead to better refinement of the total program. Added to this, of course, is testing. Tests provide data upon which we can make better decisions regarding our instruction.

Benefits to Curriculum Development in Art Education.

Comprehensively covered, the system would assist in designing increasingly individualized programs fulfilling the four points suggested by Eisner:

> ... *the development of ... (1) technical, expressive and aesthetic competencies necessary for the production of objects having aesthetic quality ... (2) critical appreciative powers and ... furthering*

the students' historical understanding of art in human culture . . .
(3) the powers of visual perception and the acquisition of creative
design skills . . . and, (4) humanistic competencies . . .[5]

Further, the system also lends itself to structures in research which, in the end, will assist in the negation or verification of the programs written.

Benefits to the Profession in General.

Among the trends of the 1970's is one towards "accountability".[6] Administrators, faced with stricter budgets and the need, themselves, to justify subject area learnings will be asking more and more of us to present our programs in terms comprehensible to them.

Benefits to Students.

The optimum of all benefits to be derived from what may prove a difficult transition for many of us is for the learner. Improved program effectiveness ought to logically lead to increased individual attention, growth and guidance. As we become more efficient in the mechanical elements of both the discipline of art and the profession of teaching, our commitment to these areas, our information and our expertise in them ought to be the base from which our students learn more and learn it better.

REFERENCES

1 This article is excerpted from the book: *Art Education: A Matrix System for Writing Behavioral Objectives.* Phoenix, Arizona: Arbo Publishing Company, 1973.
2 Interested persons might review chapters I and II of Viktor Lowenfeld, *Creative and Mental Growth, Third Edition.* New York: The Macmillan Company, 1957.
3 Mager, Robert, "Analyzing Affective Goals," a conference presentation on programmed instruction held at Arizona State University, Tempe, November 20, 1970.
4 Brouch, V.M., "An Experimental Study of the Effects of Synchronized Slide-Tape Art Learning Experiences on the Tempera Paintings of Third and Fourth Grade Children," (Unpublished Doctoral Dissertation: Tempe: Arizona State University, 1970), and, the report of this investigation in *Studies in Art Education,* Spring, 1971.
5 Eisner, Elliot W., "The Challenge to Art Education," *Art Education,* February, 1967, 28-9.
6 The theme of the 1970, December issue of the *Phi Delta Kappan* was devoted to this topic.

CHAPTER IV

ART: MEANING, METHOD, AND MEDIA —
A SIX YEAR ELEMENTARY ART CURRICULUM
BASED ON BEHAVIORAL OBJECTIVES

Mary J. Rouse
Indiana University

When Mary Rouse and Guy Hubbard, colleagues in the art education program at Indiana University, attended the first art education research training institute held in St. Louis in 1968, they had already begun to plan a six-year curriculum in art for elementary schools. For some years, they had been convinced that elementary art programs were in dire trouble in many places. They knew, for example, that approximately 90% of the elementary art was taught by classroom teachers, with only 15-20% of these receiving any help from art specialists. They knew, too, that only about 10% of all elementary children were receiving any art instruction from a special art teacher and that when and if they did, the instruction was likely to be less than once a week. And for some of these students, this instruction quite likely occurred only once a month.

While Hubbard and Rouse, in agreement with most art educators, would clearly have preferred that every child should be taught by art specialists, they were realistic enough to know that this was not possible given current financial problems in most school systems. The predicament demanded another solution.

Considered in a very pragmatic way, the only reasonable strategy seemed to be to supply classroom teachers with quality written materials which could help them do the job they obviously *must do,* with or without these materials. Almost all other curriculum areas in the elementary schools seemed to have reached the same conclusion long before, and had organized themselves to supply specially prepared materials to teachers.

Clearly these other areas, although dealing in matters in which the classroom teacher had far more background and expertise than art, were not willing to believe that the classroom teacher could provide better materials in their areas than curriculum specialists. Nor did they seem to believe that classroom teachers had the time, the energy, or the preparation to do an ad-

equate job without the help of their materials. Only art educators, for some reason Rouse and Hubbard could not fathom, appeared to hold this unique view.

Being either very courageous or very foolish, the partners had decided to do what they could to solve the problem: to attempt to prepare specific text materials for every grade of the elementary school. They fully realized that they would immediately draw the concentrated wrath of many in their own field for doing so. But they thought that a small price to pay should their text materials be successful in helping the schools to provide the art programs not possible before.

Hubbard and Rouse envisioned a sequential, structured program written to be taught to a large number of children in fairly typical situations by the classroom teachers. They thoroughly understood the problems of individual differences that would be presented by their decision to prepare materials for "modal" children, since they had been trained back on "The Farm"[1] by a leading exponent of this concept. But they had reached the conclusion that until some norms were established for this central group of children (estimated by some to be about 66% of the school population), they could not expect ever to be able to determine how far other children, not of this modal group, might deviate in one direction or other, and thus could not serve these others realistically, anyway, until their deviations were mapped. It was not that they were not concerned with these different children; only that they felt that no honest assessments of their differences could be made until some central points were established. They were rather astonished to realize that this idea had not occurred to others before them. They fully intended to devise alternative programs for these different ones once the larger group had been provided with suitable materials.

So the partners had occupied themselves for several months with the setting up of trial categories and lists of art behaviors which they would wish these "modal" children to have "gone through" by the time they had progressed through six years of elementary school. This was not an easy task since there were few resources within the field to which they could turn at this time. And so at first they had not bothered to give names to these categories of behavior; they had simply compiled those that seemed important. As they worked, some of these seemed to divide themselves into obvious relationships quite easily, but there were also many overlaps. At this stage of the game, the partners were not concerned with distributing these behaviors by grades, but rather, that they had assembled a list as complete as possible.

As they worked on, however, the behaviors seemed rather naturally to be falling into six categories. And so they invented the first of what was to be several versions of titles for these categories: (1) Formal Artistic Elements and Principles, (2) Art and Artists, (3) Attitudes Toward Art and Creativity, (4) Knowledges and Skills Concerning Tools and Materials, (5) Sources of Ideas for Communication and Expression, and (6) A Visual Vocabulary.

These titles, and categories as well, were later changed several times before the final version was agreed upon.

When they felt that a fairly complete list of behaviors under each category was assembled, they turned their attention to sequencing them among eight grade levels. In order to do this, they used the best information available to them from their own field as well as from other related areas. This information was gleaned from relevant empirical research on graphic behavior, aesthetic choice behavior, perceptual development and behavior, creative behavior, and cognitive and physical development. Some writers in art education have complained that there is not enough information to guide curriculum writers in our field, but the partners found no such dearth. Some of the sources they used have been published elsewhere.[2]

Sequencing also was based on an analysis of which behaviors logically precede other more complex behaviors, as well as such mundane matters as what the other curriculum areas in school are dealing with at certain times. For example, it is logical to suppose that one must know how to use scissors before one is asked to make paper constructions; it is also logical to consider American art at the same time that America is being studied in depth in social studies and European art at the time when Europe is the subject of discussion in other areas. Similarly, the study of color would seem to be enhanced by the fact that students are currently studying light and the color spectrum in science.

They even considered such matters as seasons of the year in positioning behaviors. Obviously, an objective such as "drawing a tree in careful detail" could best be carried out in warm weather which permits students to go outside for direct observation.

Since the partners had already been working with behavioral objectives, the St. Louis Conference's principal contribution was in helping them to better understand all of the ramifications of this approach, and in giving them more ease in handling objectives. However, it also provided another kind of opportunity.

While attending the conference, the partners met other individuals in the field who were as interested as they in innovative curriculum structures. They acquainted these colleagues with what they were doing, and this led to an invitation to present their curriculum structure to a teacher workshop during the coming summer as a part of the Arts in General Education project. The same invitation was issued to several other curriculum workers in the arts; among them Elliot Eisner.

The partners arrived at the workshop with a series of huge charts which specified their (by now) second version of categories of art behaviors. The first chart showed all seven categories then being considered, and vertical lists of behaviors covering eight grade levels under each. A second chart showed how one year's behaviors under all seven categories could be pulled from the large chart and enlarged and redistributed through six "learning periods" or

divisions of that year. A third chart illustrated a typical "learning period" from that one year, expanded so as to encompass the behaviors under all seven categories for each of the weeks within the learning period, and each day of each of the weeks. The partners had actually developed six complete years of the curriculum in this manner, requiring 33 charts to do so: one master, one for each of the six years, and one for each of the six learning periods for each of these years. Once they had completed their first lists of important behaviors needed for all six of the years under each category, they had employed a kind of logical analysis to sequence these objectives and to allocate them first according to grade level, then to learning periods, and finally to weeks and days. They had discovered that once the first master chart was accomplished, the next systematically fed itself out from that, and when that was completed, the last chart developed easily from it. In short, they had developed a kind of "systems approach" to curriculum development, quite independently, which was not only unique but extraordinarily efficient. (They later were able to utilize this chart concept as an effective tool for teaching curriculum development to their students).

As they worked with their charts, the partners had discovered something not yet thoroughly understood by other curriculum workers in art education; namely, that Mager's system of writing behavioral objectives could not work for our field—at least as originally specified. There were several reasons for this. First, in art education it is necessary to leave as much room for uniqueness and individual approaches as possible. This rule would be defeated by attempting to specify exactly what the end product of a behavior would look like. In art, clearly, we are not interested in making salmon croquettes. Secondly, the partners' use of a "systems approach" (first specifying six complete years of objectives, then translating these into individual years, then into individual learning periods, and finally into weeks and days) precluded their being too exact about each motivation, material, tool, or other component too early. To do so literally froze them before they had begun. They found it was much more practical to define behaviors in an open-ended manner, leaving more specific details to emerge at a lower level where choices could be made from several possible alternatives. In most cases the final decisions emerged only at the daily level, but even then they always tried to maintain an open solution although details such as materials might be specified by that time.

The informed reader will recognize that these statements echo other writers in the field who have also criticized behavioral objectives.[3] Rouse and Hubbard, like these others, could have engaged in long semantic wrangling about this problem, and, perhaps, ended up by changing the title from behavioral objectives to something like "instructional objectives," or "program objectives," or even, "an encounter," as others did. But they were more interested in results than debate, and so they continued working, taking what they felt they could use from Mager and ignoring the rest with a clear conscience

because they realized something that should have struck the others as well (thus saving a lot of verbiage): Mager was not God and his book, *Preparing Instructional Objectives*[4], did not necessarily carry the authority of the Ten Commandments.

And so they developed a principle of working with objectives which has since (three years later) been reinterated by H.H. McAshan in his book, *Writing Behavioral Objectives: A New Approach*[5]. McAshan made Hubbard and Rouse honest by describing a type of behavioral objective which he terms "a minimum-level objective". This new variety includes a goal statement and describes the kind of behavior that is going to be needed to carry that goal out, but it does not specify individual classroom specifics or evaluation criterions. It is particularly useful, McAshan points out, "for higher cognitive areas, in many affective domain areas," "in instances where no standards are available for the kind of evaluation required", and in some instances where "specificity would produce triviality rather than appropriate evaluation." He hoped that this kind of objective would encourage free-response creative types of evaluation activities, and would "increase teacher flexibility in both statement of goals and in planning of strategies for carrying out activities to obtain these goals"[6]; precisely confirming the feelings of Rouse and Hubbard.

The presentation made at University City had utilized objectives stated in this manner. It was well received, and consequently the partners were invited to participate in the Arts in General Education project the following spring with a trial run of their curriculum. They agreed to do so, realizing that field trials such as these were a necessary step toward the production of the final curriculum!

Additionally, they scheduled a field trial of their materials in a school in Bloomington, Indiana, their home base. This began with the fall term of 1969 when they introduced their program into all six grades of the school. Trial lessons were taught by a group of teaching fellows, and the success or non-success of each lesson was immediately fed back to the writers. Each lesson was taught twice by different teachers to different groups of students in order to reveal more problem areas. This kind of trial, rewriting, and retrial went on all that fall.

In the spring they began to feed some of these lessons to the University City Schools; in most cases these were rewrites of those already tried out in Bloomington. Once again, feedback was obtained from the teachers who taught the lesson immediately after it had been tried. This was a most valuable experience for all concerned: Hubbard and Rouse, the staff of the Arts in General Education project who were gaining valuable experience in curriculum try-outs, and even, indirectly, as it turned out, the staff in the later Aesthetic Education program of CEMREL who were able to see some of these lessons being taught, and who had access to these lessons and feedback before

they themselves came to the point where their own program packages were actually produced and tested.

The first trials were good enough for the Arts in General Education project to decide to continue working with the curriculum for the next year on an expanded basis. By this time the Monroe County (Indiana) schools evidenced interest in trying some of the material also. So the partners, (with Rouse at least having some trepidations as to the size of such a venture), committed themselves to supplying lessons for all six grades for something like 9,000 children and over 300 teachers, in two communities separated by 400 miles. Since the proposed books were not yet a reality, the Monroe County System assumed the job of printing up the lessons (2 or more pages for each teacher and 1 or more pages for each child) for 50 lessons for each of the six grades. The University City Arts in General Education Project undertook to develop a series of filmstrips to accompany the lessons.

Anyone involved in publishing can understand the problems inherent in writing, printing, compiling, and distributing what would be something over 1,000,000 pages of material. This was not made easier when the school system attempted all this on one small offset press, tended by a truculent stenographer, nor by the fact that the parcel service charged with delivering the materials to University City lost its way necessitating emergency overnight runs by research assistants. But somehow the year was survived, and all parties now knew much more than they had known before about the perils and pitfalls confronting curriculum innovators. The feedback was valuable, and resulted in the lessons either being rewritten or discarded completely before publication into a series of textbooks entitled: *Art—Meaning, Method, and Media.*

As finally worked out, each grade will have 60 lessons, each designed to be taught in a period of time ranging from 45 to 50 minutes by a regular classroom teacher. The child's lesson always includes several separate sections: (1) an introductory passage for him to read which pertains to the subject of the lesson, sometimes of a historical, sometimes explanatory, sometimes descriptive nature; (2) a paragraph or two of very explicit directions concerning problem; (3) any diagrams needed for explanation of technical matters, and almost always, visuals showing some examples of projects of a similar nature produced by other children; (4) a list of objectives to be accomplished by the end of the lesson so that the child, as well as the teacher, can have a clear idea of what the lesson is all about; and (5) a list of supplies and materials needed.

The teacher has all of the child's materials plus more of her own. She has further explanations to help her understand what the lesson is about. She has help in defining the art terms that her objectives call for her to include in the lesson. Additionally, she has a step-by-step procedure worked out for her to use in setting up the problem of the day successfully and to help her help the children in working it out in their own individual ways. She even has suggested times for each step in this procedure.

It should be emphasized that this latter device emerged from feedback from the teachers themselves during field trials. Contrary to the partners' assumptions, these teachers did *not* have the ease of handling art materials that they expected. All too many were ill at ease when asked to achieve results without fairly complete instructions.

It became clear to the partners that they, like most art specialists, had not considered the years of practice which allowed them to handle the myriad tools and materials which it takes to teach a series of good art lessons. Like their colleagues, they had perhaps assumed that one or two art methods courses, typically meeting twice a week for a period of a year, could make up for a life-time of prior neglect.

But this is simply not the case with most elementary teachers. Their teacher respondents constantly expressed a need for more help, particularly with respect to the time needed to accomplish a given step, as well as for other useful information that could make a lesson successful. And so they responded to these requests with not only time specifications, but also a section of hints which provided them with advice on handling the materials and supplies and avoiding problems that were likely to develop.

Each teacher's guide not only includes the objectives for each lesson but also a master list of objectives for the entire year classified under the six categories of behaviors that were finally settled on: (1) Behaviors concerned with perception, (2) Behaviors concerned with learning the language of art, (3) Behaviors concerned with learning about art and artists, (4) Behaviors concerned with criticizing and evaluating art, (5) Behaviors concerned with learning about art skills and techniques, and (6) Behaviors concerned with productive experiences. By doing so, Hubbard and Rouse have provided a convenient matrix of objectives to help future evaluators plan more efficient evaluation programs which undoubtedly, in this coming age of accountability, will be most necessary. This would seem to be a decided advantage not possessed by most other curriculums.

Similarly, the teacher's guide specifies materials and supplies for each lesson while also supplying a master list of all supplies and materials needed for the entire year's sequence, based on units of ten children. Thus it is possible for a teacher or a purchasing agent to reach a very close estimate of what is needed to teach the program, what this will cost, and even estimate the time of year in which the various items will need to be delivered. There are additional charts to show the teacher what she and the children will need to procure on their own—items such as old magazines and newspapers. This specificity with respect to cost and time is yet another spin-off from the use of behavioral objectives, one not often mentioned in textbooks on the subject.

All in all, Rouse and Hubbard are convinced that the advantages accruing to their program through the use of behavioral objectives are many and substantial. They believe that their use of these objectives has, in large part,

made it possible for them to provide a reasonable solution to the problem described at the beginning of this chapter.

Their program, as has been discussed, was not designed to substitute for a trained art teacher with adequate materials and time. Rather, it was designed to serve in situations where it is not possible to have the services of these specialists—a very real problem currently confronting all too many school systems.

The evidence so far suggests that it can do what it was designed to do—it can offer an effective program for those 20 million children who otherwise would have no hope for anything approximating a real art education program. This seems, to the partners anyway, a population that deserves nothing less.

REFERENCES

1 "The Farm" is the name its graduates use for Stanford University.
2 Rouse, Mary, "What Research Tells Us About Sequencing and Structuring Art Instruction," *Art Education,* May, 1971, p. 18-26.
3 Eisner, Elliot, "Instructional and Expressive Educational Objectives: Their Formulation and Use in Curriculum," Mimeo, 27 p., Stanford University, 1967.
4 Mager, Robert, *Preparing Instructional Objectives.* Palo Alto, California: Fearon, 1962.
5 McAshan, H.H., *Writing Behavioral Objectives: A New Approach.* New York: Harper & Row, 1970.
6 *Ibid.,* p. 18.

CHAPTER V

BEHAVIORAL OBJECTIVES AND THE ELEMENTARY SCHOOL ART CURRICULUM

Helen Patton
Racine, Wisconsin Unified Schools

Designing an art curriculum which is flexible, goal-oriented, and can be interpreted and used by elementary classroom teachers is no easy task. This chapter will review some of the basic materials developed with the intent of helping classroom teachers plan art experiences based on specific goals. Published in 1969* as a handbook for the teachers of the Racine, Wisconsin, Unified Schools, considerably more material has been developed than can be included here. The format of the publication, *Art for the Elementary Schools,* reflects an attitude toward art for elementary children which has evolved over a period of years but it bears the inevitable imprint of influence of the NAEA-USOE co-sponsored Pre-conference Research Seminars directed by Asahel Woodruff in St. Louis, Missouri, in 1968 and in New York City in 1969. The discipline of these seminars was of inestimable value in the development of specific goals, grappling with the problem of priorities, thinking through the importance of carrier tasks, and in forcing thought on the problem of how we can assess progress in art learnings. The publication emphasizes the importance of establishing goals for the elementary art program based on the kind of art-related behaviors expected of children, and considered important for children.

The materials developed in this particular handbook are concerned primarily with one of the major goals of art in elementary education: that of helping children learn to make art. Throughout, however, emphasis is placed on the interrelatedness of the three major goals: Learning to Make Art, Learning to See and Feel, Learning to Understand Art.

At the outset of the handbook, some statements are made and questions are posed with the intent of helping classroom teachers more thoughtfully plan experiences and analyze what children will learn through activities in art classes. It is pointed out that lately many art educators have become increas-

*2nd. edition, revised, 1975.

ingly concerned with how effectively art programs are achieving stated goals and objectives. Questions such as these are being asked:

To what extent are art programs affecting art related behaviors in and out of school?

Are art programs so planned that the aesthetic and artistic potentialities of children are being developed?

How can art more effectively contribute to the child's visual awareness, perception of natural and man-made beauty, sensitivity to environment?

Is it possible to identify what children can learn about art?

What learnings are appropriate at what levels of growth and development?

Can the effectiveness of an art program be evaluated?

A considerable body of material has been published on art experiences as related to child growth and development. There is no shortage of material on processes in making art, and on suggestions for art projects considered suitable to different ages.

Relatively few curriculum guides in art face the problem of helping teachers identify attainable goals, and in preparing a means of attaining those goals.

The handbook for the Racine teachers emphasizes the importance of establishing goals for the elementary art program based on the kind of art-released behaviors expected of children. These clearly defined goals are set and suggestions are given to help classroom teachers understand how to grow in understanding, knowledge and skills as related to these major goals.

The intent of the handbook is that it will help classroom teachers understand how to put into practice these related aspects of the art program:

I. The Making of Art

 how children derive ideas for art;

 how children can learn the grammar of art and apply art elements and art principles in their work;

 how and to what extent skills and techniques in the use of art media ought to be developed.

II. Learning to See and Feel

 how children can become more aware, more perceptive, more sensitive to environment.

III. Learning to Understand Art

how children can learn the importance of art as a part of man's cultural heritage;

how children can understand the contributions of painters, sculptors, architects, craftsmen, to our own and past societies.

If clarification of the above aspects of an art program can be made, perhaps classroom teachers will be better able to see the interrelatedness of goals, and perhaps goals themselves will take on different meaning. For goals are meaningless unless they serve as guideposts, directing us to some place.

In order to place emphasis on the importance of selectivity and the orderly planning of art experiences, five major involvements of classroom teachers are suggested, each of which is fundamental.

PLANNING ART EXPERIENCES FOR CHILDREN INVOLVES

I. IDENTIFICATION OF MAJOR OBJECTIVES

These are goals toward which all instructional effort is directed.

II. ESTABLISHMENT OF PRIORITIES

Within the framework of the Major Objectives some things are identified as more important to be taught than others. Priorities are established as a means of implementation of Major Objectives.

III. ESTABLISHMENT OF OPERATIONAL OBJECTIVES

Sub-goals directed toward Major Objectives

Within the framework of MAJOR OBJECTIVES and ESTABLISHED PRIORITIES, Operational Objectives are established in terms of yearly achievement expected.

"By the time children are ready to move from one unit or grade to another, we can expect that..."

IV. LESSON PLANS

Within the framework of MAJOR OBJECTIVES, ESTABLISHED PRIORITIES, and OPERATIONAL OBJECTIVES, Lesson Plans are developed.

Lesson Plans reflect behaviors expected and include: operational strategies, procedures, performance criteria, evaluative techniques, visual and enrichment materials, as well as working materials.

V. UNIT PLANS

Lesson Plans may be developed within a framework of Unit Plans. A unit may consist of few or many lessons taught consecutively and directed toward a specific goal. A unit is directed toward achievement of Major Objectives and helps provide for a continuity of learning.

I. Major Objectives

The goals toward which all instructional effort is directed are identified as Learning to Make Art; Learning to See and Feel; Learning to Understand Art. Teachers are asked to accept some basic premises:

BASIC PREMISE I LEARNING TO MAKE ART involves LEARNING TO SEE AND FEEL and LEARNING TO UNDERSTAND ART.

MAKING ART involves learning to derive ideas for subject matter. Children can learn, through SEEING and FEELING, to translate their own experiences into practical form.

MAKING ART involves understanding the grammar of art and learning to achieve art quality in their own work.

MAKING ART involves developing skills and techniques in use of art media.

BASIC PREMISE II LEARNING TO SEE AND FEEL is involved in LEARNING TO MAKE ART and in LEARNING TO UNDERSTAND ART.

SEEING involves the education and training of vision. There are ways children can be helped to grow in sensitivity to environment and enjoyment of beauty. Calling attention to seeing art elements in the immediate world is a means of training the senses of sight and touch.

FEELING is involved in emotional reactions to elements of art; excitement of certain colors and color combinations, repulsion to some touch sensations, joy of seeing and feeling such things as a sunrise or sunset.

BASIC PREMISE III LEARNING TO UNDERSTAND ART is involved in LEARNING TO MAKE ART and in LEARNING TO SEE AND FEEL.

Becoming familiar with works of art and becoming knowledgeable about the world of the artist are important aspects of art learning. Relating the contributions of artists in different societies and cultures is a means of learning to understand art. Training the vision and encouraging children to look and see are necessary to full enjoyment and understanding of art.

II. Priorities

It is suggested that the real and imagined world of the child affords unlimited subject matter for motivating art lessons and that children usually

make their best statements when they express ideas from firsthand experience. Children convert ideas into pictorial form through the use of color, line, shape, texture, light and dark. They can learn to organize ideas and to use such art principles as contrast, repetition, variation, rhythm, pattern, space and depth. Children can learn certain skills and techniques necessary to control art materials with which they work.

The chart of priorities in Figure 5-1 helps the classroom teacher see how fundamental it is to insure that provision be made for learnings in all three aspects of art.

SUBJECT: learning how to originate or derive ideas.

THE GRAMMAR OF ART: Learning to convert ideas into pictorial form through use of art elements and principles.

ART MATERIALS: developing skills and techniques in use of media.

III. Establishment of Operational Objectives

While this is admittedly one of the most controversial aspects of the application of behavioral objectives to the planning of experiences in art, we can no longer afford the luxury of refusing to be specific about what we expect children to learn. The important point is that within specifics we retain flexibility. In the Handbook, operational objectives have been developed somewhat loosely, but at least an attempt has been made to list, in hierarchical order, some learnings which can be expected at each grade level K-6.

For purposes of explication, three examples of expected art learnings are presented in summarized form, one from each of the categories of the priorities chart.

Subject Matter - What Children Can Learn - Figure Drawing

If children have had a continuum of experience and motivation to use the human figure in pictorial statements, by the time they leave sixth grade they should be able to:

1. Draw recognizable human forms.

2. Differentiate sizes of people.

3. Show bodily movement in the figure.

4. Include details of body such as hair, eyebrows, eyelashes, noses, lips, ears, fingers, toes.

5. Include details of clothing such as buttons, zippers, shoes, shoelaces, hair ribbons, collars.

6. Include specific design and decoration of clothing such as pattern, texture, prints, plaids, color.

7. Show front, profile, and back views.

SUBJECT MATTER	THE GRAMMAR OF ART	THE MATERIALS OF ART	
Children can learn to derive ideas for art from the real and imagined world, from their experiences, memories, and fantasies.	Children can learn to convert ideas into pictorial form through use of ART ELEMENTS.	Children can learn skills and techniques in use of basic two-dimensional art media.	Art elements, principles, skills and techniques are involved in three-dimensional crafts projects as well as two-dimensional pictorial work.
The World of Nature	COLOR	WAX CRAYON	PAPIER-MACHE
	LINE	COLORED CHALK	FOUND MATERIALS
PEOPLE	SHAPE	TEMPERA	BOXES
	TEXTURE	WATERCOLOR	CANS
ANIMALS	LIGHT & DARK	PENCILS	CARTONS
		BALLPOINT PEN	BOTTLES
PLANTS		INK WITH WEEDS, STICKS, PENS, BRUSHES	WIRE
	Children can learn to organize art elements to achieve compositional quality by using ART PRINCIPLES.	CHARCOAL	STRING
The World of Man-Made Things		GRAPHICS MEDIA	WOOD
		CUT PAPER & COLLAGE	PAPER
			CLAY
BUILDINGS	CONTRAST	Any of the above may be used in combination.	FIBER
			WOVEN MATERIAL
VEHICLES	REPETITION		FABRIC
MACHINES	VARIATION		
	ALTERNATION	SURFACES	
	BALANCE		
Subjects may be represented in a specific place or in an environment.	RHYTHM	NEWSPRINT - WHITE	
	Children can learn to use art elements and principles to create	NEWSPRINT - DAILY WITH PRINTED SURFACE	
EARTH		NEWSPRINT - COLORED	
		BROWN KRAFT WRAPPING PAPER	
SEA		MANILA DRAWING PAPER	
SKY	COMPOSITION	ODD KINDS OF PAPER	
	DESIGN	"FOUND" PAPERS	
THE WORLD	PATTERN	WHITE DRAWING PAPER	
		COLORED POSTER PAPER	
THE UNIVERSE	SPACE & DEPTH	COLORED CUTTING PAPER	

Regardless of the SUBJECT and the MEDIA, ART ELEMENTS and ART PRINCIPLES are involved in all problems.

FIGURE 5-1. IDENTIFICATION OF PRIORITIES FOR ART TEACHING IN THE ELEMENTARY SCHOOLS
MAJOR OBJECTIVE I. LEARNING TO MAKE ART MEANS OF PROVIDING LEARNING CONDITIONS AND GENERATING TEACHING STRATEGIES

8. Draw figures seated, lying down, and in action poses — walking, running, sport activities, working.

9. Overlap, or show figures behind and in front of other figures.

10. Understand relationship of placement of facial features, eyes, ears, nose, lips.

11. Show bending of joints: knees, elbows, hips, ankles, wrists.

12. Draw the human figure with parts in natural relationship: arms growing out of the shoulder, legs as an extension of the hips, head attached to the shoulders by a neck.

13. Draw the human figure as a solid form with suggestion of roundness in the parts: head, torso, arms, legs.

14. Be aware of variations such as tapering of the forearm from the elbow to the wrist, tapering of the leg from knee to ankle.

15. Put figures together in groups showing varied poses, overlapping, and front, back and profile views.

16. Differentiate between adults and children.

17. Represent individual characteristics of people.

Bodies:	Hair:	Lips:	Noses:
tall,	long,	thin,	wide,
thin,	short,	thick	narrow,
short,	curly,		long,
heavy	straight		short.

18. Depict emotions such as happiness and sadness through facial expression, and through body poses.

19. Show varied skin colors and colors of eyes and hair.

The Grammar of Art - What Children Can Learn - Color

In the Handbook it is emphasized that learnings about COLOR as an art element will be related to MAKING ART, LEARNING TO SEE AND FEEL, LEARNING TO UNDERSTAND ART. Color learnings are a means to helping children become more competent in working with art media to express ideas, develop increased sensitivity and awareness, and relate color understandings to observation of works of art. In all grades teachers are encouraged to place emphasis on enjoyment and use of color rather than memorization, rote recognition, and formal teaching of factual information.

Through enjoyment and pleasure in using color, searching for and visually enjoying color, and applying color understandings, it is expected that by

the time children leave sixth grade they should know and be able to apply in their art work these concepts:

1. We live in a world of varied color.

2. Some colors are similar, some are different.

3. Some colors suggest warmth, others suggest coolness.

4. Compositions can be made more interesting if colors are repeated and varied: some colors light, some colors dark; some colors dull, some colors bright.

5. Three colors cannot be made by mixing: yellow, red, blue. These are called **PRIMARY COLORS**.

6. Primary colors are mixed to make **SECONDARY COLORS**: orange, violet, green.

7. Many colors can be obtained by mixing.

8. White and black are not colors.

9. Brown is a shade of red, orange, or yellow. Browns may also be of violet, green, blue.

10. By adding a little color to white a light color is made. This is called a tint.

11. By adding a little black to a color a dark color is made. This is called a shade.

12. A light color can be made to stand out by surrounding it with a darker color.

13. Colors can be grayed or made less intense by adding other colors.

14. Bright colors are changed or destroyed by adding different colors or by using brushes that aren't washed or brushes that contain other colors.

15. Colors change when put on different kinds of surfaces.

16. If colors are applied so that some of the surface shows through, the colors will appear weak or less brilliant.

17. If colors are applied so that the surface is completely covered, the colors will be strong or more brilliant.

18. Colors look different in different kinds of light; bright, sunny days, dark, rainy days; bright, summer days, snowy, winter days; early in the morning, at midday, late in the afternoon.

19. The same colors look different when seen nearby and at a distance.

20. Colors are described in three ways:
 HUE refers to the name of the color,
 VALUE refers to lightness or darkness;
 INTENSITY refers to brightness or dullness.

21. The standard color circle consists of the three primaries and the three secondaries.

22. COMPLEMENTARY colors are opposite colors on the standard color circle.

23. Maximum contrast is achieved by placing complements side by side.

24. Mixing complements grays or dulls the color, or reduces the intensity or brightness of the color.

25. INTERMEDIATE or TERTIARY colors are derived by mixing secondaries with neighboring primaries.

26. ANALOGOUS colors are neighbors, or side by side, on the standard color circle.

27. MONOCHROMATIC COLORS refer to one hue in various tints and shades, or one hue ranging from light to dark.

28. Colors need not always be used realistically. Colors can be used intuitively, and imaginatively to express feeling, fantasy, or the dream world.

29. Children can learn to SEE color and to be aware of the infinite variations of color everywhere; in clothing, growing plants, buildings, vehicles, and animals; in sunsets, rainbows, reflections.

30. Children can learn that colors make us FEEL, and create certain moods: joy, excitement, sadness.

31. Through observation of works of art, children can learn how artists use color.

The Materials of Art - What Children Can Learn - The Drawing Pencil

Children can learn skills and techniques necessary to control the art materials with which they work. In the Handbook it is suggested that there are many things children can learn through experience with the commonplace drawing instrument - a pencil. (Learnings are also specified for other media.)

Characteristics
1. A pencil can make varied sizes of lines: thick, thin, broad, narrow, fat, skinny, light, massive.

2. A pencil can make lines of varied texture: smooth, rough, velvety, harsh, fluffy.

3. A pencil can be used for making outlines, shading, filling solid areas.

4. A pencil is a non-cumbersome drawing medium and is conducive to spontaneous work.

5. Pencil can be used on different surfaces, but pencil lines vary depending on the surfaces on which they are made.

6. There are different kinds of drawing pencils, ranging from soft to hard leads.

Skills and Techniques Children Can Learn

1. When the point of a pencil is pulled across the paper a thin line is made.

2. When the point of a pencil is pushed down onto the paper and lifted a dot is made.

3. When the side of the pencil lead is pulled across the paper a thick line is made.

4. Increased pressure creates darker lines.

5. Decreased pressure creates lighter lines.

6. A line with an irregular thickness can be made by alternating from the point to the side of the lead.

7. A line with an irregular darkness and lightness can be made by varying the angle of the pencil lead.

8. A pencil can be used to cover an area solidly with a single darkness or lightness.

9. A pencil can be used to cover an area with a gradual change from dark to light.

10. A pencil can be used to cover an area with an irregular change of darkness and lightness.

11. Shadows can be depicted with pencil by making broad lines with the side of the pencil lead.

12. Shadows can be depicted with pencil by covering the shadowed area with dots, parallel lines, cross hatching or a combination of these techniques.

13. A pencil can be used to make texture rubbings.

14. A pencil can be used for planning.

Finally, the Handbook suggests that we can identify and evaluate the art work of children by:
> originality of idea or concept,
> compositional quality,
> skills and techniques in use of materials.

Evaluation of art work must be based on objectives and on performance criteria established in outlining each individual lesson. In all evaluation the child's age, maturity, and individuality are to be considered. Evaluation is concerned with all aspects of the learning situation: the teacher's presentation, the individual child's response, the response of the group.

Teachers are asked to plan art lessons to insure that the following are clearly detailed: Performance Criteria: Product (What *acts* we want the child to do); Quality (Art Elements and Principles involved); Process (How will it be done? Media involved); Condition (Working condition, derivation of ideas).*

There is considerable evidence that classroom teachers are becoming increasingly aware of the need for establishing goals, and the importance of directing effort toward realizing goals. In progress is an attempt to develop some assessment instruments which will help us understand the extent to which children are reaching some of the specific learnings expected.

*The Handbook gives examples of lesson plans based on the materials used in the Pre-Conference Research Seminars as developed by Dr. Asahel Woodruff.

CHAPTER VI

CHANGING BEHAVIORS THROUGH
THE DEVELOPMENT
OF AESTHETIC AWARENESS

Corinne Loeh
School District U-46
Elgin, Illinois

"Recognition, relevancy, humanness!" These were the cries of a Sputnik generation caught up in an onrush of science, mathematics, space and war. These were the cries of a generation screaming for a birthright; a birthright allowing individuals to become sensitive human beings with feelings for art and love and equality. These were the cries of a generation sickened by the wholesale pollution of the land, the skies and the streams. Yes, these cries came from the kids with long hair, mini skirts and peace symbols. The cries came from kids who have been fed art in doses composed of pattern turkeys, scribble drawings and snowflake snowmen, seasoned with gimmick processes and junk collages—all administered by a classroom teacher who exclaimed, "How cute!"

But children do not retain their youthful vigor forever. Time molds the future. Almost as if by magic, the outward, superficial icons of an age disappear.

And, so it was with the Sputnik kids. Although the skirt lengths and the hair styles have changed, the inner convictions which they developed, remain. The rebellious ones have matured into highly educated adults with keen sensitivity for the dignity of human beings. They are committed to "righting" the wrongs of the world and replacing lies and insincerity with integrity and truth. Art has become an important part of this philosophy since art is probably one of the most sincere and truthful avenues of human expression. Sputnik parents will not be content to offer their children the same mickey mouse, make-shift misrepresented art experiences, which they once had.

In recent years, emphasis has been placed on humanistic education. However, the value of *good* art experiences in total education is under-rated.

There are still classroom teachers, in American schools, who persist on presenting art to children in an untrue light. Some continue to stress ART

successes as following directions, coloring neatly within drawn lines or just "making anything you want." There are those who teach "art appreciation" tinged with prejudicial judgments about works of art which they do not understand.

In the sixties, some studies were conducted to determine the status of art education in our schools. Very little has changed since that time.

An NEA study shows that the regular classroom teacher is expected to teach art without help from a specialist in over half the elementary schools reporting. The data also indicated that over sixty percent of the schools did not require teachers to have ability to teach art as a condition for employment. Only one quarter provided specialist help and art was taught by specialists in less than ten percent.[1]

According to a report by Elliot Eisner, of a group of about 1,000 students representing schools in the west, mid-west, and east, from the ninth grade to the senior year in college; sixty-three percent did not know the meaning of the word "hue'; seventy percent did not know what the word "value" means; over seventy-five percent did not know what the word "medium" referred to. More than fifty percent thought Rembrandt was either Italian of French.[2]

Accountability has been with us for some time now. Nevertheless, art programs, especially in the elementary schools, continue to lag behind. Perhaps the time has come to recruit the Sputnik parents. They respect art and know how it can change and effect human behavior.

When art educators define goals and objectives, determine content, develop sequences and suggest methods of implementation, they will be able to sit down with our Sputnik parents and discuss the situation with people who will buy quality education for their children if they know what they are going to get for their dollar.

According to Asahel Woodruff, behaviors are the real goals of education. He describes a human being as a true energy system, whether viewed in terms of its total biological operations or merely in terms of the less comprehensive cognitive behavioral operations within the larger whole. "Education is aimed particularly at the cognitive-affective portion of the whole.".[3]

Woodruff provides a cyclical model for behavior in Chapter I (Figure 1-5) with a point of caution. He explains that the model of behavior exemplifies the way a person normally interacts with his non-school environment.

> *The school environment interferes seriously with the operation of the full cycle and thus rarely succeeds in shaping the non-school behavior of students. If we mean to have formal education affect out-of-school behavior, we will have to find ways of changing formal educative patterns so they become like out-of-school situations in that they are capable of activating the critical parts of the behavior cycle but do it with greater purpose, selectivity, and effectiveness than*

random out-of-school behavior. This is actually the crux of most of the reforms now underway in education.[4]

Again, *behaviors are the real goals of education.* Robert Mager defines behaviors "as any visible activity displayed by a learner."[5] Behaviors are overt and visible. They do not refer to some inner attitude or incubating experience which cannot be observed. They are brought about by the influence of mediating variables and the mediating variables arise from behaviors themselves----so----the cybernetic cycle of human behavior is in continuous motion with mediating variables being cumulatively formed and altered as a person interacts with his environment.

> *It may be added that the failure of school programs to affect non-school behavior is due to the failure of school programs to include the critical empirical interactions. School work is generally limited to a verbal exchange, with a limited amount of sensory perception and with almost no real empirical feedback from attempted adjustive behaviors based on the use of what is learned.*[6]

Art experiences, by their very nature, allow a real vent for the cybernetic cycle to operate. It is logical to conclude, then, that an art program planned to operate behaviorally would include learning situations which provide:

- something to perceive
- something to interrelate to other learnings
- something to induce the learner to apply his learning to real situations

The teacher would then act as a prompter rather than an actor aiding in the operation by giving guidance to effectively shape future performances stemming from the current behaviors.

Let us move momentarily, now, from behaviors to aesthetics. Aesthetic education is a basic element for meaningful living.

The good life, not science, not the humanities, not the arts, is the purpose of general education. We justify aesthetic education because aesthetic experience does contribute to well-being in a unique way, by giving aesthetic satisfaction and by intensifying and perhaps illuminating every other mode of experience.[7]

In the beginning of aesthetic awareness there is a consciousness of colors, shapes, textures, movements, lines and forms, also, a sensitivity to the way objects smell, feel, look, sound, and taste. When aesthetic awareness attains a high level, what was there intuitively, remains but is felt and understood with greater intensity and conviction. Coupled with this, comes a commitment to art "as an elemental instrument in deepening life."[8] "Although the sciences provide the means through which man achieves survival, the arts are what makes survival worthwhile."[9]

Broudy[10] expresses the belief that schools can contribute toward the systematic development of high level aesthetic judgment through:

(1) sensitivity training concerning the technical aspects of art ... categorized in *The Awareness Program* as *craftsmanship, a successful and skillful use of art tools and materials.*

(2) sensitivity training concerning the formal properties of art ... comparable to *The Awareness Program's design, a sensitive use of art elements and principles.*

(3) sensitivity training concerning expressiveness ... found in *The Awareness Program* as *the power of art, a force which evokes response, influences, predicts, releases, affects, predicts, releases, affects, changes, communicates, expresses.*

Along with the three above aspects of aesthetic awareness, *The Awareness Program* adds:

(4) sensitivity training relating to environmental and cultural influences in art, designated as *cultural art, a reflection of the culture and age from which the art originated* ... and

(5) sensitivity training dealing with the inventiveness of man presented as uniqueness, people "thinking new" and creating visual statements in individual ways.

Aesthetic awareness *is* the business of the schools and education because it affects man and his environment. Training can produce greater sensitivity and bring about a change in man's behaviors.

The aesthetics of our surroundings are a clue to a pervasive lack of concern not only for the character of appearance of the world around us but the quality of our collective integrity. Is it, I wonder, mere unrelated coincidence that the aesthetics of Main Street in every community of America are represented by a tangle of telephone wires illuminated by neon glut and ... simultaneously ... that American soldiers are charged with a massacre in Vietnam?[11] ... and that this same kind of attitude reveals itself in the highest offices of the land, as corruption and dishonesty surface before an unsuspecting public?

My purpose, thus far, has been to introduce two major categories of The Awareness Program In Art and to establish the *importance* of both *behaviors* and *aesthetics* in a *total* educational program.

My own involvement in three institutes: the NAEA Pre-conference Institutes in St. Louis and New York in 1968 and 1969 and the Florida State Research Institute concerning evaluation in the arts led me to discover a natural affinity between the two entities which I have described. Perhaps I maneuvered aesthetics and behaviors into a marriage and now they have produced an offspring—an art program entitled Changing Behaviors Through the Development of Aesthetic Awareness, shortened to The Awareness Program. The model for this program is shown in Figure 6-1. A Process Model

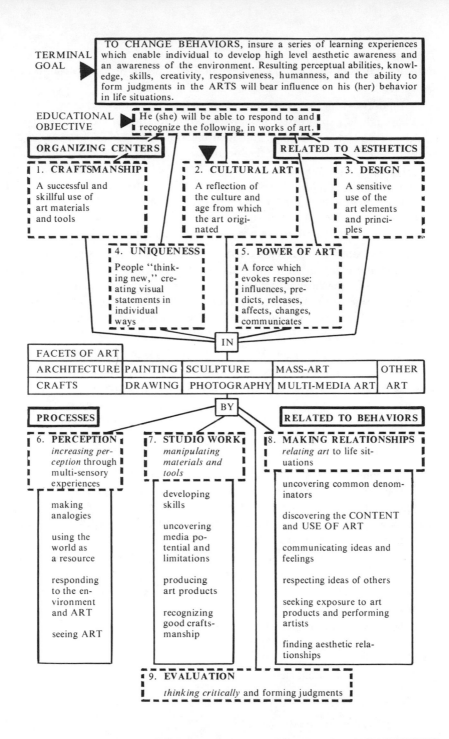

TERMINAL GOAL ▶ **TO CHANGE BEHAVIORS,** insure a series of learning experiences which enable individual to develop high level aesthetic awareness and an awareness of the environment. Resulting perceptual abilities, knowledge, skills, creativity, responsiveness, humanness, and the ability to form judgments in the ARTS will bear influence on his (her) behavior in life situations.

EDUCATIONAL OBJECTIVE ▶ He (she) will be able to respond to and recognize the following, in works of art.

ORGANIZING CENTERS ▼ **RELATED TO AESTHETICS**

1. CRAFTSMANSHIP
A successful and skillful use of art materials and tools

2. CULTURAL ART
A reflection of the culture and age from which the art originated

3. DESIGN
A sensitive use of the art elements and principles

4. UNIQUENESS
People "thinking new," creating visual statements in individual ways

5. POWER OF ART
A force which evokes response: influences, predicts, releases, affects, changes, communicates

IN

FACETS OF ART				
ARCHITECTURE	PAINTING	SCULPTURE	MASS-ART	OTHER
CRAFTS	DRAWING	PHOTOGRAPHY	MULTI-MEDIA ART	ART

BY

PROCESSES **RELATED TO BEHAVIORS**

6. PERCEPTION
increasing perception through multi-sensory experiences

making analogies

using the world as a resource

responding to the environment and ART

seeing ART

7. STUDIO WORK
manipulating materials and tools

developing skills

uncovering media potential and limitations

producing art products

recognizing good craftsmanship

8. MAKING RELATIONSHIPS
relating art to life situations

uncovering common denominators

discovering the CONTENT and USE OF ART

communicating ideas and feelings

respecting ideas of others

seeking exposure to art products and performing artists

finding aesthetic relationships

9. EVALUATION
thinking critically and forming judgments

FIGURE 6-1. ORGANIZATIONAL PLAN FOR AN AWARENESS
PROGRAM IN ART

and An Elaboration Chart of Component Tasks in the Process Structure follow in Figures 6-2 and 6-3 respectively.

Figures 6-1, 6-2, and 6-3 have demonstrated the way behaviors materialize through four processes: perceiving, manipulating materials and tools, relating learnings, criticizing, and forming opinions and judgments. What about aesthetics? How can the five organizing centers which make up the top half of the program model provide an aesthetic base for learning? The answer lies in using each organizing center as a springboard for concepts. *Conceptual statements* become the substance for UNITS which are made up of a series of behavioral objectives. The behavioral objectives set the four processes into motion and result in observable behaviors on the part of the learner.

The conceptual statements used in this program are vague, nebulous ideas until the learning situations described within the unit clarify, expand and personalize the original statement enabling it to become a meaningful idea in the mind of the learner. His understanding of the concept can usually be evidenced by observable acts which he performs. A CONCEPT CORE MODEL for THE AWARENESS PROGRAM is shown in Figure 6-4.

Since most concepts can be "grasped" by children if a continuum is built from simple to complex, the next step is at hand: to seek methods for building such continuums and arranging sequences of content material.

Bloom,[13] Krathwhol[14] and their associates have provided a categorization of domains within which all learning takes place. Art activities encompass all three of these domains: the cognitive domain, the affective domain and the psychomotor domain.

This concept can be shown graphically (Figure 6-5) as a growing tree with roots already formed before a child enters school. Thus, learning can be shown as a tree set against a background of ever-expanding complexities, promoting the maturation of that child and sending its branches into space and reaching for what is there - satisfying a child's curiosity.

Focal points, arranged according to the levels shown on the hierarchal learning tree, provide content sequences from which to work. Space will not allow full reproduction of the total chart; however, a small section is shown in Figure 6-6.

The ingredients for an awareness program have been assembled:

1. a program model

2. two major categories

3. four processes to incite behaviors

4. an aesthetic core

5. a continuum plan for experience increasing in complexity and building in content.

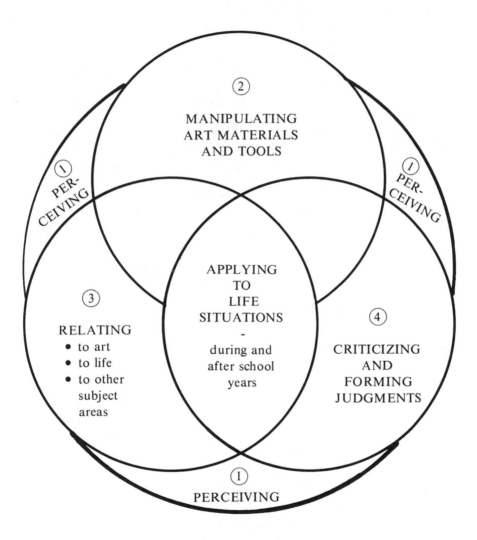

FIGURE 6-2. FOUR PROCESSES

1. INCREASING PERCEPTION THROUGH MULTI-SENSORY EXPERIENCES	2. MANIPULATING MATERIALS AND TOOLS	3. RELATING ART TO LIFE SITUATIONS - OTHER SUBJECT AREAS	4. THINKING CRITICALLY AND FORMING JUDGMENTS
Seeing, hearing, touching, feeling, smelling - using the world as a resource	Thinking through and planning materials • procedures • functions • organization	Uncovering common denominators through involvement in inter-disciplines	Making decisions regarding a choice of symbols or ab-stractions to use for graphic com-munications (i.e.: geometric symbols used by young children)
	Developing skills through • practice • recall • review • application	Discovering the CONTENT and USE OF ART through • cognitive learnings • recall • review • experiences with art objects • making compari-sons	Making decisions concerning the use of materials and techniques (See # 2)
Responding to the environment and art - • seeing art • making analogies • finding contrasts • experiencing art by making it; feeling it, physically, emotionally or kinesthetically	Producing art products by making art	Communicating ideas and feelings by • empathic (affective) understanding with artists • making art • verbalization	Choosing subjects for art ex-pression
	Uncovering media potential and limi-tations through • exploring • discovering • designing		Making aesthetic choices in life (i.e.: what to wear, how to arrange furniture, etc.)
		Respecting ideas of others through sharing, verbally and visually	
	Recognizing good craftsmanship through • working with materials • exposure to art • cognitive learn-ing	Finding aesthetic re-lationships in experi-ences, art and nature	Judging the value of works of art - through critiques, rating scales, etc.
		Seeking exposure to art products and to performing artists	Deciding how to preserve or change the environment
TEACHER USING the world, pictures, charts, movies, stories, events, models (nothing verbal)	TEACHER USING projects, tasks, activities	TEACHER USING thought processes, identifying links between acts and their consequences	TEACHER USING life application as much as possible with real situations or simulated situ-ations

FIGURE 6-3. AN ELABORATION CHART OF COMPONENT TASKS IN THE PROCESS STRUCTURE

A key to success lies with the choice and statement of concepts. Most art concepts can be "grasped" by children if a continuum is built from simple to complex.

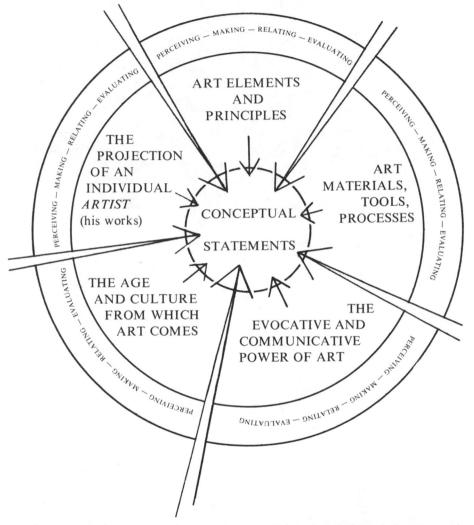

A conceptual statement (sentence concept) is a description of the properties of a process, structure, or a quality, stated in a form which indicates what has to be demonstrated or portrayed so a learner can perceive the process, structure or quality for himself.

FIGURE 6-4. A CONCEPT CORE FOR AESTHETICS

AFFECTIVE DOMAIN

COGNITIVE DOMAIN

Level 14 - Organizing Values (5.2, up)

Level 14 - Evaluating (6.2, up)

Level 13 - Valuing (4.0)

Level 13 - Evaluating (6.0)

Level 10 - Valuing (3.0)

Level 10 - Synthesizing (5.0)

Level 8 - Responding (2.7)

Level 8 - Analyzing (4.3)

Level 6 - Responding (2.3)

Level 6 - Applying (3.0)

Level 3 - Awareness (1.7)

Level 3 - Comprehending (2.0)

Level 1 - Awareness (1.3)

Level 1 - Knowing (1.3)

Level 0 - Receiving (1.0)

Level 0 - Knowing (1.0)

THE HIERARCHICAL LEARNING TREE: Levels of learning, in each domain, are indicated by numbers and horizontal lines. Level numbers correspond closely to graded levels. Decimals are from Bloom's taxonomy. Although the predominant flow of learning is upward because of increased complexity, there is always some flow in both directions.

The tree symbolizes growth. Multiple small lines on the lower branches represent short primary experiences which become fewer but longer, more complex, at the upper levels.

FIGURE 6-5. THE HIERARCHICAL LEARNING TREE

ART EXPERIENCES IN THE ELEMENTARY SCHOOLS
STEM FROM THE FOLLOWING SUBJECTS

PEOPLE	ANIMALS also:	
OBJECTS	birds, fish, insects	
MACHINES	amphibians, etc.	

AND INVOLVE THESE ASPECTS OF SIX ART ELEMENTS

| LINES | FORM AND SHAPES | COLORS |

LINES	FORM AND SHAPES	COLORS
0-like/different	0-designed/accidental	0-factory/artist
0-long/short	0-dot/spot/box	0-dull/bright
0-straight/curved	0-thick/thin	0-black/white
	0-big/little	0-like/
	0-open/closed	different
	0-old/new	
1-heavy/light	0-large/small	
1-thick/thin	0-alike/different	
1-happy/sad	0-happy/sad	
1-foreground/back-	0-original/copied	1-hues/neutrals
ground		1-primary/
1-clustered/un-	1-foreground/back-	secondary
clustered	ground	1-man-made/
1-man-made/	1-clustered/un-	natural
natural	clustered	1-happy/sad
1-sky/base	1-patterned/plain	1-dark/light
	1-man-made/natural	
	1-2D/3D	
	1-important/unimportant	
2-radiating/closing	(center of interest)	2-strong/weak
2-bent/straight		2-planned/un-
2-simple/complex	2-related/unrelated	planned
2-active/static	2-imaginary/real	2-repeated/
2-jagged/smooth	2-strong/weak	non-repeated
2-strong/weak	2-worn/unworn	2-contrasting/

Continued

FIGURE 6-6. ART EXPERIENCES IN THE ELEMENTARY
SCHOOLS

Curriculum writing begins with these ingredients and a reexamination of over-all objectives. To assist in the reexamination of objectives, an "Objective" model (Figure 6-7) was developed and its specific application to The Awareness Program is shown in Figure 6-8.

Behaviors today are in "full swing" but behavioral objectives are not so easy to "come by." Units of instruction which are composed of behavioral objectives are even more difficult to produce. The whole process usually requires a change in the manner of thinking, and writing improves with practice; so, you see, the marriage of behaviors and aesthetics is in for some "rough sledding" and much work.

Woodruff anticipated some of the problems when he said:

> *The traditional concept of education is composed of a set of parts that fit together much as the parts of a gasoline-powered piston engine fit together. The new concept of education is as different from the old as a jet engine is from the piston engine. It is composed of a different set of parts.*[15]

Presently, behavioral objectives are being designed by members of the elementary art staff, and the first phase of The Awareness Program is being implemented in the School District U-46, Elgin, Illinois. The objectives are being written for use with classroom teachers who are still responsible for the major share of the elementary art program in the Elgin schools.

Art teaching is a cooperative venture carried out by the classroom teachers and the art teacher-consultants who make scheduled visits to classrooms and perform three-fold service: doing demonstration teaching, working with classroom teachers and developing curriculum ideas for the district, with the art director.

The district art director operates as a master teacher who works with the staff. She directs the development of guideline materials, conducts in-service training sessions, prepares supplementary materials, helps build resources, edits and supervises the writing of behavioral objectives and other curriculum materials submitted by the staff after work sessions. The director performs in numerous other ways: informing the community, coordinating all levels of art instruction, and so forth.

In time, through in-service, when classroom teachers develop greater understanding and skill in writing and using behavioral objectives, it is hoped that they will be able to assist in the transformation of units into the necessary reading vocabulary for various levels of students, thus enabling some students to operate "on their own" from a wide range of choices within the structure and sequence of the program, and under the guidance of a special art person.

> *Perhaps the most vital change in practice required to make the new system operate is found in the role of the student. It hinges on freeing him from dependence on the teacher as an initiator of his*

TERMINAL GOAL

long range - broad - terminates a learning experience
- requires a long period of time, perhaps years

EDUCATIONAL OBJECTIVE

an aim for some particular segment of the
terminal goal - terminates sooner, in a
week, a month, a year

BEHAVIORAL OBJECTIVE

concise - clear - realistic - attainable
in short period of time - as short
as a few minutes - identifies
specific observable behavior
of the learner

to the point

FIGURE 6-7. GOALS- OBJECTIVES (DEFINED)

TERMINAL GOAL

TO CHANGE BEHAVIORS, insure a series of learning experiences which enable each individual student to develop high level aesthetic awareness and an awareness of the environment. Resulting perceptual abilities, knowledge, skills, creativity, responsiveness, humanness, and the ability to form judgments in the ARTS will bear influence on his(her) behavior in life situations.

EDUCATIONAL OBJECTIVE

At three different exit levels (Ages 9, 13, 17) the student will show show that he has increased his ability to respond to and recognize the following in works of art: craftsmanship, cultural art, design, uniqueness, and the power of art.

At three different exit levels (Ages 9, 13, 17) the student will be able to demonstrate increased perception, greater skill in handling art tools and materials, more ability to interrelate the arts and life and more confidence and ability in evaluating and forming judgments about art.

EXPERIENCE OBJECTIVE

Through involvement in a progression of experience units in art at each exit level (Ages 9, 13, 17) the student will be able to demonstrate specific accomplishments designated in those units.

FIGURE 6-8. GOALS AND OBJECTIVES OF THE AWARENESS PROGRAM

next learning venture and as a presentor of information which are to ingest as it is dispensed.[16]

The immediate requirement to make this change is a complete package of learning materials which he can obtain at his own initiative and through which he can move at his own direction.

A resulting writing model for The Awareness Program is shown in Figure 6-9, and criteria are given in Figure 6-10. An example of a short unit entitled Rhythmic Patterns Show Repetition and Variation is presented in Figure 6-11.

As you examine the unit, notice that it has been written in a way to provide points of focus but that there is no restriction on other creative discoveries which take place. Individual expressiveness is encouraged and stimulated.

> *The simultaneous change of all parts of a curriculum is a practical impossibility. "It might be accomplished in a laboratory school under the control of a research staff, but not in a typical public school. It will be years before the rationale of the present revolution is generally understood and the new machinery is generally available for installation. The labor involved in rebuilding the machine is almost overwhelming.'*[17]

> *This means we have to produce rather quickly a set of sequenced learning packages, each a complete and self-contained, do-it-yourself operation. For the time being, while the supply is nonexistent, the venturesome teacher will have to prepare her own units. To do this while she also teaches her students under the old teacher-dominated dispensary process is more than a full-time task. The conversion will be slow; but each new package of learning materials will move the transition along, and the effect will be cumulative.*[18]

One evaluation instrument used in The Awareness Program involves a comparison of samplings of children's art work acquired in successive years. Topics for this work are carefully chosen to provide an opportunity for students to use the concepts learned through art. Check lists and profile charts are used to record the results.

In addition, performance indicators developed under the auspices of the Illinois State Art Consultants provide a means of identifying information and communicating this information to others for purposes of evaluation.

Indicators are written for three age levels (9, 13 and 17) and are the same student ages used by The National Assessment program. It is assumed that students of age 13 should be successful with the indicators on the age 9 level. And the 17 age group should be successful with both the age 9 and age 13 indicators.

Given below, are focus performance indicators which relate cognitively to the *Design* focus of *The Awareness Program.*

In order to provide necessary workability and usability, a consistent writing model was designed especially for use in THE AWARENESS PROGRAM.

THE heading of the model includes:

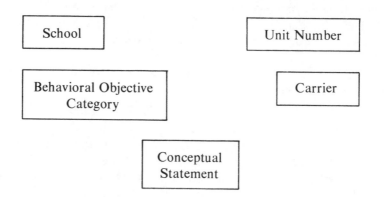

The body of the UNIT MODEL is composed of several behavioral objectives which begin with the statement:

> The student will be able to:

The statement is completed by telling how this student will:

- perform an act or acts
- involving certain aspects of art
- using suggested materials
- fulfilling specific conditions
- including vocabulary of art terms
- at a designated level in a sequence of experiences
- emphasizing experiences stemming from the cybernetic cycle of human behavior

 Note: Repeat as many times as necessary to complete the unit.

FIGURE 6-9. A MODEL FOR WORKING OUT SHORT UNITS

The total, integral experience composed of related behaviors is more important than any single behavior. Therefore, the short unit plan has been devised for use in objective writing.

Criteria for the composition of short units are:

1. The short unit will not involve a long period of time (weeks, months) although it will have a long range life application.

2. It will draw simultaneously from several fields of subject matter which are relevant to the given task.

3. It will include a "carrier" which is something which has appeal to the child and which carries learnings with it. It is something the child wants to do.

4. It will include several interrelated behavioral objectives.

5. The levels of learning will correspond to the levels of learning shown on the hierarchal learning tree. The level of the unit must be suited to the student's level of maturity.

6. The general concept will be presented as a complete statement, one or more sentences. The purpose of the unit will be to enable the student to grasp the meaning of the conceptual statement.

7. The unit will include the learning of far-reaching concepts, other than the general one.

8. It will engage the student in behaviors of the world.

9. It will foster initiative and creative thinking.

10. It must be written within the student's range of accomplishment.

11. It will result in a product the student wants.

12. The unit will be written according to the model used in The Awareness Program.

FIGURE 6-10. THE SHORT UNIT - CRITERIA

FIGURE 6-11. AN EXEMPLARY UNIT: RHYTHMIC PATTERNS SHOW REPETITION AND VARIATION

The student will be able to perform this act or acts	involving these aspects of art	using these materials
clap out	rhythmic patterns with repetition and variation	using his hands and the blackboard.
verbalize	about rhythmic patterns which have: • repetition • variation	using a comparison of hand clapping (musical rhythms) and visual rhythmic patterns found in wallpaper samples.
print wallpaper designs (See: PROCESS SECTION, GADGET PRINTING or another printing process)	showing: • repetition • variation	using gadgets, tempera, finger paint or printer's ink; one of the background surfaces suggested in GADGET PRINTING. (Background size about 18 x 24'')
role-play	applying aesthetic criteria • repetition to produce rhythm • variation to relieve monotony	using a sample wallpaper book made by combining examples from the art class.

FIGURE 6-11 (con't.) ORGANIZING CENTER: DESIGN

DISCOVERING GENERAL RHYTHMIC PATTERNS SHOW
CARRIER: LIFE PATTERNS CONCEPT: REPETITION AND VARIATION.

fulfilling these conditions	with this vocabulary	at this level	emphasizing this exper- ience type
The student will create a pattern of rhythmic clapping by: • REPETITION - repeating the same kind of clap and then illustrating the repetitive claps with drawings on the blackboard. • SIZE VARIATION - varying the loudness and softness of some claps and illustrating the variation by using large and small shapes. • SPACE VARIATION - claps (close or far apart) and show- ing this variation in blackboard drawings.	rhythm variation repetition size variation space intervals space variation	4	perceptual experience using hear- ing, sight- making analogies) cognitive (learning art terms)
The student will point out ways that rhythmic patterns are found in both music and art: • both have repetition • both have comparable variations of size - sounds intervals between shapes - sounds	rhythmic patterns	4	relational (music, art)
The student will choose color combina- tions which he considers appropriate for wall decoration. The student will show repetition in his art product by repeating the same line or shape in some order which he plans. The student will show variations of (1) size (2) space intervals in his design.	appropriate colors order plan design	4	manipulative (using a printing process) relational (applying aesthetics to home design)
The student will add his wallpaper design (including name of design, cost, etc. on the back) to a class collection which will become a wallpaper sample book. The student will role-play the part of a wallpaper salesman who is selling wall- paper by using a sample book (a com- posite book made from the class exam- ples). His sales talk will point out reasons for choosing a particular pattern. He will use the vocabulary included in this lesson. (Note: Suggest making a recording.)	wallpaper sample book	4	relational art, dramatics) manipulative critical (making choices) relational (relating art to life occu- pations, producing, selling, buying)

To what extent do the students demonstrate an understanding of basic art concepts:

Age 9 1. The student can identify the presence of elements of design in art objects (different lines, shapes, textures, or colors).

 2. The student can determine the type of balance used in an art object.

(SAMPLE) 3. The student can identify the characteristics that have helped in achieving unity in an art object.

 4. The student can identify the center of interest in an art object.

I do not contend that members of the art staff have discovered a panacea for our ills. It is my purpose here to describe what is being done about those ills in School District U-46, Elgin, Illinois; to give reasons for believing that this program has some merit since observable changes are occurring within the school system and in the community—even in this early stage in its life. There is evidence of:

1. CHANGE - IN (SOME) CLASSROOM TEACHERS' ATTITUDES. Don't think for one moment that we have convinced all of our classroom teachers, in a brief period of time that art could easily become a catalyst for a child centered educational program, because that is not true. Some of our teachers "close their eyes and ears" and do not even choose to remain in the classrooms when demonstration lessons are in progress, but we gain courage from the steadily increasing number of teachers who have become curious and interested in what is happening and are now choosing to remain in classrooms to learn what it is all about. We are encouraged by these teachers who are acknowledging the "content of art" and are slowly rejecting the former idea that art is a "how-do" consisting of a line of magic formulas which produce slick products for the bulletin boards in thirty minutes. We are pleased with their efforts to make art an integral part of learning.

 These classroom teachers are gradually building respect for the judgment of the art person's selection of subject matter. Demands for holiday bunnies, witches and Washington silhouettes are fewer these days and the classroom teachers are becoming somewhat less "slavish" to seasonal changes.

2. CHANGE - OBSERVED BY SOME JUNIOR HIGH SCHOOL ART TEACHERS, who contend that student attitudes are changing. Fewer students seem to think that "Art time is a goof-off time." Students are entering junior high school more knowledgable about art and

have some basic background in each of the five organizing centers which compose the aesthetic part of The Awareness Program when they enter junior high school.

3. CHANGE - IN THE QUALITY OF ART TEACHING by elementary art personnel in the elementary grades. This change is most pronounced probably because the greatest effort and time has been expended here. I feel that my accumulated years in art supervision entitles me to make an evaluation here.

 I have never, in these many years in art, seen so many, exciting, meaningful learning experiences taking place in art classes. Lessons are not being presented "off-the-cuff," in a haphazard manner, as a time-filler, as a baby-sitting activity. Each lesson has a point of focus, a place in a sequence of learnings. Kids are being "turned on" as they were never turned on before. Believe me, today's children know when something is worthwhile, and they eat it up. That sacred cow, creativity, isn't being lost at all—but is being sparked by challenging and diverse learning situations. Children do respond to learning "why" and "what for" as well as learning "how-to-do."

 District U-46 principals are supportive and interested in what is going on. Their wholehearted cooperation has enabled the Art Department to initiate innovative ideas in scheduling and teaching.

4. CONTINUED ADMINISTRATIVE SUPPORT. This has been a pillar of strength from the beginning but is even more so, now. The number of art teacher-consultants in the elementary schools doubled in three years. The elementary art staff is provided district work time to develop units, write behavioral objectives and to participate in in-service training.

5. GROWING INTEREST IN THE COMMUNITY. The number of patrons who visit periodic art shows is steadily growing. Interest from parents has increased. An Artists' Friends parent program involving interested parents in THE AWARENESS PROGRAM.

6. RESPONSE TO A TANGIBLE ITEM. The behavioral approach provides tangible direction for what is to be done. It gives a tool to use with classroom teachers, principals, or a superintendent. The focal chart can be used to explain what is to be accomplished within a designated time. A good unit clearly defines objectives and provides conditions for fulfillment which are obviously an integral part of living. ART PROGRAMS NEED THIS EVIDENCE OF WORTH AND INTENTION—TO SURVIVE THE SLASHING CUTS WHICH ARE BEING MADE IN EDUCATIONAL PROGRAMS TODAY.

Yes, one school district is making some headway. Granted there are many moments of discouragement with eagerness to proceed faster, but those involved know that it will be long years before the ultimate art laboratory, with students on their own, can become a reality. That will require changing parts in the old machinery and time. An old trite expression seems appropriate at this point: "Rome wasn't built in a day." However, there is consolation in the realization that although Rome isn't built yet - it is looking better every day, on its way "up."

REFERENCES

1 National Education Association. *Music and Art in the Public* Schools, National Education Association Research Division, Research Monograph 1963-MS. Washington, D.C.: National Education Association, 1963.
2 Eisner, Elliot, "Curriculum Ideas in a Time of Crisis," *Art Education,* October, 1965, pp. 7-12.
3 Woodruff, Asahel D., *First Steps in Building a New School Program.* Mimeographed booklet, Salt Lake City, Utah: Bureau of Educational Research, University of Utah, 1967, p. 5.
4 *Ibid,* pp. 5-6.
5 Mager, Robert F., *Preparing Instructional Objectives.* Palo Alto, California: Fearon Publishers, 1962.
6 Woodruff, *op. cit.,* p. 8.
7 Broudy, Harry S., "Quality Education and Aesthetic Education," in *Concepts in Art and Education,* edited by George Pappas. New York: The Macmillan Company, 1970, p. 290.
8 Hightower, John B., "Arts and Education," a presentation at the Illinois Art Education Conference, St. Louis, Missouri, November, 1970.
9 "Why Art Education?" Washington, D.C.: National Art Education Association, n.d.
10 Broudy, *op. cit.,* p. 286.
11 Hightower, *op. cit.*
12 Woodruff, *op. cit.,* p. 43.
13 Bloom, Benjamin S., *Taxonomy of Educational Objectives, Handbook I: Cognitive Domain.* New York: David McKay Company, Inc., 1956.
14 Krathwohl, Dav'd R., Benjamin S. Bloom and Bertram B. Masia, *Taxonomy of Educational Objectives, Handbook II: Affective Domain.* New York: David McKay Company, Inc., 1964.
15 Woodruff, *op. cit.,* p. 1.
16 *Ibid.,* p. 2.
17. *Ibid.,* p. 2.
18. *Ibid.,* p. 3.

PART III

HIGHER EDUCATION EXEMPLARS

In Part III of this volume, four exemplars of behaviorally based art curricula in higher education are presented. The examples were developed for art education majors as well as for elementary education majors and general university students. In Chapter VII, Kuhn presents a very comprehensive discussion of the philosophical bases out of which she evolved a behavioral objective technology for use in the education of art teachers at The Florida State University. In addition to the discussion of the philosophical discussion, she describes in detail an experiment which utilizes the technology with a group of pre-service art teachers. Chapter VIII presents a graduate research course for art education students developed around a behavioral approach by Michael. Detailing the performance objectives, he also describes the learning activities engaged in and the means of assessment used in the course.

Chapter IX deals with another important group of college students: elementary education majors. Based upon work with such a group, Lovano-Kerr presents a trilogy of behavioral curriculum models in this Chapter. Utilizing minimum level behavioral objectives, she describes an elementary art methods course, a classroom inquiry experiment, and an art experience for educable retardates.

In the final Chapter of Part III, Hubbard and Kula direct our attention to a group of students often overlooked by art educators - the general university student. In Chapter X they describe a behaviorally oriented art program which has been developed for freshmen students at Indiana University.

CHAPTER VII

EXPLORING THE SHARDS OF A
SHATTERED PHILOSOPHY:
A PERSONAL ACCOUNT

Marylou Kuhn
Florida State University

Sources

The behavioral objective Institutes sponsored by NAEA meant a way for me to begin a tangible analysis of the education of the art teacher which was uppermost in my mind in 1967. Wide discussion about the viability of behavioral objectives leads me to begin, however, with some meanings given in this paper to the words: behavioral objective technology. Technology is used throughout because the activities and ideas put into practice have been deliberately applied as tools for achieving educational ends—the pre-service preparation of art teachers—identified through a wide gamut of intuitively and empirically derived concepts held about this task, and certainly not limited to those objectives delineated by the function of the tool. Part of the furor, it seems to me, is the lack of clear identification of behavioral objectives as a tool in the service of education. Reference to behavior is an attempt to deal primarily with information about the human being distinct from that which comes from non-animate objects! Both of these sources are available to teachers in the environment through which they create education situations. The acceptance of behavior objective technology on which this study was founded evolved out of the conceptualizations sketched below.

In 1967 I was able to achieve a more comprehensive objectivity about art education by being immersed in the activities of the Institute of Education, the University of London and in the life of my colleagues there. I had enough background in cross-cultural experience and study to be able to identify basic premises of both English and American systems. It had become evident to me in the early 1960's that art education was depending heavily upon concepts of a past era. The buff and polish of surface renewal was evident, but little questioning at the gut level. My background in adult education and sociology began to pull at my consciousness. A commitment to life-long learning and to ideas of continuity as bases of education had long been disturbed by art education's child dominated theories and by practices limited to formal class-

113

room methodology. This uneasy accommodation became unacceptable as my English student art teachers faced their pupils without some of the social connections to which I had been able to sensitize my American students. Much of what I felt had made my work an organic whole in the United States could not be achieved by attention only to children in schools. Concerns I faced earlier were thrust into stark relief in England. Because of these facts I was forced to face the idea of rethinking the parts of my philosophy which were increasingly abrasive to one another. I found myself acting like an archaeologist shifting the sands of accumulation to turn up shards of the human puzzles. Important pieces for assembling my study of art education came in the Asahel Woodruff papers[2] prepared for the NAEA Institute of 1968.

By the time this Institute met I was well on the way to experimental trial of some of Woodruff's ideas with a group of art education majors just beginning their sequence of professional courses. These ideas, plus some of my own which came into relief due to the structure I was now able to give them, became the basic assumptions for a search for more shards which came to a state of stasis in March 1971. The material in this chapter recounts some of the trial balloons and some philosophical conclusions which have evolved out of this trial period.

The study has consisted of nine quarters of work with four sets of students. I began to teach Group A with the second course of the professional sequence. I was the sole responsible teacher throughout the rest of their preparation as art teachers. Group B did two terms with me then two terms with a colleague and a summary term with me. Groups C and D each spent one term with me and served more as a replication and refinement of one facet of the study rather than as an experimental group.

The beginning was meant to provide the prospective teacher with the means, or technology if you will, to understand the multiple, complex facets of the task of preparing and presenting a learning situation with an increasing perception of the causality behind it. The content of this task centered in personal skills representing a repertoire of society's heritage of leader/follower strategies in a relationship appropriate to the demands of the stated purposes of art education.

As the study developed it became clear that the major results brought about a more precise delineation of direction and outcome which behavioral objective technology has predicted, but in a very different way than had been anticipated. Rather than just answer pedagogical technology questions, the requirements of its precise structure necessitated the formulation of new questions of an increasingly basic nature about art education. Questions about content became a stumbling block. This situation was collectively shared earlier by the nation-wide delegation of art educators at NAEA Institutes who were hung up in learning about behaviorizing their activities through the inability they shared with the psychologist (Woodruff) and the measurement researcher (Clark) to move discussion beyond the simplest level

of skill represented by a pinch pot. To some this was reason to say that behaviorizing teaching and learning was inappropriate for art education. To others it directed the thrust of their efforts toward multiple yet coordinated experiences (called by Woodruff a carrier) made up of interrelated, life-oriented, individual acts which form a unity due to their contextual focus. As an example of this enlarging effort a circus carrier[3] was developed for the use of participants in the second Institute. A similar approach is represented in the reference to organizing centers in the *Guidelines for Art Instruction through Television for Elementary Schools*[4] and by episodes in *Teaching Art in the Elementary School*.[5] The carrier concept did not accomplish entry into the core of the problem of what was to be learned but it has brought to the fore some discussion of the field in behavioral terms rather than object or commodity terms, and it has shown the advantage of grouping aspects of content for a variety of reasons.

One keeps being returned to the question of the nature of content of art for educational purposes. This major question is not answered for me by gathering together the scope of the field whether stated in the generic terms of elements and principals; or in the terms of human exemplars such as artists, historians, or critics; or in thematic terms which represent concerns of humankind. All of these are important. How they are important will depend upon one's assumptions about what is art and education. A number of educators have directed their attention to these questions. For example, behavioral based technology has been related to the nature of aesthetic response by Kaelin.[6] From his philosophical reference, it has been found wanting. Eisner[7], too, found this technology wanting. In his study the qualities of the art act itself as an eventful process are used as criteria. Such studies do not seem to take into account the situational demands of the art activity or to consider that all human acts, overt and covert, constitute behavior. Consideration of a technology—non-discipline or multi-discipline based—appears to require reduction from the various realms of discourse (philosophical, psychological, sociological, etc.) for one to be able to make application and evaluation. Art education, based as it is on concepts from a number of disciplines, requires consideration of all together to adequately assess the technology.

The position of art education continues to be uncertain in relation to itself and to the current pressures of contemporary times. Traditionally artists have been at the forefront of human development by incorporating the concerns and knowledge of their time into the concerns of their art.[8] Hermann Scherchen, a world renowned Swiss conductor, is particularly well-equipped to speak of art, old and new. He has said,

> *In this era of technology art cannot function as in the past. Today man must make realities, not dreams; he must end things, not plan things ... We are living, as never before, in a world of changing values; never before have time and space come so close to becoming si-*

multaneous elements. Therefore, customary, predictable dimen-
sions and rules are violated every day.[9]

That artists and educators are thinking about a biosocial approach to the
arts as a condition for vitality and relevance in the human endeavor is sug-
gested in the following passage by John Unterecker.

> *This new aesthetic may very well see art not in terms of an arrange-*
> *ment of things but rather in terms of intersecting fields of energy.*
> *The work may emerge ... not as an object to be isolated for study*
> *but rather as a continuing dialogue between the shaping artist and*
> *his inventive audience, both of them necessary to create the device*
> *that is their communication.*[10]

The aesthetic of our recent past made art into an object-centered phenome-
non: things done by others rather than events experienced by ourselves. As
educators we must face recognition of this change and of the need to provide
learners with fields of energy as well as arrangements of things.[11] The work of
Jack Burnham, particularly *The Structure of Art,*[12] is a considerable contri-
bution to this conceptual perspective.

While these problems form theoretical propositions for art education
and need to be continually restated if we believe in the concept of evolution,
they alone do not appear to be at the core of our difficulty in regard to the use
of behavioral objective technology. This is not to diminish the importance of
this technology, particularly as it exhibits the flexibility to be adjusted to
depth studies about its use. This is shown in the more recent competency ori-
entation being pursued by education. It is to say that at this point in time, giv-
en the knowledge of human heritage which forms the cocoon of our milieu,
there appear to be additional questions to be faced in regard to art education.
The requirements of the explosion of knowledge makes us look differently
upon precision and upon systematic and structural organizations as they ef-
fect our field.

In an earlier article about behavioral objectives I compared our need to
apply current technology to education as it had been adapted for the Apollo
space experiments.[13] In these experiments an environment of concentrated
precise technology made it possible for exploration into vast distances. An
educational environment based upon precise entry and direction would make
it possible for learning to condense large numbers of complex ideas and skills
into comprehensive generalities necessary for living amidst rapid change. It is
this change of focus and need for precision which is altering much of our
world today. An example presented then seems appropriate now.

> *A most dramatic and ever-present example of this phenomenon*
> *may be found in our approach and solution to moving from one*
> *place to another. One may walk down a path with time to notice de-*
> *tails of the surface of the path, even to absorb those parts spreading*
> *to each side. Mount a horse and power gives a different dimension*

to the time we have to see our surroundings. The horse demands close attention to a narrow path. Our focus changes from the leaf of the tree to its trunk. Our reactions to the events along the way are more general and brief. When our vehicle becomes a car the potential for covering a great deal of space in a small amount of time forces our attention ahead to vector our coming. Imagine the destructive force of steel and glass hurtling along extrusions or wandering from tree to tree in random fashion. Imagine, too, the vastly magnified precision necessary in our world of jet speed and electronic travel.[14]

Education of today will be a precise process if it is to fit its environment and its purpose, or it simply will not arrive. It sits astride a world of jet speed forces. Human behavior must operate through more precise processes and respond in precise ways to its shaping forces. These forces are transient and complex. Entering into the education act today makes demands on the learner parallel to the trust the traveller must exhibit in embarking on a jet air journey. One must know where one is going and the effect of interim events upon arrival or one simply will not arrive. The traveller trusts the reality of the event through an intuitive act backed by as much precise information as possible about the plane and about the flight objective in relation to his planned destination. In education, at the same time one trusts oneself to the event it is essential that precisely the right entry into it be accomplished by both internal and external processes appropriate to move one toward the desired learning, whether the outcome may be formally predetermined or is the unpredictable results of heuristic events. Further, it is essential that one know where one has been as he emerges from the learning process in order that he may move on to the next appropriate learning. Of course the learner has a much larger possible entry into his objective orbit than the tiny window in the sky available to the astronaut, but the parallel of requirements for both remains sound.

Another condition which seems necessary for understanding the application of behavioral objective technology to education has to do with its relevance to developments in the refinement of knowledge toward interrelated, comprehensive generalities. These generalities have been described as systems, and an understanding of the conditions imposed by system orientation appears to be a prerequisite to appropriate use of behavioral objectives. The statement of objectives from a particular perspective is a philosophical question. As such it concerns value judgements and choices. Change in educational directions concerns our expanding knowledge about the dynamics of structures and the manner in which they are formed through systems. The functions of the parts of systems have been found to be closely dependent upon their position in a sequence or set and upon the input and output of each part to and with its relevant neighboring parts. When these conditions are altered, disruption of the process occurs.[15] Using appropriate references to systems

concepts, art educators may determine the manner in which behavioral objectives can serve their general goals and in what way they can be instrumental to the requirements of the substantive field. This technology, however, is not meant to determine goals. Its value lies in helping one to reach them more effectively once they have been determined. This requirement becomes very clear to the individual as he develops a learning situation. Taking an objective, it can help to locate levels of generality and/or specificity to which it can be applied and to describe the system of which it is a part; therefore, helping to solve the position aspect of the problem of reduction.

Asahel Woodruff bases his work in psychology and education on the cybernetic explanation of the human nervous system as it produces thought and feeling. By doing so he has suggested that concern about individual educational problems, such as curriculum and goals, must be consistent with the larger concepts about human knowledge today. While it may be desirable or necessary to begin to work on relatively small units or parts of the changing educational scene, it is essential that one maintain constant reference to their possible position and function in the system.

For some time art educators have been searching for questions embedded in their field through curricular study. This has been primarily a rearrangement of content within the schooling structure or institution. Examples of situations centered in the learner rather than in the teacher yet with a sensitive introduction of socially oriented concerns are promising, as in the IPI experiments in Duluth and Pittsburgh. Arrangements which cut down on the boxing and streaming of learners through heterogeneous sorting are also exciting. The open classroom, the free school, and interdisciplinary approaches are all fine examples of attempts to solve the educational arrangement problem. But, as a number of perceptive educators such as Holt[16] and Illich[17] have stated, the educating problem has been seen as synonomous with the schooling problem. This is not the case. Work on refining current ideas of programming or even of structuring education through curricular reform leaves us still not focused on a central problem. This is not to say that alteration of our concept of school will not serve to help solve this larger problem. The thrust of educational effort throughout the 1960's produced many interesting and instructive variations on schooling. In fact, the Florida State University College of Education is deeply immersed in one such revision (Elementary Model) that systematically restructures schooling as such, develops a tightly coordinated model of interaction across old boundaries of the system of teacher education to include public school systems and the first year of teacher employment. I submit that this is still not facing the problem in its entirety and that until we do define more accurately the appropriate questions the research we do must be clearly labeled as part of the whole and placed in the context of this greater whole. I am convinced that this whole is the total environment or world culture and that learning and education needs to be deliberately related through old and new institutions of great diversity.[18, 19, 20,]

[21] Some of these institutions may have the educational function as their central pursuit and some of them may, as now, operate with it as a peripheral focus. The major difference would be the position of honor and respect, therefore of effectiveness, provided to the aspect of educating facilitated by these additional institutions. Cooperation among the staffs of various social institutions for education which does not have artificial age and locale boundaries is not a utopian dream. It is the logical next step in a situation in which estimates in 1970 credited 80% of learning as coming from non-school sources.[22]

The importance of many social institutions to the arts is clear when we consider the minimal amount of arts involvement which is possible directly in the schools of today. Professional theater, musical concerts, dance and original visual art works must be sought elsewhere or artificially brought in as enrichment. The arts are not subject to conceptual transfer as are many other areas of knowledge. Any reproductive vehicle is a dilution of their meaning and knowledge content. These vehicles are better than nothing but need to be used in full recognition of the distortions they contain. Artists in residence are bringing a little of the artist's feeling of commitment to children who have learned to think of art as only manipulative fun or who have seldom seen anything more than examples of their own beginning artistic formulations. Even when the most desirable art experiences are available to learners the time allowed for them is a minute part of the school calendar. A much more livable relationship between schools and arts institutions of our society as well as new organizational forms not yet developed seem to be called for. It is not enough to inject behavioral objective technology into an already obsolete social form. On the other hand school application is apparently a viable way of obtaining some of the results preliminary to the larger task I have just described.

Warren Martin[23] has suggested our present situation can be seen metaphorically in the Egyptian legend of the phoenix. By using the ashes to nourish the soil on which new beginnings are built one can "Get nourishment from tradition without being bound to its forms." It was with this purpose that I found myself analyzing behavioral objective technology at the same time I was using it to develop students who hopefully are capable of its use or its destruction dependent upon its applicability to the new unknowns of their teaching careers as we turn to a new century in which all learning will probably need to be related to the total environment throughout all of the human life span.

I found that behaviorizing my courses provides a specificity and an efficiency which contributed to development of diverse teaching styles by providing my students a more clear feed-back on what they were doing as they carried out personal, independent, teaching decisions. They were also able to see their fellow classmates solve teaching problems in differing ways. This was the short-term gain. Effort at a better understanding of what may be the right

way of doing, of long-range effectiveness, has been approached through complementary educational technologies - particularly those applicable to the development of a comprehension of self in relation to society. This distinction between order or efficiency and effectiveness or what should be done is interestingly analyzed by Charles Silberman in *Crisis in the Classroom*.[24] This, then, is not an account of research as represented by the accountability of limited, experimental, empirical data upon the education of art teachers by means of behavioral objective technology. Rather than an extrapolation of a piece of the whole it was an attempt to orchestrate some of the cues which are extant in the questioning edge of scholarship on education. The idea of art teacher education for service in schools is a shard of a new whole coming up over the horizon of our "space ship earth", and research into behavioral objective technology seen in this context of self determination and freedom (in the English infant school sense) for education as a continuous part of life was the field of my endeavor.

Contexts

The seven professional courses in art education for undergraduate majors at Florida State University occur in a sequence of five terms. Taking committee-determined topics for each course I have attempted to transform some of them into behavioral tasks. Determination of objectives for goals provided by the department were shared by myself and the students. We added others as the need arose. Often the students chose unique tasks for themselves to obtain the same objective as other members of their class. Some of the tasks I felt it to be my responsibility to give guidelines for because they represented areas either almost completely new to the students or they involved complex social interaction with other groups of people. This will parallel the public school situation.

The experiment, while carried out under the existing sequential structure of course content, did not limit itself to these concerns; and the outcome of the study has indicated a rather drastic revision of this structure to combine the characteristics of more explicit objectives about the learning tasks which take the place of topics oriented toward teaching and a systematic rather than a sequential structure. I will illustrate later some of the kinds of experiments undertaken to achieve the first of these characteristics, that is, learning tasks. The latter, re-structuring, remains to be done in its entirety. I visualize it as an attempt to set up a curriculum which will contain discrete competencies some of which are singular, some of which have series of sequential clusters, some of which are designated by the educational institution as instruments of social tradition and change, some of which will originate from the learner himself as he understands and articulates his learning from the center of his own existence, and some of which will establish connections with a number of additional institutions in the local community. All would be subject to a

range of alternative positioning based upon entry capacities of individual students.

Change from a perspective which is object (art) or other (teacher role) centered to one which is self or behaviorally oriented appears to have first priority. Until a large enough number of concerns of teacher education are scrutinized for the clarity of their requests upon the student and for the amount of contamination from irrelevant areas of discourse and until they are stated as behavioral or task items, the organizing of these items will be a happen-chance activity. The manner of solving space probe problems can serve as a model for workers here.

Under the restraints of conducting an experiment within an already existing, complex structure, I used as a guide the concept of taxonomies to assess the appropriate placement of activities in the various five terms. According to the hierarchies suggested by the taxonomy model, learning was assumed to develop from less to more; from simple to complex; from concrete to abstract (see Arnheim[25] for a depth treatment of this topic); from individual to group and/or from incidental to global. At the same time all parts of our content were subject to being fit into the larger whole of educational structuring. These criteria were put to all terms in the sequence and helped me to deal with the study from a comprehensive or holistic perspective rather than from the disjointed parts through which I found myself working due to the pattern of faculty assignments among the teacher preparation courses.

Terminology was an important means for sharper focus among the participants. Behavioral objectives referred to the whole task of learning/teaching; while the learning parts were called performance objectives and teaching parts were called instructional objectives. The person's role in the objective determined his perspective as learner or teacher. The formal plan for these objectives were called contracts. Thus, contracts were written from either the learner's or the teacher's position and they consisted of two major divisions: pre-planning and the event. These formal contracts took the place of lesson plans which had been centered in the teacher's actions. The attempt in the contract was to center it in the learner's actions regardless of the writer's position. This is a basic premise of the Woodruff papers and this change in focus is critical to adequate use of behavioral objectives. Other terms used in the contract can be seen in the outline example of it. (Figure 7-1). Distinction was made between the terms goal and objective.[26] This was done in order to identify the level of specificity to which we were referring. A goal was a global projection and shifted to an objective when it could be stated as a human action or behavior.

I see the first step in revision of teacher preparation as being a part of the question of what its content is which was mentioned earlier. It is possible that we may find it desirable to make a much more clear distinction between teaching and learning than previously done; and, as many educators have suggested, that behavioral technology as we know it today will have a certain ap-

(IV) I. Purpose (organizing center or life centered carrier)
 II. Entry level of student: taxonomy of general maturity
(V) III. Instructional/Performance objective (single concept or as few concepts as possible)
 A. Action (stated as overt verbal or overt nonverbal expressions and executions, often of covert responses)
 B. Conditions
 1. Theater (organization or arrangement)
 2. Content or substance: Art
 a. Literary (idea)
 b. Technical (media, tools, processes)
 c. Formal (design or organization)
 C. Criteria (test of occurrence of learning)

 IV. Exit levels of students: taxonomies
 A. Art: substance
 B. Affective behavior
 C. Cognitive behavior
 D. General maturity

 V. Resources for student use.

 VI. Theater preparation and materials

> Note: Just the pre-teaching section of this outline could become a student contract for individualized learning. It has the potential of providing self-teaching instruction, i.e. performance objective.

(VI) I. Sequences of teacher actions
 A. Perceptual presentation: opening set
 B. Stimulation of recall and organization
 C. Elicitation to objective and action: choices and decisions (establishment of dymanic impetus)
 D. Provision for trial of experiences
 E. Feedback: interpretation and shaping of responses

> Note: Teacher action sequences may need to be repeated, especially when more than one concept (single) is present in the objective.

 II. Time plan
 III. Teacher resources

> Note: The teaching section provides for group or individual teacher involvement.

> Note: The Roman numerals in circles refer to the levels described in Figure 8-11.

FIGURE 7-1. CONTRACT OUTLINE FOR TEACHING/LEARNING

propriateness for teaching as such and a differing relatedness to various substantive fields. I do not think anywhere near enough information is in for us to substantiate opinion about it in regard to art. As an art educator I can not dismiss this technology for either aspect of the teacher preparation content until more descriptive research provides more concrete items for analysis and evaluation. The state of the field does not now provide this data in an empirical way; therefore, our opinions are educated guesses.

The thrust of my experiment has been to adapt this technology to the teaching of teachers, who of course are unique in that they will be art teachers. Much discussion of behavioral objectives has been directed to its appropriateness for art. I have seen none which focuses on the teaching behaviors being learned by prospective art teachers rather than on the learning behaviors expected from the student. I have a deep-seated hunch that one can prescribe a situation without predetermining the event or product of that event. If, as I am inclined to intuit, the above is true then there is a real and substantial place for this technology in the development of humanistic art learning situations. I think there are significant differences between the learning and the teaching aspects of education that have not been recognized in this controversy.

Tasks

A. Psychological set toward teaching

To provide knowledge of what a teacher can use to be a teacher, that is, to see, hear, touch as tangible evidences of events and situations was a beginning objective. Interpretation of tangible evidence is quite another area, subject to intuitive soundings as well as empirical evidence. To begin to get a young person to take on leadership tasks one needs to help him identify what, where and how he can exert such action and what he can use to inform himself about his options in any particular situation. Naming parts present in most group educational settings is such a beginning. These can be divided into two types: managerial and behavioral. The managerial deals with non-human objects and organizations, while the behavioral identifies responses of the individuals or learners involved. Content currently influencing managerial circles from space and systems technology are readily transferrable to the educational setting and can provide excellent help to the teacher faced with immense logistic detail. Behavioral tasks for comprehension of this somewhat formalized content are easily developed. The area that is of concern to us, however, is the human one. In this dilemma I have found the Woodruff[27] listing of student and teacher behaviors (Figure 7-2) of considerable help in differentiating from among globally tenuous responses seen by the unsophisticated observer of individuals in school settings. We have taken his list as a word study, defined their meanings and tried to give as many human ex-

POSSIBLE EDUCATIVE STUDENT BEHAVIORS	1 PERCEPTION	2 ORGANIZATION	3 DECISION	4 TRIAL	5 FEEDBACK	AA
	1. Recognize 2. Identify 3. Differentiate referents	1. Discover structural similarities 2. Discoverr consistent antecedent-consequent relationships 3. Recognize emotional effect of an event or condition 4. Associate symbols and data with concepts;; memorizee them when useful	1. Recognize a situational demand: a. The situation b. Values at stake c. Means accessible 2. React to it a. Decision to re-perceive b. Choice of known procedure c. Selection of new procedure (trial & error; deduction; creation) d. Commitment to re-sponse	1. Identify a referent 2. Follow a procedure	1. Operant chaping 2. Concept chaping: a. Meaning b. Value 3. Vocabulary shaping 4. Symbol memory shaping	

	UP	MP	1	2	3	4	5	AA
	Pre-Teaching		Teaching					Parallel
MATCHING EDUCATIVE TEACHER BEHAVIORS	UNIT PREP. ARA-TION	MATERIALS AND THEATER PREPARA-TION	REFERENTIAL PRESENTA-TION FOR PERCEPTION	STIMULATION OF RECALL, REVIEW, INTERPRETATION, ORGANIZATION	ELICITATION OF GOAL AND ACTION CHOICES AND DECISIONS	PROVISION OF REALISTIC TRIAL EXPERIENCES	ELICITATION OF FEEDBACK INTERPRETA-TION AND SHAPING RESPONSES	ACHIEVEMENT ASSESSMENT

FIGURE 7-2. WOODRUFF: LEARNER BEHAVIORS AND MATCHING GROSS COMPONENT TEACHING TASKS

124

amples as possible of their occurrence: first by discussion among ourselves, then as observers and participants in classrooms.

Woodruff divides his list into acts a teacher will do and those students will do, recognizing that these overlap and that they occur in response to each other. By being encouraged to focus on either the teacher's acts or the learner's responses or on both, the individual is given options for developing his knowledge in tune with his capacity and disposition to empathize with a situation. He begins to see his own entry skills in reference to educating. This initial task was deliberately kept open except for the provision of psychologically defined behavior patterns common to teaching and learning. Both generic abstractions of these patterns and their variations within type limits were used as content. An example which has helped comprehension of the differences possible is reference to a fruit: as a Delicious apple and the variations a number of apples of this type might have which make them different, yet like each other. A similar comparison is made with another type of apple, as a Macintosh, then with other species of fruit.

B. Entry or readiness

Emphasis upon the entry status of the student is present in the Woodruff papers. I had been experimenting with some forms to provide individual profiles as cumulative records of art education majors. I have used his analysis of the learning/teaching cycle with its statement of sequence of parts as a guide to extend the entry concept of the profile to learning about the teaching task. Profiles kept on individual student contracts written and fulfilled during the third term of the sequence illustrate a considerable diversity in choices of content for each one. A picture of the nature of the effort is immediately apparent from the profile, (Figure 7-3 and 7-4), and individual or tutorial guidance using this type of cumulative record is based on more than a wish and a guess.

A number of teaching aids for understanding the entry concept emerged at the same time from my attempts to analyze the learning situation as it was reflected in behavioral theory for an in-service session with art teachers of Fairfax County, Virginia. Much emphasis was placed upon the cognitive view of art experiences to provide the teacher with places where the student could enter into the study of art. Data from this experiment indicated that the concepts underlying behavioral objective technology are essential to comprehension of it as a neutral tool, and that often considerable time and many references to real educational happenings are not requisite. This reinforces Woodruff's premises. Language will be a difficulty; as will the requirement for examples from real situations directly relatable as bridges between parts used to illustrate cause and effect in teacher action. Taxonomies are of help here. Despite the risk of over-simplifying connections from a psychological point of view, I found it helpful to extend and relate one taxonomy with behaviors as an example (Figures 7-5 and 7-6). Another help was a pictorial

CONTRACT SCHEDULE FOR **STUDENT V**

KEY: W-written ▨-completed
F-fulfilled ░-planned

Major Topics	CODE 3		CODE 2		CODE 1	
	W	F	W	F	W	F
1. Personal philosophies on Art Ed.						
a. Effective teacher						
b. Meanings (1) Historical						
(2) Art Educators						
(3) Theories						
c. Effect of time, place and purpose						
2. Analysis of learning situations						
a. Parts						
b. Curriculum						
(1) Levels						
(2) Timing						
(3) Content						
(4) Structure						
c. Management						
d. Technology and aids						
e. Appropriations						
f. Dev. of learning situations						
3. Analysis of learning/teaching roles						
a. Individuation						
b. Grouping						
c. Psychological basis						
4. Application of art knowledge						
a. Development components						
b. Artistic components						
c. Artistic forms and forming						
d. Contemporary issues						
e. Critical judgment						
5. Knowledge of the human						
a. General characteristics						
b. Characteristics relevant to art						
6. Teacher role						
a. Responsibilities and opportunities						
b. Self-evaluation profile						
c. Student-teaching						

FIGURE 7-3. PROFILE FORM, LEARNING ABOUT THE TEACHING TASK

126

CONTRACT SCHEDULE FOR __*STUDENT W*__

KEY: W-written ▨ -completed
 F-fulfilled ░ -planned

Major Topics	CODE 3 W	CODE 3 F	CODE 2 W	CODE 2 F	CODE 1 W	CODE 1 F
1. Personal philosophies on Art Ed.						
a. Effective teacher						
b. Meanings (1) Historical	░					
(2) Art Educators	░					
(3) Theories	░					
c. Effect of time, place and purpose						
2. Analysis of learning situations						
a. Parts	▨	▨				
b. Curriculum						
(1) Levels						
(2) Timing						
(3) Content						
(4) Structure						
c. Management	▨	▨				
d. Technology and aids						
e. Appropriations	░					
f. Dev. of learning situations	▨	▨				
3. Analysis of learning/teaching roles						
a. Individuation	░					
b. Grouping	░					
c. Psychological basis						
4. Application of art knowledge	▨	▨	▨	▨		
a. Development components						
b. Artistic components	▨	▨	░			
c. Artistic forms and forming	░					
d. Contemporary issues	▨	▨	░			
e. Critical judgment	▨					
5. Knowledge of the human						
a. General characteristics	▨	▨	░			
b. Characteristics relevant to art	▨	▨	░			
6. Teacher role						
a. Responsibilities and opportunities						
b. Self-evaluation profile						
c. Student-teaching						

FIGURE 7-4. EXAMPLES, INDIVIDUAL PROFILES: LEARNING ABOUT THE TEACHING TASKS

CONTRACT SCHEDULE FOR **STUDENT X**

KEY: W-written /// -completed
F-fulfilled ::: -planned

Major Topics	CODE 3		CODE 2		CODE 1	
	W	F	W	F	W	F
1. Personal philosophies on Art Ed.						
a. Effective teacher	///	:::				
b. Meanings (1) Historical	///					
(2) Art Educators						
(3) Theories	:::		:::			
c. Effect of time, place and purpose	///	///	:::			
2. Analysis of learning situations						
a. Parts	///	///	///	///		
b. Curriculum						
(1) Levels	///	///				
(2) Timing	///					
(3) Content	///	///				
(4) Structure						
c. Management	///	///	///	///	:::	
d. Technology and aids	///	///				
e. Appropriations	:::					
f. Dev. of learning situations	///	///	///	///		
3. Analysis of learning/teaching roles						
a. Individuation						
b. Grouping	:::					
c. Psychological basis						
4. Application of art knowledge	///	///	///	///		
a. Development components						
b. Artistic components	///	///				
c. Artistic forms and forming	///	///	///	///	:::	
d. Contemporary issues	///	///	:::			
e. Critical judgment	///	///	///	///	:::	
5. Knowledge of the human						
a. General characteristics	:::					
b. Characteristics relevant to art	:::					
6. Teacher role						
a. Responsibilities and opportunities	///	///	///	///	:::	
b. Self-evaluation profile						
c. Student-teaching						

FIGURE 7-4 (continued)

CONTRACT SCHEDULE FOR __STUDENT Y__

KEY: W—written ///// —completed
 F—fulfilled .:.: —planned

Legend for cells below: C = completed (hatched), P = planned (dotted)

Major Topics	CODE 3 W	CODE 3 F	CODE 2 W	CODE 2 F	CODE 1 W	CODE 1 F
1. Personal philosophies on Art Ed.	P					
a. Effective teacher	C	C				
b. Meanings (1) Historical	P					
(2) Art Educators	P					
(3) Theories	C	C				
c. Effect of time, place and purpose						
2. Analysis of learning situations						
a. Parts	C	C	P			
b. Curriculum						
(1) Levels						
(2) Timing						
(3) Content						
(4) Structure						
c. Management	C	C	P			
d. Technology and aids	C	C				
e. Appropriations						
f. Dev. of learning situations	C	C	P			
3. Analysis of learning/teaching roles						
a. Individuation	P					
b. Grouping	P					
c. Psychological basis	C	C	C			
4. Application of art knowledge						
a. Development components	C	C	C			
b. Artistic components	C	C	C	C	C	C
c. Artistic forms and forming	C	C	C	C	C	C
d. Contemporary issues	C	C	P			
e. Critical judgment	C	C				
5. Knowledge of the human						
a. General characteristics	P					
b. Characteristics relevant to art	P					
6. Teacher role						
a. Responsibilities and opportunities						
b. Self-evaluation profile						
c. Student-teaching						

FIGURE 7-4 (continued)

CONTRACT SCHEDULE FOR __STUDENT Z__

KEY: W-written ▨ -completed
 F-fulfilled ░ -planned

Major Topics	CODE 3 W	CODE 3 F	CODE 2 W	CODE 2 F	CODE 1 W	CODE 1 F
1. Personal philosophies on Art Ed.						
a. Effective teacher	▨	▨				
b. Meanings (1) Historical						
(2) Art Educators						
(3) Theories						
c. Effect of time, place and purpose	▨	▨	░			
2. Analysis of learning situations						
a. Parts	▨	▨				
b. Curriculum (1) Levels						
(2) Timing						
(3) Content						
(4) Structure						
c. Management	▨	▨				
d. Technology and aids	▨	▨				
e. Appropriations	░					
f. Dev. of learning situations	▨	▨	▨	▨		
3. Analysis of learning/teaching roles						
a. Individuation						
b. Grouping	▨	▨				
c. Psychological basis	▨	▨	▨	▨		
4. Application of art knowledge						
a. Development components	▨	▨				
b. Artistic components	▨	▨				
c. Artistic forms and forming	▨	▨	░			
d. Contemporary issues	▨	▨				
e. Critical judgment	▨	▨	▨	▨		
5. Knowledge of the human						
a. General characteristics	▨	░				
b. Characteristics relevant to art	▨	░				
6. Teacher role						
a. Responsibilities and opportunities	▨	▨				
b. Self-evaluation profile						
c. Student-teaching	▨	▨				

FIGURE 7-4 (continued)

level 1 _____ simple _____

 KNOWLEDGE: defined as verbal storage with ability to recall and repeat.

 1.10 *Knowledge of Specifics:* Terminology & Facts

 1.20 *Knowledge of Ways and Means of Dealing with Specifics:*
 Conventions, Trends, Sequences, Classifications, Categories, Criteria,
 Methodology.

 1.30 *Knowledge of the Universals and Abstractions in a Field:*
 Principles and Generalizations, Theories and Structures

level 2 _____

 COMPREHENSION: defined as conceptual understanding with consequent ef-
 forts on decision-making processes in adjustmental situa-
 tions.

 2.10 *Mental Images* of Specific Objects, Events, Qualities

 2..20 *Mental Constructs of Groups* of Objects, Events and Qualities

 2.21 Concepts of Categories of Objects

 2.22 Concepts of Processes relating Events and Consequences

 2.23 Concepts of Qualities

 2.30 *Mental Constructs of Principles* Derived from Process Concepts

 2.40 *Mental Constructs of Special Technical Processes* for the Deliberate Pro-
 motion of Intellectual Behavior

 2.41 Analysis

 2.42 Evaluation

 2.43 Verbalization of Concepts

 2.44 Problem Solving

level 3 _____ complex _____

 CREATIVITY

 3.10 Inventive Creativity

 3.11 *Comprehension of Technical Processes Used* for Synthesis

 3.12 *Conceptual Imagination*

 3.121 Open Perception and Keen Differentiation

 3.122 Freedom to let Ideas Reveal their own Structure

 3.123 Tolerance of Change

 3.124 Freedom to Engage in Intuitive Flights for Ordering Elements

 3.20 Artistic Creativity

 3.21 *Comprehension of Technical Processes Used in Giving Expression to*
 Artistic Ideas and Feelings

 3.22 *Conceptual Imagination* (see 3.12)

Adapted from Asahel Woodruff, "A Taxonomy of Educational Objectives"
NAEA Institute for Research Training, 1968.

FIGURE 7-5. TAXONOMY, SIMPLE TO COMPLEX OBJECTIVES IN THOUGHT

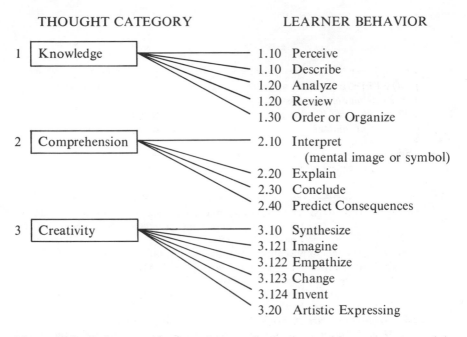

THOUGHT CATEGORY	LEARNER BEHAVIOR
1 Knowledge	1.10 Perceive
	1.10 Describe
	1.20 Analyze
	1.20 Review
	1.30 Order or Organize
2 Comprehension	2.10 Interpret
	(mental image or symbol)
	2.20 Explain
	2.30 Conclude
	2.40 Predict Consequences
3 Creativity	3.10 Synthesize
	3.121 Imagine
	3.122 Empathize
	3.123 Change
	3.124 Invent
	3.20 Artistic Expressing

Note: This listing correlates and expands these two ideas as presented by
Woodruff at the NAEA Institute for Research Training, 1968.

FIGURE 7-6. RELATION BETWEEN KINDS OF THOUGHT AND
KINDS OF ACTION

model, obviously tenative, which developed art as a taxonomy from general
to specific (Figure 7-7). The taxonomies helped to identify the place in a larg-
er whole where the teacher was focusing for the art event. The concept of lev-
els provided by the taxonomies helped to lay out the counters in the situation
in such a way that entry and outsome could be seen relative to the whole. It
provided a measure for the reliability of the event for a particular level of par-
ticipant.

Two worksheets were developed for consideration of the art event. An
art task was analyzed under six component parts in Worksheet A (Figure
7-8), and one of these parts was further analyzed for its content in Worksheet
B (Figure 7-9). Assumption was made that an item understood at this level of
specificity would be precise enough to make into an instructional objective.
The task was formalized two levels deeper than generally done. Having a
worksheet which directed thinking to several parts of an artistic task resulted
in more ideas about its nature being made available. Individuals differ con-
siderably about what these parts are except at the most simple and general
levels of formal description of the nature of artistic tasks. This should help

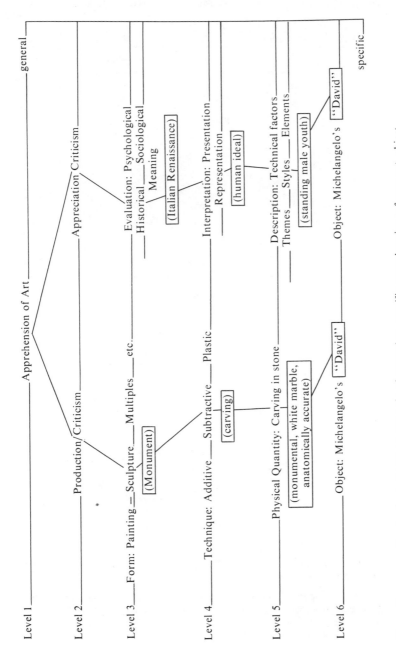

FIGURE 7-7. TAXONOMY: GENERAL TO SPECIFIC
APPREHENSION OF ART

Key: lines connecting levels represent an example of general to specific apprehension of one art object.
Note: Apprehension may begin at any level and move to other levels.

Delineation of the information necessary to carry out the task.

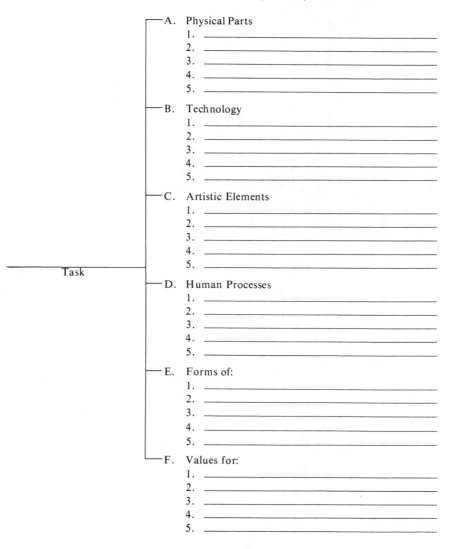

A. Physical Parts
1. _____
2. _____
3. _____
4. _____
5. _____

B. Technology
1. _____
2. _____
3. _____
4. _____
5. _____

C. Artistic Elements
1. _____
2. _____
3. _____
4. _____
5. _____

Task

D. Human Processes
1. _____
2. _____
3. _____
4. _____
5. _____

E. Forms of:
1. _____
2. _____
3. _____
4. _____
5. _____

F. Values for:
1. _____
2. _____
3. _____
4. _____
5. _____

Note: Each section may have more items than allowed. Add as many as needed. Code with letter and number.

May be concepts, operant instrumental motor patterns, vocabulary, or memorized data. Ask yourself, "What does a person need to know or be able to do in order to do this task?"

FIGURE 7-8. WORKSHEET: A. TASK ANALYSIS

Delineation of skills and knowledge necessary *before* attempting the task. Entry skill is necessary for every item in the task analysis. List according to task analysis headings.

letter	name
1.	
a.	
b.	
c.	
d.	
e.	
2.	
a.	
b.	
c.	
d.	
e.	
3.	
a.	
b.	
c.	
d.	
e.	
4.	
a.	
b.	
c.	
d.	
e.	
5.	
a.	
b.	
c.	
d.	
e.	

Note: Add more items if needed.

May be concepts, operant instrumental motor patterns, vocabulary, or memorized data. Ask yourself, "What does a person need to know to be able to do BEFORE he can do this task?"

FIGURE 7-9.

WORKSHEET: B. ENTRY BEHAVIOR FOR _____

Task

our search. The worksheets can be helpful given ample time for delving into old ideas and for relating parts. These aids were incorporated into the college courses.

Experiments with both pre- and in-service education, however, have reinforced my opinion that until art educators are better able to relate cognitively to art little can be done to develop systematic organization of specific educational situations. This is not limited to behaviorizing. In my mind it includes any philosophic structure beyond our present pre-occupation with mechanistic aspects like elements, processes and media (which incidently have been formalized) toward more than happenchance inclusion of depth intuitive, aesthetic, creative, and psychological considerations about art.

C. Assumption of teacher role and

D. Language for art criticism

Next a task was set up which would require leadership actions on the part of the prospective teacher at the same time it provided context and content for learning in art. A number of solutions could have served. The most successful, in that the learner was able effectively to assume the role of teacher most in keeping with his own personality and to assess his efficiency or ability to order the situation as a teacher, were video-tape demonstrations and micro-teaching sessions of a single concept and/or carrier about art. This task was made up of three divisions which later the students would come to know as components in a contract: planning, presentation and evaluation.

Planning centered around knowledge of what educational situations can be and of the skills needed to develop them. It was assumed that the student entered the planning task with a background in art content and in behavioral analyses from our earlier study. He was also expected to draw upon his past experiences as a learner to recreate educational situations he felt to be appropriate. To this we added new information about limiting and focusing one's objective. The behavioral technology with its system of checks and balances was of considerable help in showing where irrelevant or inaccurate conclusions were being made. Group A worked hard as they decided how to eliminate extraneous and interesting or supplementary material which did not have a direct or significant bearing on the content objective of their video-tape. This was the most difficult aspect of planning and often seemed to be the result of imprecise language surrounding fuzzy interpretations of their art experiences. This deficiency led me to include a section on language in regard to art during the first term of the professional sequence for Group B. I have labelled this task, language for art criticism (Task D).

In a course devoted to synthesizing and organizing prior knowledge about art content, I added a topic meant to provide the means for analyzing what one was saying in terms of its relationship to other statements. I used

the system of language analysis presented by Philip G. Smith[28] as part of the research project report, *Improving the Teaching of Art Appreciation* (Figure 7-10). The topic concerning language for criticism became an entry task for all others developed in the study.

When Group B undertook the video-tape planning task of a single concept (Task C) they were more aware of themselves as art critics as they chose the content they wanted to pursue and they appeared to be aware of more choices open to them.

They were, in addition, more efficient in use of their teaching assessories: language, body gesture, process and object examples, posters and graphs, sequences, and so forth. Individuals made decisions about what they would present or teach. They were advised to use familiar material so that they would be concentrating upon learning how to manage the parts of the educational situation not on learning about art content.

The activity described above was an attempt to make those factors which could be identified as essential to enter a task consciously accessible in a "formal" manner to the learner. This approach, suggested by the theory of Edward Hall in *The Silent Language*[29], was very real to me because of my experience in English art teacher preparation where cultural smearing of meaning in an "informal" situation provided a new view of slightly different, informal American teacher education practices. It has in retrospect also provided a new perspective on the total structure of professional education for teachers.

To return to the chronologue of the development and refinement of the task meant to facilitate assumption of the teacher role, the second part of the video-tape task, presentation, must be described. Work was done in teams, one to help with feedback on decision-making during planning and another to handle the technological matters of actual taping. Each student played three roles: teacher, reflector and technician in combinations of overlapping team cooperation. I had used the technique, adapted from Harvard's teacher education program, of team teachers and evaluators for a number of years. The new ingredient for behaviorizing was to intensify and record actions on video-tape. Both the system of checks in the behavioral technology and the permanent quality of the video-tape medium contributed to making casual projections. The rigor of the show quality in a new medium revealed strengths and weaknesses in this simulated situation often not caught until much later during internship. We were, therefore, able to use this information for individual development while the student still had college time.

Using in-school locales with Groups B and C, I tried to obtain similar sharp delineation of understanding about developing learning situations as that achieved with the video-tape demonstration. I found that the in-school task provided a situation more conducive to seeing one's self as an interactor with other personalities, that is, with the feeling of the ambience of a situation; while the video-taped teaching task of a demonstration was better for management problems. It is, of course, impossible to teach well without both

FIGURE 7-10. PEDAGOGICALLY PURPOSIVE VERBAL OPERATIONS

Categories

Not classified
Scheduling
Recitation
Solicitation
Valuational Structuring
Cognitive Structuring
 Surfacing————————————When teachers express facts & opinions to instruct.
 Negative or denying
 Affirming or acknowledging
 Semiotic explication————————Any discussion of meaning. When something functions as a sign
 Syntactic————————Relationships of signs one to another. Formal structure of signs.
 Semantic————————Relation of signs to the objects they designate or denote.
 Pragmatic————————Relations of signs to their users. Introduces psychological, sociological, & historical dimensions.
 Promoting cognitive set

Inferring
 Deductive
 Inductive
 Retroductive

Evaluating or justifying
 Formal
 Empirical
 Systematic

Samiotic Explication "In the art class where the signs under discussion are usually non-linquistic ones, samiotic explication becomes very complicated and each of the sub-categories could be broken down still further." (page 126)

A. Syntactics

1. Internal
 Concerned with the formal relations within a given work.

2. External
 Relates the qualities or style of the work to the other artistic works or styles.

3. Vehicle
 Concerned with the materials of the work as physical object.

B. Semantics
1. Presentational
 Some works directly present objects

2. Representational
 In addition they may also symbolize or suggest.

C. Pragmatics

1. Personal
 First person explication of what the sign means to the speaker.

2. Artist
 Talk about what the sign meant to the artist.

3. Social
 Talk about the role the sign has played in society, i.e., religious or patriotic.

from: Phillip G. Smith, "Verbal Operations in Classroom Instruction"; D.W. Ecker, ed., *Improving The Teaching of Art Appreciation;* Ohio State University: HEW Bureau of Research (project no. V-056) Report RF 2006

of these competencies. What seems to have been important in my experiment was the clearness with which it developed that we had been trying to accomplish both together in simulated situations and that the prospective teacher could develop in much greater depth in approximately the same time through better defined, more limited, more focused tasks: a.) in management, and b.) in self involvement. Without the rigor of identification of behavioral outcomes through the processes suggested by the NAEA Institutes I would not have realized how global I had been, and how happenchance was the teacher preparation I had thought to be rather precise and comprehensive. If these Institutes do no more than initiate extensive questioning about the precision of our teacher education programs in the U.S., they will have served their purposes well. I am convinced, despite this, that the need for more precision may possibly be more closely enmeshed with social forces today than with the behavioral emphasis. In order to be meaningful in the context of systems orientation, individual learning must be developed in a manner which relates it to its environment.

The third aspect of the video-tape task was its use for feedback. Group cohesiveness was high due to the team approach and real dependence each person had upon the members of his team for success. All were tense yet open to this new experience of seeing oneself on the tube. The task of a demonstration carried out by Group A, where the unseen audience became the learners, allowed us to focus upon the structure the prospective teacher had given to his material and its presentation, including mannerisms of the central actor. A gradually increasing list of factors which produce audience reaction came out of general discussions; and the possibilities of an insightful analysis began to be apparent.

The second group of prospective teachers (Group B) were given a somewhat more complex video-tape task: micro-teaching with five to eight hand picked children from our laboratory school. The presence of students in the taping situation changed the focus of feedback—as previously described for other in-school situations—from management to interaction of personality. Both types of video-tape (demonstration and micro-teaching) provide important, tangible, repeatable evidence of teacher performance which is extremely valuable to teacher preparation that has cognitive deliberation as one of its basic premises. Behaviorizing this experience provides access to human personality differences as sources of environmental or situational change.

With Group B the video-tape demonstrations done by Group A were used to expand the student's understanding of the task of video-taping, the range of choices each had in deciding upon a topic and the potential of the medium for evaluative purposes. With Groups C and D the demonstration tapes were followed by in-school teaching experiences. By this time the prospective teachers were formalizing plans which centered in the student. This was still planning for a group with the understanding that an ideal educational situation would allow such plans to be made for and by individual learners

when this was appropriate. This was a part of the attempt to shift from a teacher-centered perspective to a student-centered one. It, admittedly, is a big jump and was made explicit in later terms of the college program for Group A who experienced planning for both groups and individuals in the next term of their professional sequence. The difference in these two perspectives was subsequently elaborated upon with all Groups. I found out very soon that learning and teaching are two very different concepts when behaviorizing study, and they require quite different responses.

At this early stage we were able to succeed in the school testing of our behaviorized plans as much because we were working in a school in which the children are non-graded, the teachers work in teams and the curriculum—especially in math, social studies and parts of English—is behaviorized. Children were familiar with prescriptions and contracts, self-direction and peer help, all of which are related to a behavioral orientation. This is an old school beset by the strains of absorbing almost 50% new, black, disadvantaged children, yet it is alive with the discovery of self and with dedicated professionals. My students grew tremendously, but it was this entire combination of factors not just the precision and systematization which came from consciously looking at behaviors as the focus for developing of teaching and learning competencies. Feedback in the combination of tasks described above appeared to bring each of these four Groups of prospective teachers (A,B,C,D) full circle to entry with greater control over new teaching contexts than I had previously been able to bring about. They were more competent earlier and more of them were creative in solving the problems of student teaching.

E. Point of view

Companion with the precise, systematic behaviorally based concepts just discussed have been attempts to orient the college student to think about the profession he is preparing to enter; and to initiate an open, gradually deepening, personal point of view to serve him as his basis for operations. This content area can be used to develop comprehension of the systems approach based as it is on interrelated parts. Reinforcement and analysis as to the philosophical fit of behavioral objective technology seems to me to be absolutely essential for its use as a tool for education rather than as a criterion for action. The whole system, as Norbert Weiner[30] so aptly indicated, makes the cybernetic guide not its separate parts. Thus, considerable emphasis upon what makes up art education appears to be necessary in the preparation of art teachers.

Development of an appropriate task for this purpose has had three transformations in the experimental sessions of this study. First, the personal essay was used as a culmination of library work, searching of individual beliefs and group discussions. I was doubtful that the linear, climax and focus oriented,

and synthesizing requirements of the essay form contributed very much to helping the novice teacher put his ideas and dreams about working as an art teacher next to the real events he would encounter in schools. Interesting as these essays have been I am convinced that they mean more to the college teacher who finds in them confirmation of his own mature philosophic struggles than to the college student just beginning to think about teaching. They simply are not aware of how one part effects another until attempts to teach demonstrate it. The second type of task was a list, grouped for relatedness if the author so chose, of considerations important to the writer as a potential art educator. It succeeded in making the student more comprehensive and provided him with a skeleton for including all sorts of ideas regardless of their relevance to one another. The gain in amount of awareness seemed to be more important at this stage than the loss of synthesis or interrelatedness. This task was an improvement but not the answer. The third stage in behaviorizing this objective was to adapt the idea of a paradigm to the attempt at philosophic understanding. Several of the art education texts contain such diagrams of conceptual content so the students are somewhat familiar with them. They are also increasingly common in educational literature. For some years the ability to communicate with both visual and verbal symbols has been a part of our program. It has been used for display-type presentations. The model, or paradigm, task focuses this ability upon the meaning of the symbols as they effect one another due to context. It stresses the forces between parts as much as the parts themselves. As a teaching strategy it is more precise than either verbal listing or visual/verbal displays. The diversity of ideas, the different perspectives presented, the contextual wholeness is far more complex than achieved through the essay form; while a recognition of cause as well as effect makes it an improvement on the visual/verbal display. The results of the student's attempts to make a model of their ideas about art education have been among the most exciting outcomes I have recently experienced in teacher education. In the last stage of its evolution, this task was presented as a contract for a model of the field of art education.

F. Building curricula

The last term of our professional courses takes place after student teaching. By this time the student has had three terms of face-to-face encounters with children, experiences in a variety of schools including one of considerable length in which he is exposed as an apprentice to a wide range of problems in curriculum. The term's work centers in the task of bringing all of this information together as a formal study of curriculum theory and practice. Each prospective teacher is encouraged to innovate as he faces the conforming structures of schools and societies.

I have based the behavioral objective technology portion of this task on

systems theory as it relates to curriculum. Two concepts are basic to my approach to curriculum: 1) that the stages or levels of objectives and/or goals are interrelated in hierarchial contexts ranging from the most general to the most specific, and 2) that the event, which represents the most specific end of this continuum, is a limited combination of units chosen from a limitless number. Models worked out to illustrate these concepts served as supportive technology in the development of curricula.

The first concept is an outgrowth of the ideas presented by Manuel Barkan in the article, "Curriculum Problems in Art Education"[31]. In its present form it is an elaboration of his suggestion of enlarging locales (Figure 7-11). In curriculum planning the teacher may begin at any point, global or specific; but must account for all levels of the system. Presentation of this system of levels of contexts provided the students with a criteria for evaluating the effectiveness of their objective- or goal-oriented statements by checking them against the level(s) above and/or below them. The objective should be a direct outgrowth of its tangential levels.

Second, the concept model for developing events provided access to the idea of the immense number of isolated units which may be coordinated for the educational event. The event model provides generic units of space and time which coordinate to make an event. Starting with any specific example of a generic unit all others may be chosen to fit with it. Learning to do this may be played as a game of matching. This concept freed the students to imagine their own content from a considerable number of objectives and goals. It stopped or reduced their seeking of "art ideas" whole cloth as if they were goodies hiding just over the horizon. It helped the student to realize that art activity evolves out of the specifics (objects, humans and ideas) of any event. These specifics are validated according to the reason for their inclusion, shown as goals and objectives in the model of enlarging locales. These two concepts, presented as a system of interrelated parts, helped the students to realize that the educational event is contextual in nature and that its limitations as well as its potential are derived from the parts of the context.

Group A began to state the ideas that were to determine curricula as a total class. Group B divided into two sections. Each of these groups, representing a society's wishes in microcosm, enunciated the values they could agree upon as a group. This took them through Levels I and II of the model (Figure 8-11). Level III provides for a choice of perspectives for the content, depending upon the curriculum theory chosen by the student. Thus, Levels III through V were evolved individually as preteaching plans, all coming out of the base laid in Levels I and II. Development of Level VI could only occur within a real, not a simulated or a future oriented event. This is the face-to-face encounter; therefore, not a part of our seminar on curriculum. The contract outline (Figure 8-1) refers to these Levels in the circled Roman numerals IV, V, and VI. The diversity and depth of understanding in individual curriculum plans is witness to the opportunity for personal involvement which

143

LEVELS

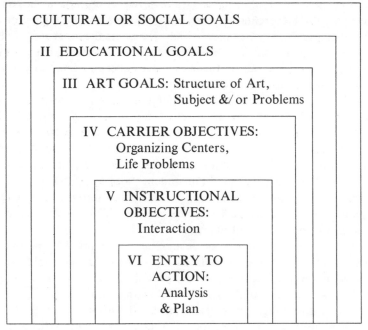

Depiction of how levels of curriculum are related to one another. The tele-scoping rectangles show that each succeeding level is less comprehensive than the former and fits into its scope. Level I is the most global or comprehensive, gradually focusing down to very specific analysis and ordering necessary for a moment of interaction at Level VI.

The taxonomy: (a) moves from general to specific,

(a) from abstract to concrete,

(c) it pyramids as it becomes specific,

(d) levels I, II, & III depict generalizations,

(e) and levels IV, V, & VI depict specifics as defined by time/space.

This taxonomy was developed to illustrate the position in a continuous sequence of objectives which is occupied by instructional (or behavioral) objectives. With such a series of references, this technology can develop the specificity needed by today's educational personnel.

FIGURE 7-11. A PARADIGM DEPICTING A TAXONOMY OF CURRICULUM OBJECTIVES*

*This concept is an outgrowth of a number of sources on systems and particularly of the theoretical speculations of Manuel Barkan in *A Seminar in Art Education for Research and Curriculum Development*, p.245-246.

144

has been the outcome of this task and of the series of behavior based tasks which have made up the experiment in art teacher preparation presented in this chapter.

The development of art teachers who have the capacity to change with the demands of their profession led to encouragement of a general attitude of questioning. This technology has had little acceptance among art teachers, thus it has had little chance of empirical testing. It seems desirable to keep an objective view by continually questioning its viability, not for reasons of dismissal upon romantic or reactionary bases. Rather for reasons of sound scholarship. Behaviorizing the professional education of art teachers, including the specific knowledge and skills necessary to do so, must meet the question of what is the half-life of this subject matter and at what time in the future will its relevance, procedure and/or attitudes pass its inflection point and start downhill toward obsolescence? Meanwhile there is much to be said for the advantages it provides the teacher/leader and the learner/guide for increased control of their environment.

REFERENCES

1 Skinner, B.F. *Beyond Freedom and Dignity,* N.Y.: Knopf, 1971, pre-publication condensation in *Psychology Today* August, 1971, p. 37.
2 Woodruff, Asahel. *Instructional Materials* Preconference Educational Research in Art Education NAEA, HEW Project No. 8-0259, 1968 (Xerox).
3 Davis, Donald Jack, ed. "A Circus: A Carrier Project Model for the Primary Grades" University City, Mo.: The Arts in General Education Project, 1968 presented as part of *Instructional Materials* Preconference Educational Research Program in Art Education NAEA, HEW Project No. Asahel Woodruff, dir., 1969 (Xerox)
4 Barkan, Manuel and Laura Chapman. *Guidelines for Art Instruction through Television for the Elementary Schools.* Bloomington, Ind.: National Center for School and College Television, 1967.
5 Rueschhoff, Phil and M. Evelyn Swartz. *Teaching Art in the Elementary School,* N.Y.: Ronald Press, 1969.
6 Kaelin, Eugene. "Are 'Behavioral Objectives' Consistent with Social Goals of Aesthetic Education?" *Art Education,* November, 1969, p. 4.
7 Eisner, Elliot. "Instructional and Expressive Educational Objectives: Their Formulation and Use in Curriculum" in *Instructional Objectives,* American Educational Research Association Monograph Series on Curriculum Evaluation, Number 3, Chicago: Rand McNally and Company, 1969, pp. 1-18.
8 Kuhn, Marylou, "The Relevance of Art Education to the Future" *Art Education,* June, 1967, p. 4.
9 Scherchen, Hermann, "The Musical Past and the Electronic Future" *Saturday Review,* October 31, 1964, p. 65.
10 Unterecker, John. "Art as Intersecting Fields of Energy" *Saturday Review,* June 14, 1969, p. 38.
11 Kuhn, Marylou. "Responses to Social Cultural Forces on Art Education which are Nonrandom, Multiple Institutional and Individual" paper presented to International Society for Education through Art World Congress at Coventry, England, August, 1970. (unpublished)
12 Burnham, Jack. *The Structure of Art.* N.Y.: Braziller, 1971.
13 Kuhn, Marylou. *Op. Cit.* INSEA, 1970.
14 Kuhn, Marylou. *Op. Cit.* INSEA, 1970.
15 Levi-Strauss, Claude *The Savage Mind.* Chicago: The University of Chicago Press, 1966.
16 Holt, John *The Underachieving School.* N.Y.: Delta Dell, 1970.

17 Illich, Ivan "The Alternative to Schooling" *Saturday Review,* June 19, 1971, p. 44 and *Deschooling Society.* N.Y.: Harper & Row, 1971.

18 Kuhn, Marylou "Creative Potential in the Visual Arts for the American Adult" unpublished doctoral dissertation, Ohio State University, 1958.

19 Burnham, Jack. "Art in the Marcusean Analysis" *Penn State Papers in Art Education, No. 6, Penn State University, 1969.*

20 Fuller, R. Buckminister and John McHale. *Inventory of World Resources, Human Trends and Needs,* Document No. 2, 1963 and *Comprehensive Thinking,* Document No. 3, 1965. World Design Science Decade 1965-1975 Southern Illinois University: World Resources Inventory.

21 de Chardin, Pierre Teilhard. *The Phenomenon of Man,* N.Y.: Harper & Bros., 1959.

22 Nixon, Richard "Message on Educational Reform" to the Congress of the United States, March 3, 1970.

23 Martin, Warren. "A Conservative Approach to Radical Reform" in *The Individual and the System: Personalizing Higher Education.* W. John Minter, ed., Western Interstate Commission for Higher Education, 1967, p. 38-39.

24 Silberman, Charles E. *Crisis in the Classroom,* excerpt from Ch. 11, "The Education of Educators" in *Perspectives on Education,* N.Y.: Teachers College/Columbia University Winter, 1971.

25 Arnheim, Rudolf. *Visual Thinking.* Berkeley: University of California Press, 1969.

26 EPIC Evaluation Center "Educational Objectives Workbook" Tucson, Arizona prepared for Conference of the Florida State Department of Education and FSU Office of Continuing Education, Tallahassee, 1968 (Xerox).

27 Woodruff, Asahel D. *First Steps in Building a New School Program,* Mimeographed booklet, Salt Lake City, Utah: Bureau of Educational Research, University of Utah, 1967, p. 13.

28 Smith, Philip G. "Verbal Operations in Classroom Instruction" *Improving the Teaching of Art Appreciation,* David Ecker, director HEW & U.S. Office of Education Cooperative Research Project No. v-006, 1966, p. 107-145.

29 Hall, Edward. *The Silent Language,* N.Y.: Doubleday, 1959 and Fawcett Premier (8 printing), 1966.

30 Weiner, Norbert. "Cybernetics" (1948) *Communication and Culture.* Alfred G. Smith, ed. N.Y.: Holt, Rinehart & Winston, 1966, p. 25; and "Cybernetics and Society" and "Some Communications Machines and their Future" *The Human Use of Human Beings* (1950) N.Y.: Houghton Mifflin reprinted in *The Human Dialogue.* Floyd W. Matson & Ashley Montagu, ed. N.Y.: The Free Press, 1967.

31 Barkan, Manuel "Curriculum Problems in Art Education" *Report of Seminar in Art Education for Research and Curriculum Development.* Edward Mattil, dir. HEW & U.S. Office of Education Cooperative Research Project No. v-002, 1966, p. 240.

CHAPTER VIII

THE DEVELOPMENT OF A BEHAVIORAL APPROACH IN A RESEARCH COURSE IN ART EDUCATION

John A. Michael
Miami University

Research is one of a required core of courses for those students pursuing a master's degree with art education as a field of concentration at Miami University. Generally speaking, this course is to acquaint students with research, noting kinds and purposes, methods, important people in the field, and appropriate written research form for those who elect to do a thesis. The materials presented herein should not be thought of as final and complete, but as being experimental and evolving. This course is taught primarily as a seminar in research, there being little or no lecturing. Class discussion centers around readings in the field and the research projects being carried out by the participants. At the present time, the following are the behavioral objectives of the course which have been developed.

Behavioral Objectives

1. To read, discuss, and evaluate (oral and written) current and past research in the field and related areas as found in various types of publications, dissertations, etc.

2. To identify and discuss the outstanding researchers in the field of art education.

3. To recognize and discuss the importance of research in solving problems in the field of art education.

4. To identify and discuss problems concerning the field of art education which are amenable to research methods.

5. To differentiate among various common types of research, i.e., experimental, historical, normative survey, empirical, theoretical, and alternative methods.

6. To apply research methods as a means of solving problems in art education.

7. To write an unchallengeable statement of a research problem with appropriate hypothesis(es).

8. To develop and appropriate design for a research study.

9. To analyze and evaluate one's research design and that of others in the class.

10. To identify and use the proper statistics appropriate for various research designs, i.e., percentages, correlations, measures of significance (t test, F values), etc., either by hand or by the computer.

11. To recall the meaning of various levels of significance: .05, .01, .001.

12. To interpret data via charts and tables.

13. To list conclusions and to interpret the results of one's own research findings, noting any significance for the field of art education.

14. To write the research study in accepted thesis form.

15. To present orally before the class and guests the research study which was conceived and carried out.

These behavioral objectives are achieved by four activities or projects: (1) class discussion-participation, (2) written summaries (three) of research in art education and/or related areas found in the literature of the field, (3) a research project (written in thesis form), and (4) an oral presentation of the research study. The research project which the student develops and carries out is considered the most important aspect of the course. The following is an edited example of one of the resulting studies by a member of the class. This study has been edited severely because of space. Introductory pages, related literature, bibliography, and appendices are not included.

A STUDY OF THE RELATIONSHIP BETWEEN ABSTRACT QUALITIES OF CEREBRAL PALSIED CHILDREN'S PAINTINGS AND DISEASE INVOLVEMENT (CONDUCTED BY MARGARET B. NEEL, ART TEACHER FORMERLY WITH THE CINCINNATI PUBLIC SCHOOLS).

Introduction

Of all the handicapped children taught in art classes, the cerebral palsied child seems to be the most neglected in both literature and practice. This may be due to the fact that there usually is a communication barrier and that art work generally does not appeal to this child because of his gross muscular movements. Therefore, it would seem that more knowledge of this particular child and his art aptitudes would be beneficial in identifying, understanding, and evaluating his work.

Painting is an art area in which these children enjoy their efforts and pro-

duce satisfying results. They are involved in their painting to a remarkable degree and pursue their work for long uninterrupted periods. Even though their paintings appear somewhat abstract, they are generally ready and eager to explain them, tell a story about them, or relate them to meaningful personal experiences. After examining their paintings for some time, the following question arose. Is the degree of abstractness closely related to the degree of disease involvement of the child? If such be the case, it may be possible for art teachers to ascertain from the abstractness of a child's painting some indication of the severity of the disease involvement and vice versa. The following pilot study was undertaken with the hope of giving some insight and understanding to the art work of the cerebral palsied child and thus help the teacher guide the child and aid his progress.

Carrying Out the Study

Working with the null hypothesis—there is no relationship between the degree of abstractness of the cerebral palsied child's art work and the degree of his disease involvement—the study was carried out with the fourth, fifth, and sixth grade cerebral palsied children in the Condon School of the Cincinnati Public Schools.

Paintings from the regular art classes of this group were collected over a four-week period. In each painting the child was asked to paint something that interested him. He was then given an opportunity to explain his picture and relate its meaning and contents. If the child could not talk about or explain his picture in an understandable manner, the picture was not used. In all of the paintings used for this study, the children were attempting to depict concrete (realistic) and meaningful experiences in their lives.

The doctor's diagnosis was taken from the medical charts, coded with a three-point scale, and placed on the backs of thirty-three pictures which were produced. The following scale was used: 1 - minimal, 2 - moderate, 3 - severe. The pictures were then taken to Miami University, where they were displayed on bulletin boards. Nine graduate students in art education were asked to judge them, also on a three-point scale, concerning abstractness. The judges were made aware of the following scale: 1 - realistic, meaning that everything in the picture corresponded to some known or recognized person, place, or thing; 2 - partially abstract, at least one thing in the picture was abstract, the quantity of realistic or abstract qualities did not matter but the picture contained both; and 3 - abstract, meaning there was nothing in the picture that corresponded to a known or recognized person, place, or thing.

Findings and Conclusions

The doctor's diagnosis of disease involvement was correlated with the judgments of the art educators concerning abstractness, resulting in a high positive correlation of .88. See Figure 8-1. For nine of the thirty-three paintings,

149

Picture Number	Judges' Ratings of Abstractness								Doctors' Diagnosis of Disease Involvement
	Judges								
	A	B	C	D	E	F	G	H	
1	3	3	3	3	3	3	3	3	3
2	3	3	3	3	3	3	3	3	3
3	2	2	2	2	2	2	2	2	3
4	1	1	1	1	1	1	1	1	1
5	2	2	2	2	2	2	3	2	2
6	3	3	3	3	3	3	3	3	3
7	1	1	1	1	1	1	1	1	1
8	2	2	2	1	2	2	1	2	2
9	3	3	3	3	3	3	3	3	3
10	3	3	3	3	3	3	3	3	3
11	1	1	2	2	1	1	1	1	1
12	1	1	1	1	1	1	1	1	1
13	2	2	2	1	1	2	1	2	1
14	1	2	2	1	1	1	2	2	1
15	1	1	1	1	1	1	1	1	1
16	2	2	2	2	2	2	2	2	2
17	3	3	3	3	3	3	3	3	3
18	3	3	3	3	3	3	3	3	3
19	1	2	2	2	2	2	3	3	1
20	1	1	2	1	1	1	1	1	1
21	2	1	1	3	2	3	2	3	2
22	2	2	3	1	2	2	2	2	2
23	2	2	2	2	2	2	2	2	2
24	1	1	2	2	1	1	2	1	1
25	2	3	1	2	2	3	3	3	2
26	1	1	2	2	1	1	2	2	1
27	2	2	1	1	1	1	1	1	2
28	2	2	1	1	1	2	1	2	2
29	2	2	2	1	1	2	2	2	2
30	1	2	1	1	1	1	1	1	1
31	1	1	1	1	1	1	1	1	1
32	3	3	3	3	3	3	3	3	3
33	3	3	3	3	3	3	3	3	3
Grand Means							1.95		1.91

r = .88

FIGURE 8-1. CORRELATION OF JUDGMENTS CONCERNING ABSTRACTNESS IN PAINTINGS AND DIAGNOSIS OF DISEASE INVOLVEMENT OF CEREBRAL PALSIED CHILDREN

note the 100 per cent agreement among the judges and between the judges' scores and the doctor's diagnosis for the abstract pictures belonging to the severely involved cerebral palsied children.

It appears that there is a strong relationship between disease involvement of cerebral palsied children and abstractness in their paintings, thus rejecting the null hypothesis. Therefore, one may assume that it is somewhat possible to tell from the abstractness of the paintings of the cerebral palsied subjects the degree of disease involvement, especially in the paintings of the severely handicapped. The results also suggest that even though realistic forms are intended by the child, there is a strong tendency for the art work to become abstract in character. Such knowledge of the relationship of the intent of the child, abstractness in painting, and disease involvement is of prime importance to the teacher who instructs cerebral palsied children in art.

A checklist and three rating scales are used for evaluation and are distributed at the beginning of the course. Both the students and the instructor may use these same instruments privately, in conference, or both. Aspects of all behavioral objectives are included in these measures which involve the four activities of the class. The checklist and rating scales follow.

Summaries of Three Research Studies in Art Education Yes No

1. Title is given completely .
2. Date of report is noted .
3. Researcher is listed .
4. Source is noted .
5. Design of research is given .
6. Statistics used are noted .
7. Conclusions and findings are summarized
8. Type of research—experimental, historical, survey, etc.—is identified .
9. Original sources are used .
10. Student's name is given on each summary
11. Summary is typed .
12. Student's evaluation of the research is given

Evaluation Form: Using the scale below, evaluate your work for the course
3 - outstanding, honors
2 - appropriate, good
1 - poor, lacking

Class Discussion—Participation 1 2 3

1. Attended all class sessions .
2. Participated in discussion .

3. In class discussion, designated research studies
 and researchers from reading.
4. Contributed original ideas, criticisms, etc.,
 concerning research titles, designs, procedures,
 conclusions, etc. .
5. Cooperated in evaluating and judging art work,
 etc., for classmate's studies .

The Research Study 1 2 3

Problem (Introduction)

1. Problem clearly stated. .
2. Hypothesis(es) and sub-questions are appropriate. . . .
3. Significance recognized. .
4. Problem properly limited. .
5. Assumptions stated. .
6. Limitations recognized. .
7. Important terms defined. .
8. Content well organized. .

Review of Related Literature (When available)

1. Adequately covered. .
2. Well organized. .
3. Adequately summarized. .

Procedure—Design of the Study

1. Design and procedure are appropriate for the problem
2. Design and procedure are described in detail.
3. Design and procedure are well organized.
4. Appropriate data-gathering devices (measures) used. .

Data and Results

1. Data clearly presented. .
2. Data adequately analyzed (appropriate statistics
 if applicable). .
3. Results followed from data. .
4. Results clearly stated. .
5. Data and results well organized.

Conclusions

1. Conclusions follow from results.
2. Clear interpretation given of results.
3. Significance to the field indicated.

Summary (If included)

1. All important aspects of the study included..........
2. Summary concisely and clearly stated.............
3. No new material presented......................

Form and Style of Writing (According to a prescribed 1 2 3
guide, i.e. William G. Campbell, Kate Turabian)

1. Margins...
2. Spacing...
3. Headings..
4. Quotations..
5. Footnotes...
6. Pagination..
7. Typing..
8. Tables..
9. Figures...
10. Title page..
11. Table of contents.................................
12. Bibliography......................................
13. Appendices..
14. Spelling..
15. Sentence structure................................
16. Writing style.....................................

Oral Presentation of the Research Study

1. Content clear and well organized (logically
 ordered)..
2. Charts and tables used to aid explanation
 (if appropriate)................................
3. Depth of understanding the problem area indicated
 by reference to other work in the area.............
4. Design and procedure defended....................
5. Results and conclusions clearly stated.............
6. Significance of the study to the field pointed out.....
7. Enthusiastic manner held interest of class

CHAPTER IX

A TRILOGY OF BEHAVIORAL CURRICULUM MODELS

Jessie Lovano-Kerr
Indiana University

Part I: Undergraduate Elementary Art Methods Course
 Sequel: Art Unit for Grade 2
Part II: Classroom Inquiry—Individual Assessment of Performance
Part III: Art Experiences for the Educable Mentally Retarded

Introduction

The coming-of-age of behavioral objectives in art education has been nurtured by the discrepancies observed between what art curricula purport to do and what actually occurs in the classroom. These discrepancies may be the result of confusing the objective—the learning outcome, with the instruction—the learning experience. Basic to this confusion may be the lack of certainty and agreement on what the specific goals of art instruction should be. To alleviate this confusion two vital tasks need to be confronted: one, defining art content and identifying specific art behaviors; two, developing methods for better evaluation of processes and products.

The author views behavioral objectives as organizers for the teacher and as advanced organizers for the student. As organizers for the teacher, they aid in curriculum planning and student evaluation, and as advanced organizers for the student, they identify course expectations and define evaluation procedures. Curriculum that is behaviorally based can also be used as a means to describe to others, in specific terms, what one is trying to accomplish.

The purpose of this article is not to describe how to write behavioral objectives, nor to laud or criticize their use, but rather to outline three uses that the author has made of behavioral objectives.

Part I: Undergraduate Art Methods Course

Undergraduate art education majors at Indiana University take a sequence of four methods courses, the first of which surveys the field and emphasizes art teaching at the elementary school level. Most students in this

course are first term juniors with fifteen credit hours or more in art studio and art history.

Minimum level behavioral objectives as described in McAshan[1] were used as the model for defining this curriculum. Objectives at this level give a complete, basic statement of the goal as well as stating the performance, behavior, activity, or instrumentation, that will be required of the learner in the evaluation of his achievement of the intended goal. The minimum level behavioral objectives allow for increased teacher flexibility in stating goals and in planning strategies for carrying out activities to obtain these goals. As pointed out by McAshan this level provides an alternative approach to behavioral objective development when it is either impractical or impossible to develop an objective into a higher level classification, especially if appropriate behavioral observations and critical standards are not available for the purpose of evaluation. Another reason for using this level is to allow for individual differences, since individual students are not expected to react the same way in all situations or toward all common phenomena.[2]

The following course description defines goals and states minimum level behavioral objectives for each task:

Art in the Elementary School: The main objective of this course is to provide a number of diverse performance experiences within a general framework of art education theory and related areas for the purpose of developing competencies germane to art teaching in the elementary school. This course values and incorporates many opportunities for the participant to draw on his new experiences and ideas and use them in realistic situations.

The first eight weeks of the course focus on student participation in panel and individual content presentations, observations in the elementary school, textbook assignments and quizzes, curriculum development, and training in the use of A-V equipment and the development of instructional visual materials.

The second eight weeks of the course concentrates on teaching performance in the elementary school. Each student is assigned to teach art once a week for eight weeks to an elementary class. Students meet weekly at the University to evaluate current lesson plans, to discuss problems encountered during the last teaching experience and to exchange ideas and observations.

The student records his teaching experiences with reference to the total effect of each lesson taught.

Mid-term and final individual conferences are used to assess the student's progress and the effectiveness of the course.

1. Minimum Level Behavioral Objectives for each task:

A. Student Panel Presentations:

 1. To demonstrate an understanding of some aspects of contemporary culture and how these forces influence the teaching of art.

2. To demonstrate the ability to research the content of art theory (child development in art, evaluation of children's art, creativity, perception, etc.); to summarize salient points and to present the information in a unique, visual manner emphasizing the implications for teaching art.
3. To demonstrate the ability to plan a learning experience, to perform with confidence in front of peers and to experiment with new ideas for presenting information.
4. To demonstrate a knowledge of where to obtain visuals, how to develop instructional materials, and of how to use A-V equipment.

Evaluation: Students are evaluated by peers using a form that defines criteria appropriate to each stated objective.

B. Observations in the Elementary Schools (6):

1. To develop the ability to analyze teaching—learning activities in relation to different schools, teachers, teaching strategies and students.
2. To use this analysis to select a preferred grade level, teacher and school for his own teaching experience.

Evaluation: Observation form completed by student after each experience.

C. Media Presentation:

1. To demonstrate the ability to research, independently, an unfamiliar medium appropriate to the elementary level, develop a lesson plan, and present it to peers.

Evaluation: Students are evaluated by peers using a form that defines criteria standards appropriate to the task.

D. Textbook (McFee):

1. To demonstrate the ability to think with the content in McFee through the use of hypothetical situations presented in four essay quizzes of twenty-five possible points.

Evaluation: Level of performance expectation is 20 to 25 points.

E. Curriculum Development

1. To demonstrate the ability to distinguish between three different teaching strategies: Discovery-Inquiry, Didactic and Nondirective.
2. To demonstrate the ability to write performance objectives. Criterion level: The written objective must specify what the

pupil will be able to do as a result of the lesson, what concepts are to be learned, what skills are needed and what criterion standards will be used for evaluation.

3. To demonstrate the ability to design and organize a learning experience that includes the following components:
Previous experiences
Present activity
Performance objectives
Concepts, skills and information needed
Method of presentation
Materials needed
Organization of materials, students, equipment
Evaluation

4. To demonstrate the ability to define or identify what can be taught in art and how it can be taught most effectively.

Evaluation: Specificity of lesson plans.

F. Field Experience:

1. To demonstrate the ability to translate written lesson plans into an actual teaching-learning experience.
2. To demonstrate the ability to relate to students and be sensitive to the psychological and physical environment of the classroom.
3. To demonstrate the ability to get students involved and interested in the activity.
4. To demonstrate the ability to identify and cope with adverse student behavior.
5. To demonstrate the ability to time an art activity to comply with the limits set, and to organize appropriate clean-up procedures.
6. To demonstrate the ability to use visuals and A-V equipment for more effective presentations.
7. To demonstrate the ability to assess whether performance objectives of the lesson were reached.
8. To demonstrate a professional attitude during the field experience. (To include: adherence to school policy, preparedness, promptness, responsibility, interest, cooperation, etc.).

Evaluation: Classroom teacher-university student mutual agreement on the quality of performance using an evaluation form that incorporates the above criteria.

Sequel: Art Unit for Grade 2

A critical task for the student in the above described courses is to develop a curriculum for a specific grade level using behavioral objectives. Since curriculum development is one of many tasks included in the introductory methods course, the initial presentation of the theoretical bases for behavioral objectives and their uses is not complete. Subsequent methods courses extend this initial experience improving the student's competencies in preparing behavioral objectives. Students use the three basic questions in Mager's book as a framework for developing and critiquing curricula: "What is it that we must teach? How will we know when we have taught it? What materials and procedures will work best to teach what we wish to teach"?[3]

Determining the content of art, writing meaningful objectives, identifying, defining, and measuring terminal behaviors and designing instructional procedures to accomplish these goals appears to be a formidable task even for the experienced art teacher. However, students accept the challenge. They write behaviorally based lesson plans; try these plans on children, and then evaluate their experiences, critically reviewing the structure and content of their lessons with the intent of improving the next teaching experience. As would be expected, increased skills and competencies in writing and using behaviorial objectives in teaching evolve from this procedure.

The following is a selection from some lessons on art designed by a student in the course and used by him in a second grade class:

Lesson Plan I **Line**

A. Introduction

 1. Discovery for these six weeks will include line, shape, space, texture, and color.

B. Present Activity: Drip Printing

 1. Drip printing relates to the previously learned principle of form and to the present lesson on the principle of line.

C. Behavioral Objectives

 1. As a result of today's activities students will be able to coordinate the geometric principle of line with the artistic principle of line.

 2. Students will observe a peer demonstration depicting the directional patterns of line. As a result of this demonstration, each student will be able to express verbally and draw manually on newsprint with a crayon the directional patterns of line such as diagonal, horizontal, perpendicular, radiating, and circular.

 3. Each student will be able to draw manually on newsprint with a crayon a line to represent different moods such as fear, anger, humor and love.

4. Each student will be able to drip lacquer on cardboard shaping a vivid design. Each student will be able to repeat dripping on top of the lines already formed in order to build up the surface of the lacquer.

D. Concepts, Skills, Information Needed to Fulfill the Desired Behaviors:

1. Perceiving, directed toward evaluating and discriminating in the use of line.
2. Design Elements (Concepts-Information): Expressiveness and use of line with an end result of producing a combination of lines into an organized design.

Lesson Plan II **Shape**

A. Previous Activity: Line

B. Present Activity: Shape

C. Behavioral Objectives:

1. The students will be able to reinforce their learned directions of line in an alternate activity which involves decorating a portable cylindrical sculpture.
2. Utilizing the cardboard block, each student will be able to ink the roller, ink the bottle, print with a wooden spoon, and "pull" the print.
3. Each student will be able to draw, glue, and piece together shapes into a preferred line pattern.
4. Each child will be able to handle the various tools for the four operations in printing a block.
5. Each student will be able to verbalize the functional utility of each piece of printing equipment.

D. Kinds of Concepts, Skills and Information:

1. *Concepts:* Through visual perception and physical activity each child will have formed the basic knowledge of what constitutes a print.
2. *Skills:* Having previously constructed a block, each student will be able to become involved in the printing process.
3. *Information:* The printing process will enable the student to differentiate "printing" as a distinct technique uniquely different from "drawing" or "painting".

Students will give a visual demonstration of shapes in space and will show how overlapping gives an illusion of depth. The demonstration will also

show how shapes seem to vary in size according to the size of the picture plans.

Lesson Plan III **Space**

 A. Previous Activity: Shape

 1. *Concepts emphasized:* Line segments that are stretched, bent, or inverted can become a shape.
 2. *Skills:* Overlapping the shapes produces the dimension of depth.
 3. *Information transmitted:* Cylindrical sculpture utilizes both line and shape in forming unique patterns.

 B. Present Activity: Building a piece of sculpture and "pulling" a print.

 C. Behavioral Objectives

 1. The student will be able to view the sculpture of famous artists and determine the balance, rhythm, and dominance of each piece.
 2. Each student will be able to sketch his own sculpture and use as many principles as possible in his creation.
 3. Each student will be able to ink the roller, ink the block, print with a wooden spoon, and "pull" a print.

 D. Kinds of Concepts, Skills and Information:

 1. *Concepts:* Each student will be able to distinguish the different processes involved in building a sculpture. Verbal interaction will initiate his awareness of the dimensions of balance, rhythm, and dominance and subordination. Also through visual perception and physical manipulation each child will form the conceptual knowledge of what constitutes a "print". Lastly, each child will form a beginning concept of what elements make a collage.
 2. *Skills:* Students will be involved in such mental activity as contrasting famous sculpture, organizing new concepts, and discriminating subtle variations. Additionally, they will be able to define and describe through graphic illustration their understanding of the newly learned principles by sketching their projected piece of sculpture. Manual coordination will be a necessary skill in completing the end product. Visually receptive students will look for a variety in texture and pattern in a film.

Lesson Plan IV **Texture**

 A. Previous Activity: Space

 1. *Concept emphasized:* Space has dimensions of balance, rhythm, and dominance and subordination.

2. *Skills:* Mental activity to the point of discrimination between subtle variation in concepts is acquired in addition to the physical skill of manipulating a hammer and coping saw.
3. *Information Transmitted:* Vocabulary, design, and materials are all important variables to be considered when utilizing space as in making a piece of sculpture.

B. Present Activity: Texture

C. Behavioral Objectives:

1. Utilizing a cardboard backing of 18 x 24 inches, each student will develop a collage utilizing his understanding of line, shape, space, and texture. The student will cut, glue, and paste his collected materials to form a spatial design that he will be able to verbally describe to his peers.
2. Each student will review with the aid of visuals the principles of line, space, shape, and texture and will begin to verbalize these terms when discussing his art work.

Lesson Plan V **Color**

A. Previous Activity: Texture

1. *Concept emphasized:* Design contains elements of line, shape, space, and texture.
2. *Skills:* Knowing the concepts of line, shape, space, and texture, each student glued, pasted or stapled materials to form a collage.
3. *Information Transmitted:* Collage is a design which utilized different media to achieve a successful balance between the elements of design.

B. Present Activity: Color

C. Behavioral Objectives:

1. Utilizing previous demonstration groups, the students will be able to review within their groups of five the important factors in their element of design and will give this information to the class in a demonstration that will be taped and can be played at the art fair. After this review of concepts, each child will be given pentels to sketch a design on the film.
2. Each group of students will be able to choose a method to point out the importance of an element of design.
3. Each group will be able to describe and define for the class, the connotative values of their element in design.
4. Utilizing these concepts of design, each student will be able to sketch a colored design on film.

162

Part II: Classroom Inquiry:
Individual Assessment of Performance

How do we know how much an individual child has learned as a result of instruction? Do we state desired or expected success level of performance for an entire class?

The literature on objectives emphasizes the importance of defining terminal behavior by stating conditions to be met by the learner in demonstrating his mastery of the objective,[4] or by specifying the desired level of performance[5] using a criterion standard for the expected success level. Explicit in the literature is the potential and possibility of using objectives for individualized instruction.[6,7] Yet, terminal behaviors, whether stated for a group or an individual usually are not concerned with pre-instructional levels.

A given student's readiness to assimilate certain concepts, skills or knowledge may be greater than or less than the specified level of performance necessary to enable him to advance to criterion. It is possible for a student to have greater increments of learning than his peers, yet not meet the criterion standard stated by the objective. The educational significance of his accomplishments tend not to be recognized. On the other hand a student who is more endowed may need to exert very little effort to reach the desired level of competency. Although his increment of learning is much less, his rewards are greater for having reached the "finishing line".

If we want to make success possible for children of the same age who display different levels of readiness to learn, then we need to assess both the initial level and the final level to determine the increment of learning. While the author gives an example below of a behavioral objective based on learning increments (incremental objectives), she feels that much more attention should be given to the concept.

To test the effectiveness of using objectives of this nature in the classroom, the author designed a pilot experiment in classroom inquiry.

The purpose of the inquiry was three fold: (1) To determine the level of readiness of the student to graphically represent space, (2) To determine the effects of short-term instruction on the readiness level of the student, and (3) To determine the range of individual differences within each classroom.

Four art teachers and one art education undergraduate student participated in the inquiry. These participants were involved in a variety of teaching situations at the elementary level: inner city, mentally retarded, and middle class suburban. Each teacher received the same instructions with the suggestion that the vocabulary be adjusted for the comprehension level of their students. Prior to presenting the one or two lessons on spatial representation, each teacher instructed his students to draw a landscape. This was in the form of a verbal request without any elaboration. Spatial representation concepts such as overlapping, size of objects, position of objects, color intensity and detail were then presented by teachers to their respective groups by means of

the inquiry method and student involvement. Reproductions of scenes by landscape artists were shown and questions posed such as: How does this artist show that some objects are closer than others? The teacher continued to ask questions until all the spatial concepts were identified. Students were taken out of doors to experience spatial phenomena. Again, questions pertaining to space were asked. A number of student activities were suggested in which the spatial concepts of overlapping, size, and position could be demonstrated by positioning students in relationship to other students.

These instructions and procedures were developed from the following objectives:

> Given two lessons on devices which artists use to represent space and on the cues that we use in perceiving space, the student will be able to increase his concepts of spatial representation as demonstrated by pre and post instructional drawings. The post drawing will either achieve criterion (14th category) or will show an increment of learning of at least five categories on the Eisner Visual-Verbal Spatial Representation Scale.

The terminal behavior of each student will be a function of his initial readiness level, the effect of the instruction and his ability to translate perceptual information into graphic form. The Eisner scale identifies, graphically, the less sophisticated to more sophisticated devices used by children to represent space with a fourteen category range. Its clarity and simplicity makes this scale highly useable in an instructional situation.

The initial drawings indicated a wide range of individual differences in readiness for spatial representation within each group. The brief instruction narrowed the range considerably within each group and between groups even though the composition of the classes varied from mentally retarded children with a mental age of 9, to inner city children in the 1st and 6th grades and middle class suburban children in grades 3, 4, and 5. However, the greatest range within each group, appeared in the increments of learning as derived from the differences in the scores from the pre and post drawings. Some children moved from category 2 on the Eisner Scale to category 12, an increment of 10 categories; others in the same group moved from category 10 to 13—an increment of 3 categories (see Figure 9-1). If one were to look only at the terminal behavior, a limited amount of information about the actual achievement of individual students would be transmitted. Neither the student nor the teacher would be aware of how much was learned during the instruction. On the other hand, assessing pre and post instructional behaviors provides a measurement of individual growth and can provide guidelines for further instructional development based on the levels of student achievement of previous objectives. Using the concept of increment of learning as the basis for developing instructional objectives in art for educable retardates is the subject of Part III.

FIGURE 9-1. PHOTOGRAPHS OF STUDENT EXAMPLES

Part III: Art Experiences for Educable Retardates

The need for more research and curriculum development in art for retardates is made evident by the lack of relevant literature in this area. Art curriculum guides for the retarded generally give step-by-step procedures for making specific objects. The emphasis is on the use of materials and the following of directions. Art is generally viewed as therapeutic activity or as intermission between "hard-core" subject learnings. Until the time when we identify specific art behaviors appropriate for retardates, state the behaviors adequately for instructional purposes and develop the necessary instructional materials and evaluative instruments, special education administrators will continue to question the efficacy of art in the curriculum.

As an attempt in this direction the author, assisted by Steven Savage, designed several art units for retardates which are based on the incremental behavioral objective model.

A sequence of 36 lessons have been developed from behaviors identified as specific to two central themes: Body and self awareness and spatial representation. Although many concepts are repeated from lesson to lesson, activities, media, and objectives vary with each lesson.

Each child would be continually assessed according to his increment of learning as demonstrated by successive products when compared to the original product. For example, the child would be asked to draw a person prior to his art experiences in body and self awareness. The Marlen Scale on the Sophistication-of-Body-Concept or a more discriminating scale could be used to assess the child's drawing. All art products resulting from the 19 - lesson unit on body and self awareness would be compared to the initial drawing. An example of an incremental objective for this unit is as follows:

> Objective: Given certain experiences in body- and self-awareness, the student will achieve a score of 5 or demonstrate at least a 2 point increment on the 5 point Marlen Scale. These experiences will include comparing, contrasting, and analyzing of self with respect to others using drawings, mirrors, polaroids, clay, papier mache and other media.

The following is a brief description of the first lesson in the body and self awareness unit and an abbreviated synopsis of other lesson from this unit.[9]

I. Pre-Lesson Work:

A. Before beginning this unit:
 1. Take a full length polaroid photograph of each child, the classroom teacher and art teacher.
 2. Take three color slides of each child—front, side, back.
 3. Have each child draw a person, a self-portrait and full-length portrait.

II. Concepts:

 A. Every child has different physical characteristics.

 B. Every child has physical attributes similar to other children.

 C. Every child's side view, back view and front view differ.

III. Activities:

 A. Simultaneous projection of three slides showing the three views of each child.

 B. Simultaneous projection of three slides showing three different children for comparison purposes.

IV. Behavioral Objectives:

 A. The child should be able to recognize all children from various positions using the slides for identification purposes.

 B. The child should be able to recognize his own physical appearance from the different views present in the slides.

 C. The child should be able to contrast and compare the differences and similarities of his peers when shown simultaneous projections of three children.

Several subsequent lessons with similar concepts but different activities will be presented before the child is asked to draw another self-portrait and full length portrait. The purpose of comparing his initial drawings with the later drawings is to assess the increments of learning.

Synopsis of Lessons from the Body and Self Awareness Unit:

Lesson I

I. Concepts

 A. Every child is unique and worthy

 B. Every child has a different physical image.

II. Activities

 A. Children trace each other on a large sheet of paper, then each child paints and cuts out his own image.

 B. Teachers and students discuss the individuality of each tracing.

III. Behavioral Objectives

 A. The child should be able to trace another child so as to make the tracing look somewhat like the child.

B. The child should be able to paint his own tracing so as to reflect his own characteristics.

C. The child should be able to cut around his tracing so as not to destroy the image.

D. The child should be able to verbally discuss the differences between tracings.

Lesson II

I. Concepts

A. Every child is unique in physical appearance.

B. Children may have the same structural similarities, but each is unique in makeup and size.

II. Activities

A. Each child will develop a "How Big Am I" chart. This activity includes the measuring and recording of the height, width, and parts of the body.

B. Every child will participate in a number of physical activities designed to emphasize various parts of the body and their relationship to each other. Movements will be analyzed as to bodily positions and bodily parts used.

III. Behavioral Objectives

A. The child should be able to measure other members of the class.

B. The child should know the various parts of the body and their relationships to each other.

These introductory lessons are followed by a number of activities and experiences emphasizing self-awareness, self-concept, and body image, such as:

1. Drawing a full length self portrait and a head/shoulder self portrait.

2. Drawing and painting a head/shoulder portrait as well as a full length portrait of another class member.

3. Expressing feelings, first through actual movement (using music) and then in making gesture drawings using a model

4. Looking at reproductions of expressionistic portraits that depict emotions and feelings in facial expressions. Drawing a self portrait (using a mirror) showing a definite mood or emotion.

5. Molding a self portrait in clay.

6. Making papier mache puppets to resemble oneself and developing a puppet play with one or two classmates. Plays can be video-taped and presented in this medium.

Behavioral objectives are written at a minimum level for most lessons since clusters of lessons seem to be necessary for certain behaviors to be demonstrated and, also, to prevent evaluation activities and criteria from becoming too restrictive. With the completion of each lesson or cluster of lessons that emphasize a certain aspect of body and self awareness, the resulting product would be compared to the initial drawing. A record of incremental learning would be kept for each child. The child and the teacher would be made aware of the direction of graphic growth and the development that occurred as a result of the unit.

In summary, the author finds behavioral objectives to be a very useful tool in developing, organizing, and presenting art curriculum. If, however, the art curriculum is to retain its strength of flexibility and sensitivity to individual differences, it should not be tied down too securely by rigid performance criteria. It is in an attempt to preserve both specificity and sensitivity that the author is exploring the concept of incremental criteria.

REFERENCES

1 McAshan, H.H., *Writing Behavioral Objectives: A New Approach.* New York: Harper & Row, 1970, pp. 18-19.
2 McAshan, *Ibid,* pp. 18-19.
3 Mager, Robert, *Preparing Instructional Objectives.* Palo Alto, California: Fearon Publishers, 1962, p. V.
4 Mager, *Ibid,* p. 26.
5 McAshan, *op. cit.,* p. 23-25.
6 McAshan, *Ibid,* p. 18.
7 Woodruff, Asahel, "First Steps in Building A New School Program", unpublished materials, Salt Lake City: The University of Utah, 1968.
8 These lessons were written by an undergraduate student, John Sitterding.
9 Lovano-Kerr, Jessie and Steven Savage, "Incremental Art Curriculum Model for the Mentally Retarded" *Exceptional Children,* November, 1972, pp. 193-199.

CHAPTER X

COLLEGE ART INSTRUCTION FOR THE GENERAL STUDENT

Guy Hubbard
Indiana University
Judith A. Kula
University of South Carolina

Art barely touches the lives of most of the more intelligent youth of the nation who are attending institutions of higher education. Denial of art is clearly evident in a large proportion of elementary schools. The same is true of secondary schools. And college-bound youth attending secondary schools are typically less fortunate in art than most due to the constraints imposed by college entrance requirements. The mass of intelligent youth are thus systematically starved of an aesthetic education—all, paradoxically, in the name of "education."

On arrival at college most freshmen are again denied entry into art studies unless they propose to specialize in art or art education. On the level of general studies the chances of engaging in art experiences calculated to expand their sensitivity toward the visual aesthetic are either non-existant or are confined to lecture courses that often include in the titles words such as "survey" or "appreciation." This situation is pitiful wherever it occurs. Students marry soon after graduation and begin families. A few years later their children are attending elementary schools, and the cycle of aesthetic starvation begins all over again.

The program described here for college students is an attempt to attack this problem. It derives from the premise that general education is not a distant ideal but a matter of cultural survival. Recent writers, such as Maslow, Holt, Rogers, Tofler, Leonard, and McLuhan—to name only a few—have all sought to stir the minds of people to the crisis in living that we all face; but cultural patterns are impressive for their inertial qualities of resisting change. The primary intent of the course has been to open the study of art to large numbers of college students who would otherwise be denied the exposure to art and, in addition, to make it an experience that offers opportunities to students for freedom of choice that is typically not open to them. It is designed

to reach toward the goal of "effective living" where effort is directed toward personal needs and desires as distinct from the conventional educational goals of "scholarship" and "social conformity."[1]

Structure and Development

The course is a direct outgrowth of both the NAEA sponsored Research Training Institutes of 1968 and 1969 and an elementary art program developed by Guy Hubbard and Mary J. Rouse for use by non-artist teachers.[2] It consists of a cycle of seven steps (Figure 10-1).

Step One reflects assumptions such as those which introduce this paper, where the concern resides with the nature of human beings and an individual's right to expand in all areas of his potential—not the least of which is his expressiveness. It includes decisions relative to the appropriate functions of education in our society with specific reference to art. It is also the point where the substantive field of art is identified; and where data about human development in art are assembled. The character of all that follows is thus determined by decisions made at Step One.

Step Two is the point where those art learning objectives that are suited to non-art major college students are listed. This list is derived from decisions

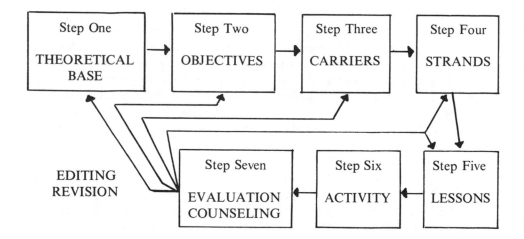

FIGURE 10-1. COURSE STRUCTURE

made at Step One. Over 600 objectives are in use, although this number is not thought to be by any means complete. Each objective is stated behaviorally and is classified as: perceptual, verbal, judgmental, or technical to correspond with the kinds of behavior that characterize the field of art.[3]

Step Three introduces the concept of the "learning carrier"[4] as a vehicle for the achievement of a cluster of related objectives. Thus while a certain carrier might appear superficially to be a lesson in collage-making using magazines and natural objects, it is more properly considered as an umbrella for objectives designed to steer students toward making judgments concerning the symbolic significance of various objects and images.

It will be apparent that given an inventory of explicit objectives, a program design staff may create innumerable learning carriers from combinations of objectives. In effect, the high level of specificity in defining objectives offers the opportunity for great diversity and flexibility of instruction compared with the more common methods of curriculum organization based on a simple progression through a series of experiences in a given medium or art form. Such specificity also encourages more accurate evaluation and more effective counseling.

The establishment of an inventory of objectives in Step Two led to the formulation of a corresponding inventory of carriers in Step Three. This system of linkages is developed still further in Step Four. The clusters of objectives that support carriers also exhibit relationships to one or more objectives in other carriers. A trained instructor is likely to appreciate the relationships that can exist, for example, between an art history lesson that instructs a person on the French Impressionist painters and a lesson in painting that directs a student to capture the character of a favorite outdoor location. And a task requiring cardboard sculpture based on arch forms may unite studio creativity with medieval art history. But typical undergraduates cannot be expected to do this. These relationships, therefore, have been established clearly in advance to permit students to take advantage of them. The result of this effort led to the construction of "strands" of related carriers (Figure 10-2). Progression through clusters of objectives is made clearly evident to the student for every assignment. Experience in working with students has also revealed the need for some terminal activity in order to invoke closure relative to a given sequence of instruction. Consequently, a series of seven terminal tasks has been introduced requiring that students do such things as mount a preferred product or write a brief critique of one or more products from within the strand.

The plotting of the objectives and carrier activities establishes the foundation for an extremely flexible system of art instruction that provides considerable freedom of choice for students, while not imposing the tyranny of extreme free choice—that offers no choice at all. But before the instruction can be made ready for student use, each carrier has to be translated into a form that a student can understand easily and, most important of all, will

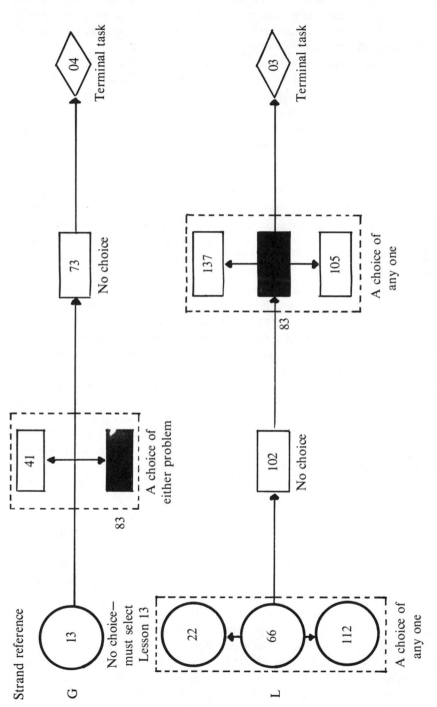

FIGURE 10-2. STRAND FORMATIONS

want to try. A fully complete set of instructions has been prepared that offers the student the maximum opportunity for success. Each carrier is subjected at Step Five to a formal analysis. A battery of nine sets of critical questions devised by Virginia M. Brouch is applied to every component of the material: (1) preparations; (2) resource distribution; (3) motivation and demonstration; (4) type of design emphasis; (5) materials selection; (6) art activities; (7) purposes of experience, and (8) evaluation.[5] This analysis serves as a checklist for writing the actual instructional materials—or lessons—that the student uses. The objective-carrier-strand material is thus finally translated into a manual of lessons.

The format of the lessons in the manual is identical. Each occupies one side of a single sheet of paper (Figure 10-3). Each is assigned an accession number for identification. Each is also given a title and a brief introduction calculated to attract student attention. A set of explicit directions follow in which reference is made to useful visual and literary resources for that lesson. This in turn is followed by a list of possible art materials.[6] At the base of each sheet is a diagram showing the strand or strands in which that lesson falls.

Step Six indicates the point in the system where student activity takes place. The present collection of 140 lessons is organized into 50 strands which, because of internal options within the strands, expands the actual number of strand pathways to over 250. Since only four strands are required for the two credit hour course it is apparent that individual students could never exhaust the possibilities open to them. And yet the number of opportunities has not revealed itself to be so great that students are swamped by the alternatives that face them.

Step Seven is undertaken when an assignment has been completed. A student may receive assistance at any time during the execution of a lesson, but when the work is done it is submitted for evaluation. The formal act of evaluation is made with reference only to the stated objectives, where the degree of success is recorded as a score on a five point scale. The student participates with a counselor in all the evaluation processes. Since the course takes a final grade of either Pass or Fail, a student has only to score modestly on each lesson in order to pass. In practice, students regularly take work back even when it receives the minimal passing score so that they may work on it further and improve it. Since no grade advantage may be gained, other than a higher score, the practice suggests considerable motivational value. Throughout the course, in fact, the evaluation process is used as an instructional device rather than as a screening mechanism for singling out those with talent.

Environment and Procedures

A number of obstacles face the art curriculum developer at the college level. Two important ones are space and staff, both of which are extremely costly when budgeted in the conventional manner. In planning this program these problems were identified and then by-passed. The program is held in a

CARRIER STATEMENT
TITLE AND INTRODUCTION

Instructions

1. _____

2. _____

3. _____

Suggested Materials

Strand Ref.

J

FIGURE 10-3. LESSON FORMAT

dormitory. Students work by choice either in their rooms or in a large lounge area. College dormitories naturally have limitations as art studios in that plaster, for example, is an unacceptable medium. However, through negotiation with the housing administration, the counseling staff, and the student government, it has been possible to include studio experiences in drawing, painting, design and lettering, textiles (mainly stitchery and weaving), collage, and sculpture into the course.

Formally scheduled class meetings were judged to be an impediment to the intent of reaching large numbers of students, so the lounge is staffed four evenings a week for three hours each evening. This disperses the large enrollment across twelve hours of time. The personnel problem has been further reduced by consigning much of the instruction to written form with supporting sound film strips, slides, prints, and specific book references. The actual staff consists of one teaching assistant and two experienced seniors—under faculty supervision. The teaching assistant trains and directs the activities of the seniors. This team then prepares a class of students enrolled in a secondary art methods course as paraprofessional instructors. This arrangement has been beneficial to both groups. The art methods students are exposed to a rich practicum experience.* The college students benefit correspondingly from having access to faculty, advanced graduate students, and their peers.

Typically a student enters the lounge, takes his record file to an instructor and signs in. He then proceeds to a table, on which there is a collection of course manuals. He searches among the 140 lessons for a topic he would like to pursue. All the pages in the manual are color-coded to correspond with different areas of art study, i.e., blue for painting, green for art history, pink for sculpture, etc. Lessons are clustered into strands that may follow a given area of art study or may embrace several related areas.

Having settled on a strand, the student then proceeds to execute the first lesson. If at any time, he feels uncertain about what is expected of him he goes to one of the instructors on duty. Before making his decision, however, he may want to see examples of work executed for that task by students enrolled in earlier semesters. To do this he asks to see the slides for that lesson. He may also ask to see a particular print or read an extract from a book recommended for that lesson. Should he select a history lesson he would ask to see the appropriate sound film strip.[7] All of these resources are housed permanently at the instructional site and are available on demand. Crowds are unusual in this course because of the absence of formal sessions, so a student will only rarely have to wait more than a few minutes to have his requests satisfied.

Three projection units are used in the course. They are housed in specially designed cabinets (Figure 10-4). They consist of two sound film-strip projectors and one carousel slide projector. The hinged top of a cabinet

*Students in this course also have practicum experiences in secondary schools.

PROJECTOR:
slide, sound film
strip

SCREEN

MIRROR

36"

24"

36"

30"

FIGURE 10-4. INSTRUCTIONAL FURNITURE

creates a simple rear projection system. The lower part of each cabinet consists of lockable cupboard space. Each unit stands on large rubber-tired casters and may easily be rolled to a point where a sound track may be listened to without interference. Since rear projection is employed, students are able to view images in near normal lighting without loss of definition. Three smaller units have also been constructed. They are table-top height and serve as counseling centers and as storage cabinets for student records, books on art, course manuals, art prints, etc. All six units are rolled into a corner at the end of an evening, where they are locked together and resemble nothing so much as a collection of kitchen stoves or refrigerators.

As the semester progresses, a student works his way through four strands including at least one in studio and one in art history. He works at his own pace. Some students complete the requirements of four strands by mid-semester and frequently continue working throughout the remaining time. A few students have enrolled at mid-semester and have finished by the semester end, although university administrators tend to frown on this practice. Other students find it difficult to discipline themselves and need continual help and encouragement to keep going.

Regardless of the status of a student's work, however, he is obliged to sign in once a week with the instructional staff. Early in the history of the course it was found that freedom was a mixed blessing for students who had spent their school lives following instructions and meeting deadlines set by other people. They had to be assisted to make the most of their liberty.

Postscript

The course has attracted large numbers of students for seven semesters, and its future seems assured. But the potential for this system of instruction has by no means been exhausted. Modified versions have been successfully applied in junior and senior high schools. A further modification has been developed for use with the PLATO IV system of computer assisted instruction. This last enterprise points the way to opportunities for individualization of art instruction that can only barely be comprehended. The key to all of these programs, however, lies in the union that has been established between the specificity of behaviorally based art instruction and the freedom granted to students to make their own selections of what to learn.

REFERENCES

1 Woodruff, Asahel D. and Philip G. Kapfer, "Behavioral Objectives and Humanism in Education: A Question of Specificity," *Education Technology,* 1972, pp. 51-55.
2 Hubbard, Guy and Mary J. Rouse, *Art: Meaning, Method, and Media,* six volumes. Westchester, Illinois: Benefic Press, 1972, 1974, 1975.
3 Rouse, Mary J., and Guy Hubbard, "Structured Curriculum in Art for the Classroom Teacher: Giving Order to Disorder," *Studies in Art Education,* 1970, pp. 14-26.
4 Woodruff, Asahel D., *First Steps in Building a New School Program.* Mimeographed booklet, Salt Lake City, Utah: Bureau of Educational Research, University of Utah, 1968.

5 Brouch, V. M., *Art Education: A Matrix System for Writing Behavioral Objectives,* Phoenix, Arizona: Arbo Publishing Company, 1973, pp. 203.
6 The suggested materials listed in the lessons were the least expensive possible for the tasks, but numbers of students preferred to enrich their work with higher quality materials. An informal study revealed that most of them spent 50¢ or less on each of their products. The costs ranged from zero to $8.00 or more; although many more zeros were registered compared with the higher figures.
7 Warren Schloat Productions, Inc., Pleasantville, New York, 1972. Selected sound film strips on art.

PART IV

STAFF ORGANIZATION AND UTILIZATION

Part IV of this volume concerns itself with a very critical, but often over-looked, issue in any curriculum development effort: the organization and utilization of staff. In Chapter XI, Dace describes in detail how he organized and utilized an art staff of twenty-one people in the development of a behaviorally-based curriculum.

CHAPTER XI

AN APPROACH FOR INITIATING STAFF INVOLVEMENT
in
THE DESIGN OF A BEHAVIORALLY ORIENTED PROGRAM
of
VISUAL ARTS EDUCATION (K-12)

Del Dace
Coordinator of Visual Arts Education (K-12)
School District of the City of Ladue
St. Louis, Missouri

Today, creativeness is no longer considered a special ability reserved for a gifted minority, nor is it assigned to a limited number of human activities. In art education today, emphasis is placed upon the development of the individual as a creative person and not merely as a producer of art forms. W. H. Kilpatrick suggested that creativeness is a characteristic of all learning, although it differs in degree from one situation to another, and that everyone can, and indeed must, create to live a normal life.[1]

In their new book on curriculum, Trump and Miller indicated that the inclusion of a subject in the school curriculum is determined partly by the significance attached to the subject and that there is no research to prove that one subject is more important than another for all pupils.[2] If it were to be decided that art is a valuable area of instruction, its status in the school curriculum might be improved. Trump and Miller recognize that art is more readily included in the elementary curriculum than in the secondary curriculum that is overcrowded with basic requirements.

> *Art provides pupils with experiences that are satisfying and directly useful to them in their daily lives. Through art, pupils develop their critical faculties and discover constructive avenues for emotional expression that enable them to contribute artistically to the creation of a more satisfying environment.*[3]

The general purpose of this chapter is to share an approach to a program of curriculum revision and development in visual arts education (K-12) for

the Ladue, Missouri, School District. The Ladue School District is located ten miles west of downtown St. Louis. It is almost completely residential and covers an area of twenty-five square miles. The district boundaries encompass the municipalities of Ladue, Olivette, Creve Coeur, Frontenac, and fractions of five others. The residents of the school district are primarily business and professional people. Many commute to St. Louis, but a number are employed by firms such as the Monsanto Chemical Company and McDonnel Douglas Corporation. There are twelve schools (nine elementary, two junior high schools, and one senior high school) to serve the student population of the school district.

The art staff is fortunate to work in the schools of a community where cultural activities are an integral part of everyday life. The community is willing to make a substantial financial commitment to a visual arts program ($170,000 for art staff compensation, $37,000 for art materials, and $40,000 for facility improvement). For the school year 1970-71 a total of $237,000 was spent. There are well-equipped art rooms in every elementary school, two in each of two junior high schools, and five in the high school.

Initially, the art coordinator was approached by the superintendent of schools and the curriculum coordinator concerning the design and development of a behaviorally oriented sequential visual arts education program for K-12. At that time the Ladue School District had very little which could be described as a written art curriculum. The administration wanted an attempt to be made to include the affective domain of learning as well as the cognitive domain of learning.

The coordinator of art was aware that if any written visual arts curriculum was to be implemented, it would need the involvement and support of the art staff.

Benn M. Harris states in his book on *Supervisory Behavior:*

> *One of the problems faced by supervisors who attempt to change certain aspects of the educational program is resistance from staff. The concept of staff involvement in planning educational changes is well developed and widely accepted.*[4]

The art coordinator was aware that if the new curriculum were written by himself and then handed down to the staff members, there would be little concern on their part for the implementation of the program.

Any number of texts on school administration indicate that no better method of achieving acceptance and understanding has been devised than the method of staff participation.[5] Thus, the plans called for all members of the staff to participate in the development of the plan of organization and the writing of the visual arts program.

The Ladue School District Art Staff consists of twenty-one people (eleven elementary and ten secondary). They are full-time art instructors for the district, and each member of the staff has his degree in fine arts and/or art education.

When approached by the art coordinator at a general art staff meeting to consider participating in the revision and design of a visual arts education program K-12, they responded to this invitation with mixed emotions and many concerns. They definitely wanted to be involved in the design, and they welcomed the opportunity to voice their opinions and to share their ideas and aspirations about what direction the art program in Ladue should take. However, the staff was a little hesitant and concerned about writing a behaviorally oriented program.

Many felt inadequate to write in a behavioral manner and some were concerned about putting down a written program for they felt it would inhibit them in the flexibility desired in their art rooms. They did not want to inhibit creativity and freedom of expression.

Aware that curriculum work is time consuming, the art staff suggested the possibility of an in-service program discussing the writing of behavioral objectives with consideration for the cognitive and affective domains of learning.

The art coordinator agreed that curriculum work is time consuming, and he assured the staff that they would have released time to participate in a program of in-service training in writing in a behavioral manner. Secretarial help and resource materials would also be provided.

The coordinator of art shared with the art staff the following justification for wanting to involve them in the design and writing of a district-wide visual arts program of study.

In his book, The *Process of Education,* Jerome Bruner states that each field should look for its underlying structure and devise ways to present it at all educational levels. He specifically states:

> *If the dangers of meritocracy and competitiveness, the risks of an over-emphasis on science and technology, and the devaluation of humanistic learning are to be dealt with, we shall have to maintain and nurture a vigorous pluralism in America. The theatre, the arts, music, and the humanities as presented in our schools and colleges will need the fullest support.*[6]

In discussing the scope of education, McFee advocates, "children's awareness in all subjects can be sharpened by their study of art."[7]

The art program should be designed for and around the youth, for through the youth the art program in the schools has the potential for making significant contributions to the cultural level of the area as well as enriched, exciting lives for the youth themselves.

A concise program of study with a sense of direction will improve the status of art education and encourage interest and participation by students as well as interest and continued support by counselors, teachers, parents, and administrators.

After this introduction and an assurance that all of their expressed concerns would be taken care of, the art staff committed themselves to the task

185

of designing and writing a behaviorally oriented, sequential program of visual arts education (K-12).

At the outset, the twenty-one art staff members were involved in gathering data for the design of a behavioral program of visual arts through their participation in a survey, each art staff was asked to state what in his opinion was important to include in the rationale, general art curriculum, general objectives for students, general objectives for the art staff, general objectives for coordinator of art education, and suggested evaluation criteria for the district-wide visual arts program.

In the general sessions which included all of the staff, the various parts of the initial staff survey were discussed. The primary purpose of these sessions was for addition, deletion, or revision necessary for clarity, in order to come to a consensus on a general direction of the program. The staff discussed and compared the merits of a media-oriented program to a behaviorally-oriented, conceptually-designed program. A number of general sessions were concerned with the purpose (rationale, justification for art being in the general curriculum). The staff members were asked to chart their course by the purpose and aims agreed upon. In these sessions, the staff was introduced to the cognitive domain of learning and the affective domain of learning and to the construction of behavioral objectives.

In addition to the general sessions, the staff met in grade level sessions (elementary, junior high, and senior high) to share ideas and to discuss problems pertinent to a particular area of study for a specific grade level. The staff was divided into their respective grade levels and assigned to committees to develop their part of the sequential program of learnings. The ten elementary art instructors were divided into teams of two to work on conceptual programs of study in the areas of clay, construction, drawing, painting, and printmaking for grades K-6. The four junior high school instructors formed a team to work on conceptual programs of study in the elements and principles of design for grades 7-9. The six high school instructors formed a team to work on full-year conceptual programs of study in Art Survey, Crafts, Pottery, Graphics, Sculpture, Beginning Painting, and Advanced Drawing and Painting.

The coordinator of art education worked closely with the art staff, the coordinator of curriculum, and the building administrators in planning and coordinating the desired in-service programs.

In-service training can make a significant contribution to the professional growth of educators. The evidence could be manifested through the staff becoming involved in a self-improvement program geared toward the improvement of instruction for students.

The in-service program could serve as an outlet for the staff to have the opportunity to voice their opinions, feelings, and desires and to make suggestions about the visual arts program.

For many of the Ladue Art Staff Members it has been several years

since they were students on a university campus. An in-service program utilizing the resources of the educational services of the community could bring the university campus to the teacher if the teacher is not getting to the campus.

A well-designed in-service program could help them be aware of new trends and developments in art education and the field of education in general, i.e., learning and curriculum theory, process, organization, construction, and evaluation.

The art staff was subsequently involved in a number of work sessions throughout the school year. They met in general sessions (all twenty-one art teachers present) to discuss problems, share ideas, and develop objectives relevant to the general direction of the district-wide visual arts program. They also met in grade level sessions (elementary, junior high, and senior high) to share ideas and to discuss problems about a particular area of study for a specific grade level and to construct specific behavioral instructional objectives for each grade level.

The work sessions varied in length of time. There were three six-hour sessions (in-service), three four-hour sessions (in-service), and ten two-hour sessions (after school), plus many extra individual hours of homework. A total of thirty hours of released time was provided by the administration to help the art staff accomplish this task.

In-Service Program Objectives (Global)

The visual arts staff will become more aware and sensitive to the needs of their students. The staff will see a need for a defined program of study with a sense of direction. The staff will want to be involved in the design of a sequential program of learnings.

Specific Objectives of the In-Service Program

(Intended outcomes for the art staff)

The visual arts staff will be able to:

1. become *aware* of their colleague's talents, energies, interests, opinions, and general expertise through the sharing and working experiences of the in-service programs.

2. *develop* objectives relevant to the general direction of the district-wide visual arts program.

3. *construct* behaviorally-oriented objectives in the affective and cognitive domains of learning for the various grade levels.

4. *be committed* to the design of a vertically-articulated, behaviorally-oriented visual arts curriculum (K-12) for the Ladue schools.

5. *be aware* of the hierarchical order (learning process) of the principles, concepts, discriminations, verbal associations, chaining, etc., representing an analysis of the capabilities considered prerequisite to the key capability (problem solving).

6. *defend* in *writing* and *orally* the learning sequence in such a hierarchical listing (objective 5) describing the type of learning involved in each item in the listing and its subordinate relationship to the next higher item in the learning process.

7. *apply* the theoretical principles of teaching and learning upon which the teacher predicates his instruction and *infer* from and ultimately *test out* in terms of what is observable and measurable in the teaching-learning process situation.

8. *design* a viable curriculum through their diagnosis, the formulation of intended improvement and the predesign of learning conditions which would provide an educational environment conducive to exciting educational experiences.

9. *perceive* that a written art curriculum can serve as a reservoir of ideas to be used as a springboard into meaningful experiences for students and not meant to inhibit them or to create recipes to be included in a cookbook type program of art.

The total art staff determined an exact sequence of areas or units to be studied throughout the grades K-12. Then smaller writing committees worked out the details of the curriculum for the particular grades with the assurance that the planning fitted into an organized total pattern of conceptual learning, based upon the needs of students. This list of the units to be covered over the total range of all grades will be referred to as the "sequence of learnings." Students should be able to formulate their own aesthetic concepts through perceptions they have received in their art experiences. The art staff should help students perceive by directing their attention toward selected foci in a sequential order.

A first task of the teams working on the development of specific conceptual units was to define exactly what pupils were to be expected to be able to do after they have experienced the unit. The emphasis here was on stating these objectives in terms of definite pupil behavior. They were not to be stated in terms of what the teachers were going to do or to describe learning activities. Each statement was to describe something that the pupil will be able to do after he has had the learning experience. They were not to be stated in such terms as "to understand," "to master," "to appreciate," etc. Rather, they were to tell what a pupil will be able to do if he understands, masters, or appreciates. They were to be stated in terms of pupil behaviors, as "to explain," "to state," "to solve," "to manipulate," "to carve," "to blend," "to scratch,"

"to interpret," "to compare," "to list," and any others listed by the art staff. Two worksheets (Figures 11-1 and 11-2) were developed to assist in this task.

FIGURE 11-1. WORKSHEET NO. 2

Words Open to Many Interpretations

to know	to enjoy
to understand	to believe
to really understand	to have faith in
to appreciate	to grasp the significance of
to fully appreciate	

The above words are open to a wide range of interpretation. In the case of our students, we leave ourselves, as teachers, open to misinterpretation.

What do we mean when we say we want a learner to "know" something? Do we mean that we want him to be able to recite or to solve or to construct? Just to tell him we want him to "know" tells him little—the word can mean many things.

Words Open to Fewer Interpretations

to write	to compare
to recite	to contrast
to identify	to _____
to differentiate	to _____
to solve	to _____
to construct	to _____
to list	to _____

Please think of verbs that relate to our field of art. Add them to the above list.

Use in an "overall" general objective ⎰ Although it is all right to include such words as "understand" and "appreciate" in a statement of an objective, the statement is not explicit enough to be useful until it indicates how you intend to sample the "understanding" and "appreciating." Until you describe what the learner will be DOING when demonstrating that he "understands" or "appreciates," you have described very little at all.

The statement which communicates best will be one which describes the terminal behavior of the learner well enough to preclude misinterpretation.

*Adopted for the program from Mager[8]

FIGURE 11-2. WORKSHEET NO. 3

The purpose of this sheet is to help you construct clear, specific behavioral objectives.

Consider the following diagram.

Example:

A. *General Objective*

The student will understand two 19th century art movements in the field of painting.

B. *Specific Objective*

The student will identify the difference between Impressionistic and Expressionistic painting.

C. *Specific Behavioral Objective*

1. The student will be able to *distinguish the brush stroke of Impressionist and Expressionistic movements by painting* two 12" x 16" canvasses in oil using the characteristic stroke of each movement.

2. The student will be able to identify how color was used in Impressionistic and Expressionistic movements by *bringing in* examples of reproductions showing the important use of color.

Please classify which of the following paragraphs are examples of:

 A. General Objective
 B. Specific Objective
 C. Specific Behavioral Objective

The student will be able to appreciate the difference between 17th century German Baroque Architecture and 19th century Italian Baroque Architecture.

190

The student will be able to appreciate the difference between Baroque and Classic architecture.

The student will be able to identify the characteristics of columns from the 17th century German Baroque and 19th century Italian Baroque architecture if shown slides of each.

Exercise:

Please write a specific behavioral objective, using the following:

The fourth grade student will be able to express himself visually with art materials.

In developing the behavioral objectives and the activities of the curriculum guide, the writing teams were asked to make an effort to design into the program a variety of experiences (see Figure 11-3) that would utilize various pupil abilities, i.e., avoid units that were centered solely on the acquisition of knowledge.

It was suggested that some attention be given to objectives in each of the following general categories:

Cognitive Domain

1. *Knowledge* - What the pupil will be able to name, to describe, to list, to state, to explain, to recall, etc.

2. *Skills and Abilities* - What the pupil will be able to do, to solve, to interpret, to work, to draw, to apply, etc.

Affective Domain

3. *Attitudes and Appreciations* - - What the pupil will enjoy and will choose to like and dislike, what expressions he will manifest, what value judgments and interests he will pursue, etc.

As the objectives were completed, the criteria in worksheet 5 (Figure 11-4) were applied.

For each unit the writing teams developed a list or brief description of conceptual learning activities that would be effective in helping pupils to achieve the specific objectives. This was done on the Art Planning Sheets (Figure 11-5) which were designed to include behavioral objectives, teaching strategies, materials needed and evaluation techniques. These art sheets were intended to be suggestive. They were to serve as a springboard into art experiences. They were not intended as a strait jacket which would prevent the art teacher from using instructional procedures which seem most effective for him with his particular students. In no way did the art staff want to inhibit creative outlets or write receipes which would establish a cook book type art program.

FIGURE 11-3. IDENTIFYING BEHAVIORAL OBJECTIVES IN ART EDUCATION

Worksheet No. 4

Write specific behavioral objectives for the nine phrases below. Underline the words open to a wide range of interpretations (Mager called them "loaded words").

1. "knowing about art objects" _____

2. "understanding art" _____

3. "cultural understanding" _____

4. "visual discrimination" _____

5. "producing works of art" _____

6. "personal expression" _____

7. "qualitative aesthetic judgments" _____

8. "evaluating art products" _____

9. "serving and feeling visual relationships" _____

FIGURE 11-4. WORKSHEET FOR ANALYSIS OF "BEHAVIORAL OBJECTIVES AND CRITERION TESTS"*

Worksheet No. 5

Write yes or no in a column opposite each question where you can give a response about the behavioral objectives constructed for each grade level.

	1	2	3	4	5	6
1. Is the objective written in behavioral terms?						
2. Does the objective describe the educational intent?						
3. Does the objective describe what the learner will be doing?						
4. Does the objective define the conditions, restrictions, or limitations?						
5. Does the objective define the criterion of acceptable performance?						
6. Do you feel a teacher could work from the objective and achieve the outcome desired?						
7. Can you identify the level of knowledge expected (re: Bloom Taxonomy) through the wording of the objective?						
8. Is the criterion test written at the same level of knowledge?						

Knowledge:
> Knowledge of Specifics
> Knowledge of Terminology
> Knowledge of Specific Facts

*Adopted for program from Woodruff.

FIGURE 11-4. (continued)

 Knowledge of Ways and Means of Dealing with Specifics
 Knowledge of Conventions
 Knowledge of Trends and Sequences
 Knowledge of Classification and Categories
 Knowledge of Criteria
 Knowledge of Methodology
 Knowledge of the Universals and Abstractions in a Field
 Knowledge of Principles and Generalizations
 Knowledge of Theories and Structures

Comprehension:
 Translation
 Interpretation
 Extrapolation

Application

Analysis
 Analysis of Elements
 Analysis of Relationships
 Analysis of Organizational Principles

Synthesis
 Production of a Unique Communication
 Production of a Plan or Proposed Set of Operations
 Derivation of a Set of Abstract Relations

Evaluation
 Judgments in Terms of Internal Evidence
 Judgments in Terms of External Criteria

ART PLANNING SHEET

Area of Study ___SCULPTURE___

Carrier Project ___BRANCH RECONSTRUCTION___

Materials Needed

Student:
1. small tree branch
2. contact cement
3. wood varnish
4. saw

Teacher:
Same as students.

BEHAVIORAL OBJECTS
(Intended Outcomes for the Student)

The learner will be able to:

1. *dissect* a solid shape (tree branch) into ten or more parts with a saw.

2. *select* and *separate* the dissected shapes into categories of large, medium and small.

3. *rearrange* and *reconstruct* the cut shapes into a balanced composition (putting the parts together to form a new whole).

4. *exhibit* perception of visual relationships (how things are put together and/or work) as he orders and assembles his construction of dissected shapes.

5. be *visually aware* and *sensitive* to the contrasting textures and colors of the outer rough bark of the tree prance parts and the inner smooth cut surface of the tree branch parts.

6. *display* a feeling of success as well as *demonstrate* pride in his new composition of dissected branch parts into his own unique solution to the structural problem.

*Cognitive Behavior Analysis and Synthesis
Affective Behavior - Responding

Teaching Strategies
(Motivation and Procedure)

1. Prepare one finished piece of wood sculpture for students to observe.

2. Discuss concept of balanced composition (symmetrical and assymmetrical).

3. Students saw wood branch into ten or more pieces.

4. Pieces are organized and rearranged until balanced composition is achieved with consideration for the relationships of the large, medium and small parts to each other.

5. Pieces are glued into a permanent construction.

EVALUATION TECHNIQUE
(Acceptable Performance)

1. Observation of student involvement as he attempts to solve the constructional problem through his rearrangement and reconstruction of the large, medium and small branch parts to form a new whole.

2. Has the student utilized the demonstrated method of dissecting the tree branch with the saw.

3. Does the student demonstrate his grasp of the concept of a balanced composition of branch parts through the principle of symmetrical and asymmetrical balance.

4. Observation of any sign of the student's display of a feeling of success and/or pride in his finished solution to the construction of his branch sculpture.

N. B.

Often a student who has not achieved a measure of success in a two dimensional carrier project will attain a successful feeling in a three dimensional construction experience.

FIGURE 11-5. ART PLANNING SHEET

Each unit was developed further through the identifications of media, tools, equipment, audio-visual aids, supplementary books (for students and/or teachers), and any other materials which would be helpful in teaching the conceptually designed unit (Figure 11-6).

The twenty-one members of the art staff in the Ladue School District were integrally involved in the design of a behavioral sequential program of visual arts education for the Ladue schools. Each staff member was given an opportunity to voice his opinions, feelings, and desires and to make suggestions about the art program through a survey. They shared their views in the general and grade level workshops. Two key elementary art instructors and one secondary art instructor with personal interests and some previous training in the behavioral approach to curriculum design were most helpful in assisting the art coordinator to receive commitment from the total art education staff to this tremendous task.

To bring about such a major revision in the design of the visual arts curriculum demanded cooperative teamwork and coordination. It demanded a defined program of study with a sense of direction which was determined and established by all parties involved in its design. The process as implemented in the Ladue Schools involved sixteen distinct steps or procedures which are described below and presented graphically in Figure 11-7. The sixteen steps varied in number of general sessions and grade level sessions needed to achieve the desired goals in each of the steps. The sessions also varied in length of time (1 hour, 2 hours, 4 hours, 6 hours, etc.).

1. *Orientation:* Define task of team. Identify roles of team members, coordinators, and IPC. Make an initial listing of available resources. Plan time and space for working. Examine scope and constraints of project. Project next steps.

2. *Planning:* Refine original planning to more specific expected outcomes. Project general visualization of final product. Plan considerations for nature of the learner, rationale, basic aims, objectives, a variety of teaching strategies and materials, and format.

3. *Search:* Make a substantial search for available commercial materials. Research content area and related concepts through IPC, libraries, surveys (teachers and students), catalogs, county AV, and other college and community resources. Reduce material to a few alternatives.

4. *Content:* Select the general content area to be included in project. Define the concepts to be developed. Develop main topics and related sub-topics.

5. *Checkpoint A:* Coordinator is to assist in future planning by asking: Is content related to level of learner? related to rationale? relevant to other units in the same area of curriculum? reasonable within time allotted for teaching and learning? and are concepts well documented?

ART AUDIO-VISUAL AID PLANNING SHEET

The following suggested audio-visual aids will supplement, reinforce, and make the art presentation a more interesting, graphic experience for the student.

16mm. Sound Films:

Recording:

2-D Reproductions:

8 mm. Film Loop:

Tapes:

3-D Alvacast Reproductions:

35 mm. Slides:

Overhead Transparencies:

Models: (i.e. Still Life Arrangement)

35 mm. Filmstrips:

Opaque Projector Materials:

FIGURE 11-6. ART AUDIO-VISUAL AID PLANNING SHEET

The following sixteen-step procedure will be used to document the activities of the writing teams in their development of the behaviorally oriented curriculum of visual arts education. The 16 steps will vary in the number of general sessions and grade level sessions needed to achieve the desired goals in each of the steps in the diagram. The sessions will also vary in length of time (1 hour, 2 hours, 4 hours, 6 hours, etc.)

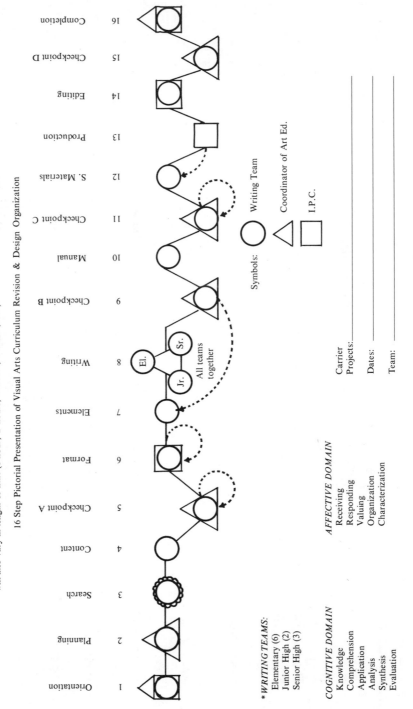

16 Step Pictorial Presentation of Visual Arts Curriculum Revision & Design Organization

WRITING TEAMS:
Elementary (6)
Junior High (2)
Senior High (3)

COGNITIVE DOMAIN
Knowledge
Comprehension
Application
Analysis
Synthesis
Evaluation

AFFECTIVE DOMAIN
Receiving
Responding
Valuing
Organization
Characterization

Carrier
Projects:

Dates:

Team:

FIGURE 11-7. 16 STEP PICTORIAL PRESENTATION OF VISUAL
ARTS CURRICULUM REVISION & DESIGN

6. *Format:* In what form will material be presented to learner, and what will the teacher's resource include? Then communicate with the IPC to discuss and plan physical characteristics and appearance of unit. The IPC director is to establish procedure with typists and artists to work from rough to finished copy.

7. *Elements:* Divide larger content area into several smaller pieces. Select and sequence specific content elements to be developed. Proper selection of content elements leads to better learning development and motivation.

8. *Writing:* Start the writing phase, relating each lesson to the specific content. Include the behavioral objectives, teaching strategies and materials and techniques of evaluating the outcomes of the lesson. This step is to be repeated as many times as necessary to complete the project.

9. *Checkpoint B:* Coordinator is to assist in evaluating each lesson as to clarity of objectives and the sequence of lessons related to learning theory. Added teaching strategies and materials may be suggested to provide a variety of motivating learning experiences.

10. *Manual:* Complete teacher's manual with all necessary teacher resource information. Teacher prep-sheets and introductory notes are effective to convey proper teaching attitude. All material must be numbered and a table of contents is useful.

11. *Checkpoint C:* Coordinator is to provide an evaluation of teacher's manual, checking format and whether or not the writer's intent was properly described in the manual.

12. *Student Materials:* Complete all student materials which are to be duplicated or printed. Also complete all other teaching materials such as: transparencies, tapes, slides, pictures, worksheets, laminated cards, etc.

13. *Production:* Check with the IPC for final production plans. Supply all necessary instructions as to printing: paper size, color of paper, color of ink, type of binding, number of copies, etc.

14. *Editing:* Proof read all finished mats and material. Most problems in producing a finished product are created by improper editing procedures. Care must be taken in handling finished mats to enhance best appearance in finished products.

15. *Checkpoint D:* The coordinator is to check the completed project. Writers are to list all items which have not yet been completed and expected completion dates.

16. *Completion:* Plans are formulated for distribution of completed materi-

als. This step marks the climax of the "writing-production" phase and the commencement of the "piloting-implementing" stage.

The Instructional Planning Center (IPC) referred to in Figure 11-7 proved to be a valuable support to the writing teams. Housed in the IPC were the materials, supplies, secretarial assistance, printing, reproduction, and binding services needed by the various grade level writing teams. The IPC facilities include a professional library, an instructional materials library, individual planning stations, team planning stations, and AV screening and production areas.

In addition to an organized and coordinated approach to curriculum revision and design, there exists a definite need for a strong support system for such efforts. In their book on supervision, Unruh and Turner stress the importance and necessity of support for a curriculum development program and point out that support should be encouraged throughout the school system and community.[10] Figure 11-8 is a pictorial construct for a support system with consideration for all of the supports suggested by Unruh and Turner.

Involvement in this effort required a strong commitment on the part of the art coordinator and the art staff. Because of this involvement and commitment, implementation does not present itself as a major problem. Such an effort, although time consuming, seems to be well worth its cost in terms of the payoffs.

REFERENCES

1 Kilpatrick, W.H., *A Reconstructed Theory of the Educative Process*, New York: Teachers College, 1935.
2 Trump, Lloyd and Delmas F. Miller, *Secondary School Curriculum Improvement: Proposals and Procedures*, Boston: Allyn and Bacon, Inc., 1968.
3 *Ibid.*, pp. 76-77.
4 Harris, Ben M., *Supervisory Behavior in Education*. New Jersey: Prentice-Hall, Inc., 1963, p. 421.
5 Morphet, Edgar L., Roe L. Johns, and Theodore L. Reller, *Educational Organization and Administration: Concepts, Practices, and Issues*, New Jersey: Prentice-Hall, Inc., 1967, p. 288.
6 Bruner, Jerome S., The Process of Education, Cambridge, Mass.: Harvard University Press, 1962, p. 80.
7 McFee, June King, Preparation for Art, San Francisco: Wadsworth Publishing Company, Inc., 1961, p. 7.
8 Woodruff, Asahel, *Instructional Materials*, Preconference Education Research Program in Art Education, NAEA, HEW Project No. 8-0259, 1968 (Xerox).
9 Unruh, A. and H.E. Turner, *Supervision for Change and Innovation*, Boston: Houghton Mifflin Co., 1970, p. 244.

SUPPORT CONSTRUCT
for
*Organizational Proposal for Coordination, Production and Evaluation of
Curriculum Revision and Design in Visual Arts Education*

FIGURE 11-8. SUPPORT CONSTRUCT

NOTE: Must establish roles before selection and placement of people in the various rectangles. This consideration might help to avoid conflict. (An important sociological concept)

CONTRIBUTORS

Virginia M. Brouch is Associate Professor of Art Education at The Florida State University, Tallahassee.

D. Cecil Clark is Professor of Instructional Evaluation and Testing at Brigham Young University, Provo, Utah.

Del Dace is Coordinator of Visual Arts Education, K-12, for the School District of the City of Ladue, Missouri.

Guy Hubbard is Professor and Head of Art Education at Indiana University, Bloomington.

Marylou Kuhn is Professor of Art Education and Constructive Design at The Florida State University, Tallahassee.

Judith A. Kula is Assistant Professor of Art Education at The University of South Carolina, Columbia.

Corinne Loeh is Art Director, School District U-46, Elgin, Illinois.

Jessie Lovano-Kerr is Associate Professor of Art Education at Indiana University, Bloomington.

John A. Michael is Professor and Coordinator of Graduate Studies in Art Education, Miami University, Oxford, Ohio.

Helen Patton is Consultant in Art, K-12, for the Racine, Wisconsin Unified Schools.

Mary J. Rouse is Professor of Art Education at Indiana University, Bloomington.

Asahel D. Woodruff is Professor Emeritus of Educational Psychology in the Graduate School of Education at the University of Utah, Salt Lake City.